HOW TO DESIGN AND APPLY
AUTOMOTIVE AND MOTORCYCLE PAINT AND GRAPHICS

Dedication

This book is dedicated to all the old custom painters
who broke the trail for those who followed. The
painters and artists who have spent so many nights in
the shop, only to watch the sun come up in the
morning and know that the clock is ticking. Knowing
I'm not alone is what keeps me going on those nights.

HOW TO DESIGN AND APPLY
AUTOMOTIVE AND MOTORCYCLE
PAINT AND GRAPHICS

FLAMES, PINSTRIPES, AIRBRUSHING, LETTERING, TROUBLESHOOTING & MORE

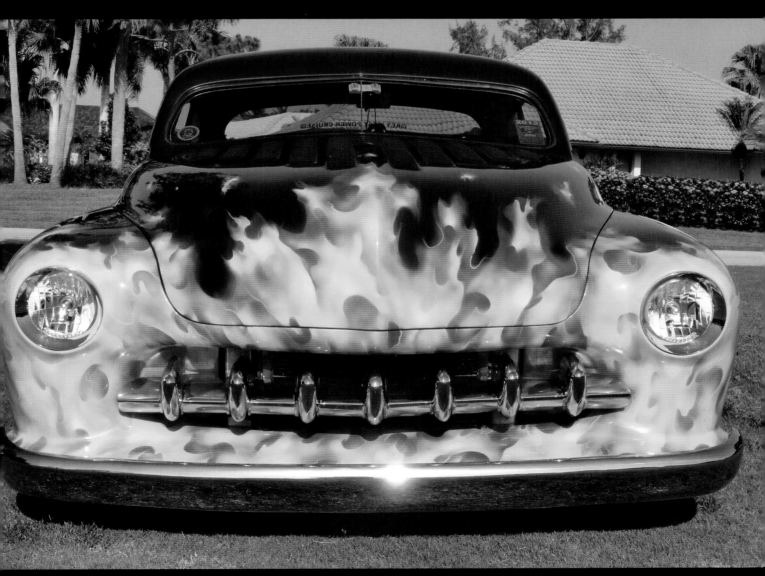

JoAnn Bortles

motorbooks

Inspiring | Educating | Creating | Entertaining

Brimming with creative inspiration, how-to projects, and useful information to enrich your everyday life, Quarto.com is a favorite destination for those pursuing their interests and passions.

Digital edition published in 2022
eISBN: 978-0-7603-6953-1

Library of Congress Cataloging-in-Publication Data

Names: Bortles, JoAnn, 1960- author.
Title: How to design and apply automotive and motorcycle paint and graphics
 : flames, pinstripes, airbrushing, lettering, troubleshooting & more /
 JoAnn Bortles.
Description: Beverly, MA : Motorbooks, 2022. | Includes index. | Summary:
 "In How to Design and Apply Automotive and Motorcycle Paint and
 Graphics, award-winning custom painter JoAnn Bortles covers the most
 popular custom painting styles and techniques in an easy-to-understand
 format"-- Provided by publisher.
Identifiers: LCCN 2021048171 | ISBN 9780760369524 (trade paperback) | ISBN
 9780760369531 (ebook)
Subjects: LCSH: Motor vehicles--Painting--Amateurs' manuals. | Motor
 vehicles--Decoration--Amateurs' manuals. | Decoration and ornament.
Classification: LCC TL255.2 .B692 2022 | DDC 629.222--dc23/eng/20211029
LC record available at https://lccn.loc.gov/2021048171

Design: The Quarto Group
Cover Image: JoAnn Bortles
Page Layout: *tabula rasa* graphic design

Printed in China

Contents

Introduction . 6

CHAPTER 1 **Designing and Testing Your Paint Job** . 8

CHAPTER 2 **Tools and Materials** . 21

CHAPTER 3 **Two-tone Paint** . 36

CHAPTER 4 **Rally Stripes** . 48

CHAPTER 5 **Flames** . 62

CHAPTER 6 **Graphics** . 80

CHAPTER 7 **Retro Styles** . 94

CHAPTER 8 **Lowrider and Flake Paint** . 102

CHAPTER 9 **Pinstriping** . 126

CHAPTER 10 **Gold and Metal Leaf** . 148

CHAPTER 11 **Lettering** . 157

CHAPTER 12 **Patina Paint** . 168

CHAPTER 13 **Creating and Using Plotter Stencils** 181

CHAPTER 14 **Clearcoating** . 203

CHAPTER 15 **Troubleshooting and Problem-solving** 212

Resources . 220

Acknowledgments . 221

About the Author . 221

Index . 222

Introduction
Reality Check!

I seldom read the introduction in How To books. I skip right to the chapters that explain the techniques I need. So, I'll keep this short. I've been doing custom painting for forty-two years. And I have learned some brutal hard lessons. I've seen countless hours of hard work and many dollars' worth of materials turn to ruin and become worthless because I took a shortcut, wasn't paying attention, or broke a painting rule that I knew not to break and broke it anyway. All of those hard years seemed like a waste of time until I had the opportunity to write these books and pass on the lessons I had learned.

But the journey of writing the first seven books was also a learning experience, and in the almost twenty years since I wrote *How to Custom Paint Your Motorcycle*, I've grown as a writer. For two years, I wrote for *Car Craft* magazine and the editor, Johnny Hunkins, did not cut me one bit of slack. He cracked on me as if I turned in the worst thing ever written and it only made me want to improve as a writer. And I worked hard to improve until he praised each article I turned in. It made me a much better writer. If you've read my other books, you'll see that this one is much better than the older ones. Much in the same way, I have always tried to improve as a custom painter. Instead of giving up or feeling bad when criticized, I just try again. And with each paint job, I try to do a better job. The flames I paint tomorrow will be better than the flames I paint today.

The road of custom painting is not an easy one. Things are going to go horribly wrong, and you might get discouraged. But know this, every awful thing that happens as you're painting has happened to the very best painters. And the reason you know their names is that instead of giving up, they went back into the shop and tried again.

Expect things to go wrong, and when they do, don't be too hard on yourself. Don't give up or get an attitude. Take a break. Maybe even close up the garage or shop for the day. Relax and get some rest. It's not the end of the world, even if it feels that way. *There's always another car or bike show.* Then go back with a fresh set of eyes and solve the problem. Do research, talk to other painters. This is a part of every custom painter's journey. Now get in the shop and paint! Good luck with all your painting projects!

Chapter 1
Designing and Testing Your Paint Job

Custom paint offers the greatest freedom to make your vehicle unique. No two customizers are likely to arrive at the same concept. Even if they did, limitless differences in colors, finishes, and personal artistic style ensure that each machine would be distinct, unlike every other ride on the planet.

THE JOB OF CUSTOM PAINT

Like clothing on a person, custom paint can enhance or downplay certain aspects of a vehicle's shape. Be thoughtful when picking colors and designs. Bright colors on a bulky or bulbous vehicle will accentuate the roundness. Darker shades can make a broad vehicle appear more slender. The lines in your design can have a similar effect. Artwork with vertical elements will stop the eye as it moves over the surface of the car or motorcycle. Horizontal designs will draw the eye across the length of it.

Stand back and look at your project. Just what do you want to accomplish? Are you looking for sleek and subtle? Want to make that car or bike look like it is a mile long? Or maybe you want the vehicle to shout out, "Hey! Look at me!"

To begin, let's go over a few rules for newcomers, including some risks to avoid. There are numerous potential mistakes that are guaranteed to create a painting disaster and nightmare stress.

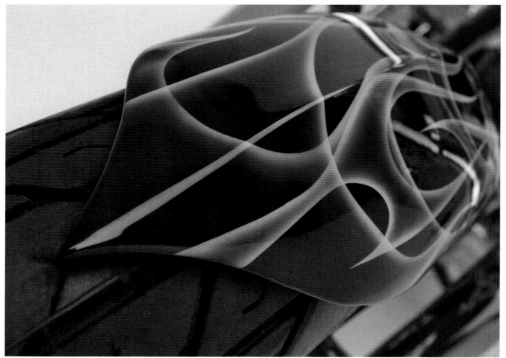

Effective color and design will bring out the best features on a vehicle and compliment them. The flames on this fender were designed to accent and emphasize the point on the front of it.

The 1939 Ford is a classic, but the back end of the car appears fatter than the front. Could custom paint give the car a more symmetric look?

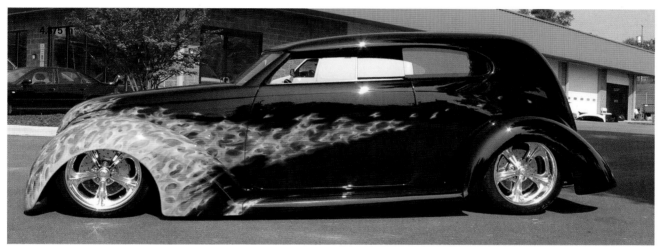

Is this the same '39 Ford? Yes, it is, and it won PPG's Top 5 Most Outstanding Paint of 2006 award. It was also featured in *Street Rod Builder* and it appeared in several other car magazines. How was this accomplished? Look at the previous photo. The rear end of the car is so round and big that it overpowers the front half. The front needed something to bring it out. The back half needed to be deemphasized. As black is "slenderizing," the car was painted black, and the artwork was limited to the front portion of the vehicle. The brightness of the real fire flames gives more balance to the car's body style.

ADVICE FOR FIRST-TIME PAINTERS

1) Knowledge is power! Even custom painters with years of experience will admit that they are always learning something new. Be curious and soak up all the knowledge you can. Go to car and bike shows and take plenty of pictures. See a car with a cool color on it at a car show? Ask the owner who painted it and what kind of paint it is. Look closely. How is it holding up?

2) Enthusiasm and expertise are not the same. Beware of information from fans or celebrities who are not custom painters. They may offer opinions from what brand of paint to use, as in "Real painters only use Triple X Paint!," to what kind of artwork you should do—"Oh, flames are so last year. No one's painting flames on their cars this year." Make your own

The first paint I ever did. It was simple. The gold base color was the perfect choice. Don't over-complicate your first paint jobs. Keep it simple. Use interesting colors to give them impact.

I had a short amount of time to get this paint completed on NBC's *Today Show* chopper. I used the most outrageous color paint, Crystal Orange Pearl Candy. Note how the color emphasizes the lines and style of the bike. This is what is meant by effective use of color and design to suit the style of the vehicle.

decisions. Listen to people with real world experience. Custom painting has a long history, and this year's fads may have no importance for a vehicle you might keep for years or decades.

3) Shut out distractions and protect your creative space. Even when you know what you want to do, there will be many creative decisions throughout the process. Give yourself the time and space to make them. Don't let anyone get under your skin about how you should do your paint work or how quickly. Put your full focus on your project and enjoy the journey! And don't hesitate to shut out the world. Turn off the phone and turn on some music. Too often a painter will be on a roll, turning paint into art, and the phone rings. The concentration is broken and it's often hard to get back into that happy place that makes the experience so worthwhile and satisfying.

4) And one more thing about time deadlines and paint. Paint is the last step in the custom process. The builder or fabricator had all the necessary time to do that job. The engine builder had plenty of time to put together a sweet powerplant. Then there was the whole getting the parts thing. Body panels were aligned and assembled on the car until all the gaps were perfect. So why, in the final stage, should you rush the MOST noticeable part of your project? Whether painting for yourself or painting for a client, don't rush! Be realistic about deadlines and be ready to explain the reasons if the deadline needs to be changed.

WHAT MAKES AN EFFECTIVE PAINT JOB?

Custom paint's contribution to a vehicle is powerful, but subtle. Its effects lie outside the quantifiable aspects that people love to tout, such as displacement, horsepower, torque, acceleration, and top speed. Most of the time when people look at vehicles with cool paint, they simply appreciate the way it looks. They don't think about what exactly makes it so cool, what makes it "work." Many different things come into play to make a custom paint job effective. The key is to consider the project as a whole and to find the right combination of color and design that will bring out the vehicle's best features.

HOW A DESIGN WORKS

By drawing viewers' eyes toward or away from certain regions, paint design can be used to "alter" a car or motorcycle's shape. Use paint design to enhance or bring out various features of your project. Look at these examples of how paint design changes how a vehicle is perceived.

King-style sportster tanks have a fat, short look. Can design give it a sleeker look? This king tank was painted with a special tangerine candy pearl mixture. A dark color would tend to "slim" down the tank. But the hot, bright tone of the orange has a glow to it and "thickens" the tank.

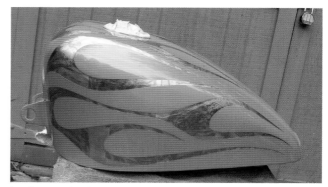

I really wanted to deemphasize the "fatness" of the tank, using flames to make it appear long and leaner—not just a "squat bean" sitting on top of a motorcycle frame. I did the flames in variegated gold leaf. The tank color looks great with the gold flames. The flames look good. But it feels like something is missing . . .

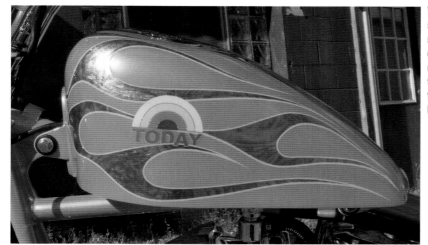

Wow, what a difference a pinstriping makes. The striping does numerous things. It creates a clean separation between the gold and orange, creates contrast, and compliments both colors. But what it really does is add length to the flames. The pinstriped tips only extend maybe 1–1½ inches past the gold, but that makes all the difference. And that gives the tank a longer, sleeker look.

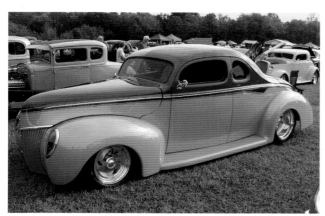

Splitting the profile of a vehicle with a two-tone is very simple but can completely change the look of the vehicle's shape. Compare this photo with the next one.

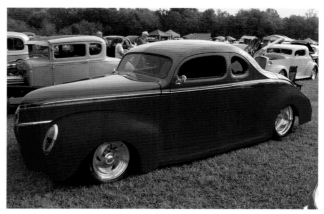

I've used Photoshop to make the bottom half of the car appear to be a simple purple like the top half. Does the car look shorter? The orange in the previous photo is bright and gives the car the illusion of being longer.

ARTWORK VS. SOLID COLOR

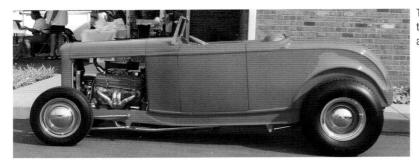

This Ford 1932 Hi-Boy looks very cool painted this fiery tone of red. What kind of difference or effect would artwork have on it?

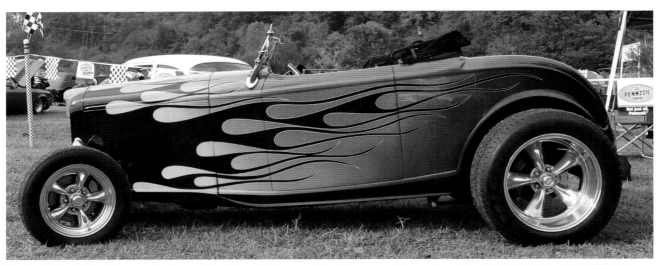

Here's a Hi-Boy with black flames and a wicked killer rainbow fade basecoat. Now these cars are the same length, but the flamed car looks longer. The area under the trim line along the bottom of the car has been painted black and disappears. That, plus the flames, narrows the body of the car and accentuates the length of the car. The fade also helps this lengthening effect. The brightness on the front of the car makes the surface look bigger, farther away from the dark colors on the rear. Flames by Wade Hughes.

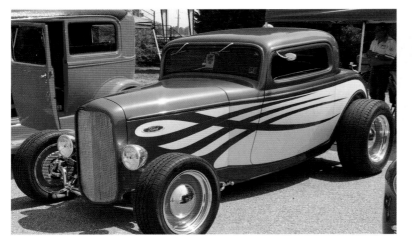

Compare this altered photo to the previous picture. The car looks shorter than the other, yet it's the exact same photo.

Now check out the graphics on a 1932 Ford Coupe. Besides the fact that this is a very well thought out and flawlessly executed custom paint job, it is very unique. The white side panels, narrowed by green above and below and accented with flamelike green stripes stretching and tapering front to back, draw the eye along the car's length, making it look longer.

I like for the bikes I paint to have a long, lean look. When the customer wanted yellow for this bike, I knew it would be a challenge to find the right color for the artwork. Yellow is a glow color and makes a vehicle look bigger, but in all directions, not just the length.

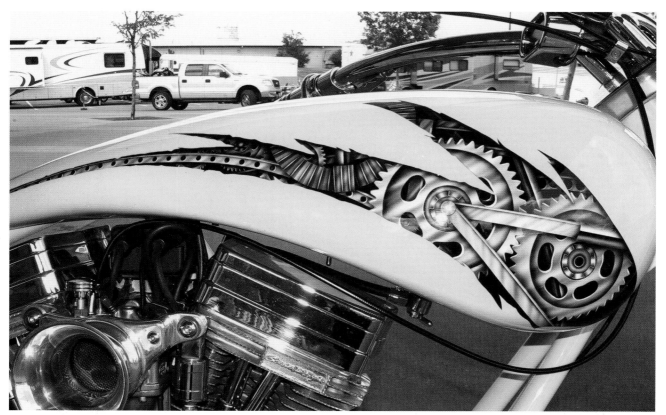

This black and white gear design slashes across the tank. The black and white has a touch of blue, and the colors are very cool yet work great with the yellow. The angle of the design makes the most of the downward curve of the front of the tank. It slims down the tank, and the gears make the paint interesting. The paint goes from bland to sleek and intricate.

WHAT IS AN EFFECTIVE DESIGN?

A customer sent me this tank with his old paint job still on it. The round design and muted colors didn't visually transform.

They say black is slenderizing. What is true for fashion is sometimes true for custom paint. The artwork cuts the tank in half, giving the illusion of more length. The black frames the red, creating contrast, and in turn making the red look brighter. The line design is limited to the middle of the tank. It is more than just a straight line but is not overly complex. There is only one really curved line. The rest are nearly straight.

PLAY WITH COLOR

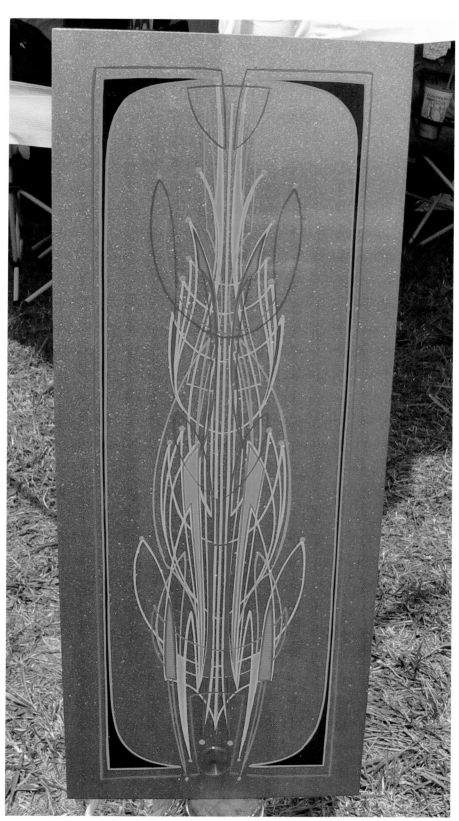

This pinstriped panel has many colors on it, and it looks amazing. But look closely at the basecoat color. It's an odd kind of a green gold, but it looks perfect with the stripe tones. Don't discount offbeat colors. Don't settle for colors that everyone else is using. Try something new. Panel by Jim Norris.

TEST YOUR PAINT AND TECHNIQUES

It's so important to create spray-out cards and test panels for colors and design. Never use your project as the testing ground. Test your color and your technique on panels and spare pieces. Once you're satisfied with the results or your client approves them, spray it on your project.

Here are three different examples of purple pearl. One is redder, another is bluer, and one is in between. Explore your color possibilities. Never trust what you see in the mixing cup. Spray it out, let it dry, and apply clearcoat. It is the only true way to judge a color.

These are just a few of the many color test samples and test panels I've painted over the years.

TRYING ON A DESIGN

Every paint job design should start with photos of the car, truck, or motorcycle. The main angle I use is the straight-on side view, which people tend to associate with a vehicle's shape. I'll also take shots of whatever other views will be getting artwork, like the top of the hood or the top of the gas tank. Next, create a "blank" by whiting out the paint areas using a graphics program or actual white, office-style correction fluid. Then make copies of the blank, and you're ready to sketch out your ideas. Then you can compare the ideas, find the features you like best, and edit your drawings until you have a design that is perfect for your project.

Here's a simple tank design. First, I took a photo of the tank, opened it in Photoshop, and whited out the tank. Next, I drew the design on the tank.

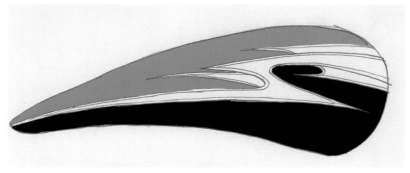

Now to try out the color choices, black and lime green. Here's lime green on the top surface.

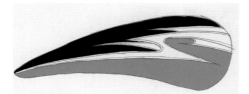

Here's black on the top surface. Which one is better?

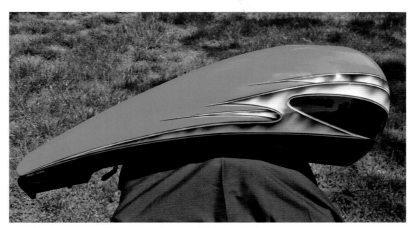

I went with the green. The green on top gave it a bolder look.

OLD-SCHOOL DESIGN

You don't have to use a computer for your graphic design. You can print out the photo, place a piece of tracing paper over it, and trace the outline of the paint areas of your project and the paint elements of the photo. Next, print out a few copies on your printer. Now use colored pencils or markers to create your design and try out options.

THE JOURNEY OF A PAINT DESIGN

I started with a blank of a Harley Street Glide. The client wanted graphics and skulls.

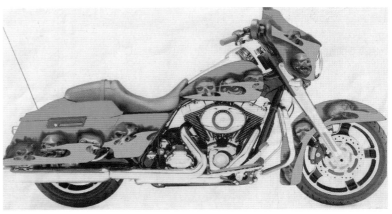

The first drawing shows how it looks with one layer of graphics backed with the skulls. I start by pasting the skulls into the blank drawing with their own Photoshop layer. Then the graphic layers are added on top with a new layer. This could also be done by hand, drawing the skulls onto a blank, and then creating copies. Then draw the graphics on the copies.

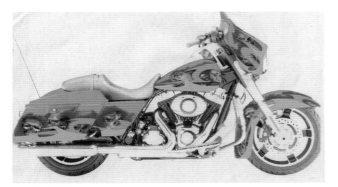

The next drawing shows a second layer of graphics has been added.

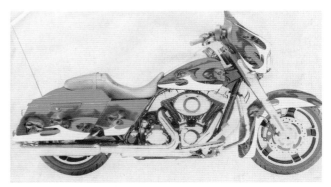

One of the graphic layers is lightened up.

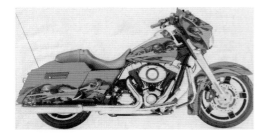

How would it look with leaner, thinner graphics?

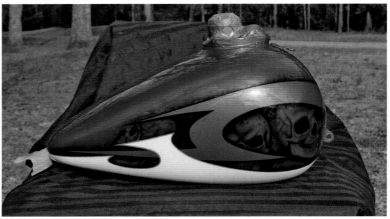

You can see from the tank that the client went with the third option.

THE JOURNEY OF A PAINT JOB: COLOR AND DESIGN

Chapter 5 features a flamed 1955 Dodge panel truck project. But how did I know what colors would work best? Or how the flame design would best suit the truck?

Here's the evolution of that paint's color and design. This showcases actual hand drawing and using a computer graphic program to fill in colors.

My client didn't know exactly what he wanted at first. But he decided on hot rod flames. I created a blank drawing, made some copies, and started to sketch with colored pencils. The first drawing had a minimal number of flames.

The second drawing had just a little more flames, this time stretching across the entire length of the truck.

And just for fun, I covered the entire side with flames. And that was the one my client chose.

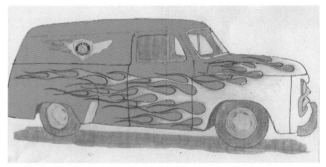

Now to try on a few colors. We didn't want to go with a plain black. Too typical. Does an orange base work for these flames?

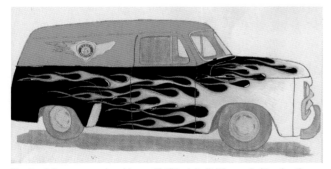

The truck is very round and has a "fat" look to it. We wanted to give the truck a little more attitude to match the Hemi motor under the hood. Splitting the truck into a two-tone gives it a leaner, more aggressive look. But it's not striking enough. It needs something more.

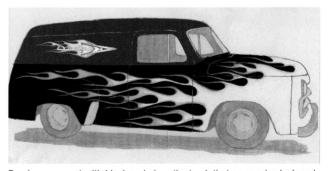

Purple goes great with black and gives the truck that aggressive look and sets it apart. Some purple tones are carried into the flames to give the paint design some symmetry. The artwork on the upper sides of the truck is changed to a leaner, sharper design. This flows better with the flames.

USING GRAPHICS PROGRAMS TO RENDER DESIGNS

While other software may meet your needs, Photoshop is an easy-to-use program for creating designs using photos. Many online tutorials explain how to use the various drawing tools in the program. Many artists use Photoshop to create realistic renderings that make it easy to see how effective the paint job will be.

Photoshop was used to draw the blue fire flames on the car in this photo. If you're learning how to use Photoshop, be patient. Try out the different tools and experiment. For this, I drew out the darker tones using the Pen tool. Then I used a smaller Pen tool setting to draw the lighter parts of the fire. The flames are blended together using the Blur tool. The Erase tool is used to trim away any unwanted blue areas. This can also be done using old tech. Create a white blank, and then use colored pencils to draw out the fire flames. Next, use colored pencils to fill in the basecoat color.

Here are the flames after they were painted on the car.

Chapter 2
Tools and Materials

While it's tempting to flip ahead to get to the "good stuff," there's essential information in this chapter about the paints and tools you'll be using. We'll cover information like which paint should be used for what, the kinds of paint *not* to use, and problems you might encounter when using different kinds of paint. The chapter will explain how paint works, how to get the best from the products, and what to look out for to keep paint problems to a minimum. You'll also learn about the tools and other materials used for custom painting.

Good paint isn't just about custom artwork. Good custom painters know how paint works and how to make it work to their advantage. Good paint jobs are only as good as the paint under the artwork. Taking the time to understand the different kinds of paint and using paint correctly is the difference between a successful paint job and weeks in painting hell.

HOW PAINT WORKS

This is a very simplified drawing, but for the most part, this is the quick and simple explanation of how paint works. The paint is sprayed onto a sanded surface. The sanded surface provides a "tooth" to help the paint to stick. The solvents in the paint carry the pigments and resins to the surface; then, as they evaporate out, the layers bond together.

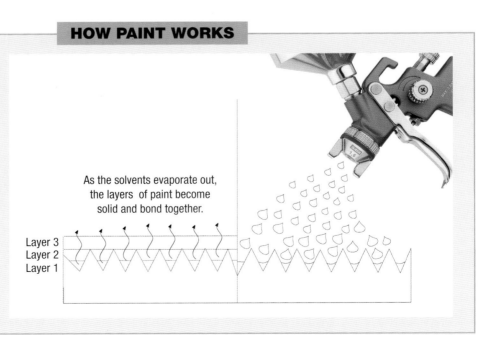

As the solvents evaporate out, the layers of paint become solid and bond together.

Layer 3
Layer 2
Layer 1

TYPES OF AUTOMOTIVE PAINT

Basecoat or 1K Paints

Acrylic basecoat is the best choice for custom paint work and artwork. Basecoats are 1K paints. They don't require a hardener. Adding hardener, as is often done for repair tasks in the collision industry, will give the basecoat a pot life. For custom painting, it's better to use basecoat with no hardener added. This way the paint will last a long time. Basecoat without hardener is used for all the artwork in this book.

Basecoats are low in gloss and provide better and faster coverage. They're also low in solids, which means the thickness of the paint coats is one-third less than single stage or 2K urethane clearcoat. The paint edge is thinner and levels out more quickly when clearcoated. These qualities make it great for doing artwork and most kinds of custom paint, which tend to require more coats of paint than single-color paint jobs. Thick coats would not be good when you are doing a custom paint job with ten or more coats.

TOOLS AND MATERIALS

Custom paint is more than artwork. Here's a two-tone paint job that jumps out. The magenta contrasts strongly against the black. This is what effective use of basecoat paint looks like.

POT LIFE

"Pot life" is a term you will see throughout this book and in technical information, or P sheets for the paint products you use. Pot life describes how long mixed paint remains good to spray. Most mixed basecoats (mixed with reducer), for example, have a very long pot life. In fact, in some cases, you can add reducer to basecoat that has solidified and make it usable again. But if you also added hardener to that basecoat, it will last only a certain amount of time before it becomes hard and unusable.

Urethane paints always use a catalyst or hardener. Their pot life will vary depending on the specific kind and brand of paint. The pot life for any paint will be given in the P sheet for that paint product.

THIN VS. THICK COATS

The better the paint dries, the less chance there will be paint problems. Thin paint coats dry faster and more efficiently than thick, heavy coats. There's a reason that basecoat spray guns have smaller tip sizes, like 1.2 and 1.3. They spray lighter coats than big nozzle sizes and they atomize much better. Never spray thick, heavy coats of basecoat. But don't go the other extreme and spray light, dust coats either. Always spray your paint per the recommendations on the P sheet.

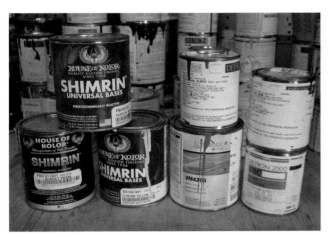

House of Kolor has a complete line of basecoat colors ready to go. Just reduce and spray. PPG's Deltron and Vibrance paint lines are my favorite for basecoat paint as they're very easy to use and are great for doing artwork. You can find House of Kolor and PPG Vibrance colors charts online.

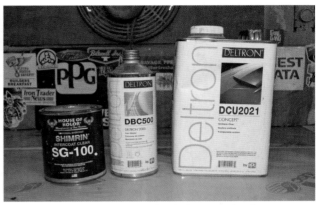

House of Kolor SG100 is a longtime favorite basecoat clear for many custom painters. PPG Deltron DBC500 Color Blender basecoat clear is easy to use and very popular among painters. Urethane clearcoat is vastly different from basecoat clear. Deltron DCU2021 is durable, glassy, and very painter friendly.

Clearcoats 1K and 2K

Custom painters use two main types of clear paint—clear basecoat (1K) and clear urethane (2K) topcoat. Basecoat clear is not a topcoat clear. Basecoat clear is often mixed with pearl powders and metalflakes to create custom colors. Both kinds of clearcoat are covered extensively in chapter 14.

Single-stage Urethane 2K Paint

Single-stage paint is not often used for custom painting. While it is used as a basecoat, it's a completely different product from regular, acrylic basecoat. It's a 2K product, a *urethane* basecoat that has been catalyzed with a hardener to provide quick drying, durability, and chip and scratch resistance. Single-stage urethane 2K paints are usually sprayed as solid colors. They are rich in resin, to provide gloss, and low in pigment, so they may need more coats to get total coverage. Painters typically don't spray urethane clearcoat over them because they dry glossy.

If you were to do artwork over single-stage paint, use care. Single-stage paint needs to dry overnight at a warm temperature of at least 70 degrees Fahrenheit before you do any taping or sanding. The surface would need to be sanded or scuffed before the artwork could be done. That means you would be sanding into the color coat. If the single-stage paint were a pearl or metallic, chances are high that the sanding action would cut into the metallic and scratch it.

Lacquer

Lacquer is very seldom used these days. In fact, many auto paint supply stores do not even sell it. If someone talks to you about using lacquer on your project or in your shop, think twice. Today's custom paints are urethane technologies. Never mix urethane and lacquer technologies. It's a formula for problems. If you need to work over an old lacquer base or if you have a client that needs lacquer work done for restoration purposes, know that the technique is similar to using basecoat. Apply it over a sanded base, mix it 1:1, and spray light to medium

PRODUCT OR "P" SHEETS

All through this book, I keep talking about P sheets. This is page one of a P sheet for DCU2021. I print out or get a P sheet for every paint and body product I use. Even after thirty-plus years of painting, I still refer to the sheet immediately before using a product, even if I use the product all the time. Take no chances leaving something to memory. The minute or so you "save" by not looking at the P sheet could cost you hours if you remembered wrong. Referring to the P sheet refreshes your knowledge and helps reduce the chance of making a mistake.

HOW TO AVOID PAINTING PROBLEMS

When using 2K products, such as body filler, primers, sealers, and clearcoats, the best way to avoid problems is to use only the hardener or catalyst designed for that product. If you do not have the correct hardener to go with the stuff you're using, *stop and wait until you get the right hardener.* Trying to substitute a wrong product for the right one is never worth it!

coats. But be warned, the solvents in lacquer are very strong, as it's reduced with lacquer thinner. If you spray it over urethane or acrylic basecoat, there's a good chance the lacquer thinner will eat into your base and soften it, causing wrinkling and other problems. If that happens, then all the paint must be removed.

Among painters who have been pressed to work over an old lacquer finish, some recommend using an adhesion promoter to help the urethane to stick. Either way, painters who report spraying urethane over lacquer advise against it. There's a 50/50 chance the lacquer base will react badly with the urethane in some way. If you feel compelled to try it, test a small area in a hard-to-see place before proceeding.

CHOOSING THE RIGHT TEMP SOLVENT

Picking the right temperature solvent to go with your basecoat or clear can make or break a paint job. When slower reducer is used, the paint dries slower. A slow-drying top layer allows the coats under it to dry out better. Fast reducer, while reducing wait times, can dry too fast if used in warm temperatures. With thick coats of paint, fast reducer can cause the topcoat to skin over before the bottom layers have dried out. This traps solvents in lower coats and causes a multitude of problems, including peeling, bubbling, and tape marks when doing artwork.

A paint's P sheet will say what temp reducer to use for certain temperature ranges. For example, PPG's DT 870 Reducer is a fast/medium reducer that should be used for temps under 70 degrees Fahrenheit. A little slower is DT885, which I use for temps around 80 degrees Fahrenheit. PPG's slowest reducer is DT898. For doing artwork, sometimes it's best to use a slower-drying, or "warm," reducer. Because paint used for artwork is sometimes mixed very thin (with lots of reducer), it can start drying as it's being airbrushed. Some painters will use a slower reducer for artwork. Slow reducer is also used for finish clearcoating because the longer cure time allows more time for the paint to flow out after spraying.

One last thing to remember about painting. No matter what paint product you're using, applying it is mostly common sense. For example, if I'm spraying more than just two coats of paint, I wait the maximum time in between coats to give each coat plenty of dry time before the next coat is sprayed.

PPG REDUCER TEMPS	
DT870	65°F–80°F
DT885	75°F–90°F
DT895	85°F and above
DT898	95°F and above

This graphic explains the temps that the different PPG Deltron reducers are designed for. Whatever brand of paint you're using, know the exact recommended temps for your reducers.

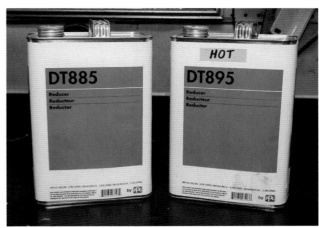

It's easy to grab the wrong can when they look alike. Mark your reducer cans. That way you don't pick up the hot reducer when you needed to use the reducer for colder temps.

CLEANING PAINT FROM YOUR SKIN

N*ever use lacquer thinner to remove paint from your skin!* In addition to causing skin irritation and maybe chemical burns, the solvents in thinner will absorb through your skin and pass into your body. Painters have become poisoned by this practice. There are hand/skin cleaning products made especially to remove paint. 3M's Paint Buster and 5 Star Xtreme Hand Cleaner, for example, are nontoxic cleaners that are great at removing any kind of paint or auto body product from your skin.

SPECIALTY PAINT PRODUCTS

Candy

Candy colors are highly concentrated colored transparent toners or dyes that are mixed with a clear urethane or clear basecoat. Some companies, like House of Kolor, sell premixed urethane candy colors with the candy toners or concentrates already in it. Candy toners or concentrates should never be used alone without first mixing into a paint product. When they are used as the base color, they are mixed with clear urethane and sprayed in layers over a metallic, flake, or pearl base. For artwork, they're mixed with clear basecoat and used in everything from fades to murals to flames and much more. Custom artists like to keep a few candy toners in their shop. Here are a few House of Kolor Kandy Koncentrates that will come in handy: KK04 Oriental Blue, KK05 Cobalt Blue, KK08 Tangerine, and KK11 Apple Red. If you're spraying real fire flames, candy colors will be a big part of the process.

Please note that some candy colors can bleed up through artwork or topcoats. If you're doing artwork and spray white over a color like Cobalt Blue, that white will turn light blue. Applying basecoat clear over the candy won't stop this. Apply several coats of catalyzed urethane clear over the candy. Let it dry. Sand it, then continue your artwork. Candy Colors that are likely to bleed up include Cobalt Blue, purple, and some candy reds.

TOOLS AND MATERIALS

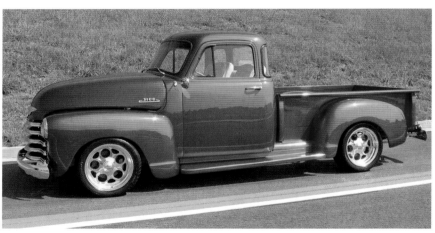

To get a candy finish like this takes practice. If you're spraying candy colors for the first time, test your colors and your spray technique on some large panels. If you have some fenders or an old hood lying around, prep them as you would your paint project and practice spraying candy paint. Use a horizontal back-and-forth motion for one coat, an up-and-down motion for the next, then a diagonal coat. This will help to avoid uneven streaks or "tiger stripes."

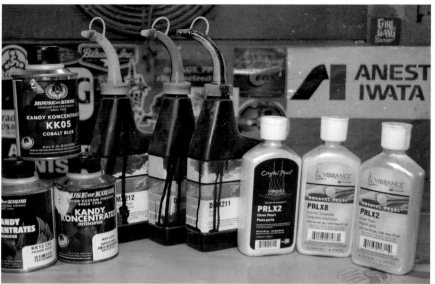

Candy toners and pearl powders are part of every custom painter's inventory. They come in very handy when creating custom effects in graphics and flames. Find some interesting colors and keep them in stock. House of Kolor and PPG both have a great line of candy concentrates and pearl powders. Check out their color charts online and find your favorites.

Pearl paint is great for doing fades like on this 1941 Chevy truck. Fades can be tricky. Start the fade at one end of the project and keep the gun directed at the front of the fade. Pull the gun away as you get closer to the transition point, so less paint lands on the surface. Stop this transition about a foot from where you want the fade to start, leaving plenty of room for actual fade. Then add more reducer to the mixture and create a smooth transition between the colors, now directing the paint toward the rear of the fade, directing the paint up and away at the end of the stroke. Practice fades on a large panel before trying it on your project.

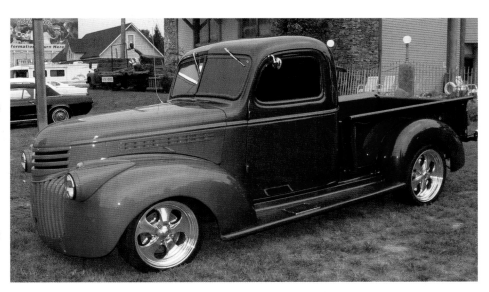

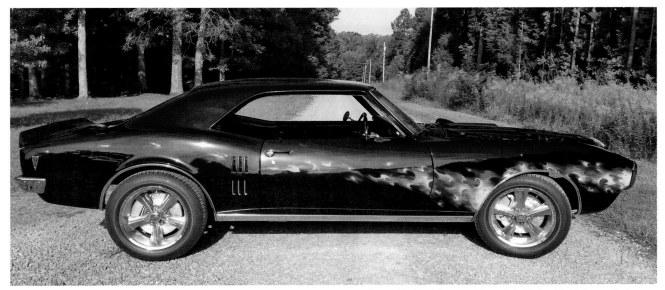

You can get some crazy effects with pearl paint. For this 1967 Firebird, we mixed purple pearl in black basecoat. In certain kinds of light, the car looks black, but in the sun, it lights up purple. If more pearl had been used, the purple would have been brighter.

Pearl

Pearl powders come in many different sized and shaped particles. The effects are endless. And pearl is easy to use. You can mix the pearl powder with clear basecoat or urethane or mix it with colored basecoats. Mix pearl blue powder with clear basecoat and spray it over a white for a light blue pearl. Create a midnight purple pearl by mixing purple pearl powder with black basecoat. Pearl powders allow the painter to be completely creative. The more pearl mixed in, the more noticeable the effect will be. Mix in less pearl for a subtler effect. Play around with test panels and see what you can create. Most automotive paint companies have their own line of pearl powder.

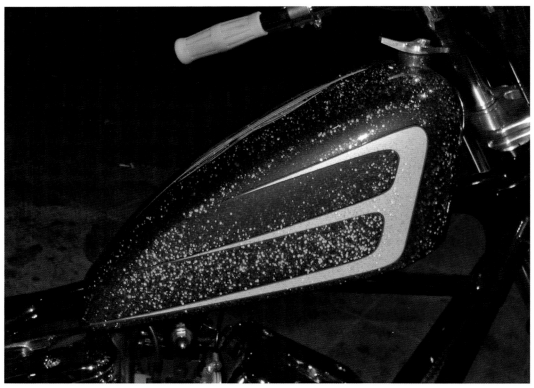

Spraying metalflake paint is messy, but it sure is fun! Metalflake paint is never boring and it's for more than just retro and lowrider paint.

Flake

Metalflake comes dry in a jar and is usually mixed with clear basecoat. Many colors and sizes are available, from 0.002-inch micro mini flakes, to bass boat big flakes 0.062-inch wide. Among the most popular sizes at present is 0.015 inch. For a close look at metalflake's ability to enhance your project, see chapters 7 and 8.

Cleaners

Preparing the surface beforehand is just as important as painting. Precleaners remove surface contaminants that can otherwise cause a variety of problems with the paint's appearance or adhesion. Use a strong precleaner, like PPG's SX330 or House of Kolor's KC-10. These are solvent precleaners, sometimes known as wax and grease remover. To cleanse, the surface while painting, use a post-paint cleaner, like

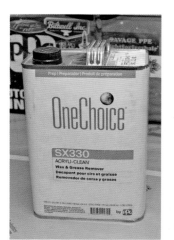
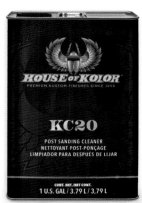

A good selection of precleaners is as important as the paint itself. PPG's SX330 is designed for cleaning surfaces prior to painting. House of Kolor's KC-20 is a water-based cleaner that can be used to clean the surface during the paint process.

PPG's SX320. Another great post-paint cleaner is House of Kolor's KC-20. It removes sanding residue and light contaminants but is not so strong as to damage your fresh paint. KC-20 also reduces static on painted surfaces. It's a waterborne cleaner, so *do not* let it dry on the surface. If it does, repeat the cleaning process, wiping up every bit. Some waterborne cleaning products leave a residue on the surface, which must then be cleaned again with a solvent cleaner. If you're using one for the first time, test it on something unimportant and see how it reacts. And don't go cheap, here, just because it's a cleaning product. Use a good-quality precleaner to suit your costly paints.

SETTING UP AN AIR SYSTEM

Many painting problems can be avoided by having a well-thought-out air system. It doesn't have to be expensive. Simple tricks like angling the line air and running drops to allow for natural water runoff, combined with a water separator and filter, will supply you with clean, uncontaminated air. Make sure there's 25–50 feet of airline between the compressor and the water separator to allow the hot air to cool down. Hook up a coiled 25-foot air hose, at the compressor, and use this extra line as an air cooler.

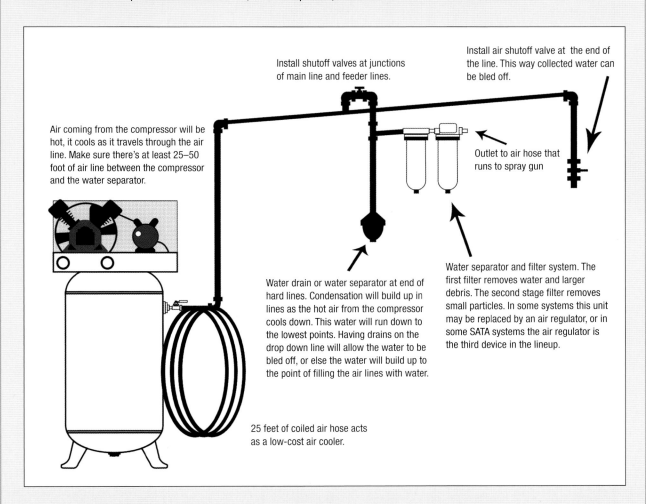

Install shutoff valves at junctions of main line and feeder lines.

Install air shutoff valve at the end of the line. This way collected water can be bled off.

Air coming from the compressor will be hot, it cools as it travels through the air line. Make sure there's at least 25–50 foot of air line between the compressor and the water separator.

Outlet to air hose that runs to spray gun

Water drain or water separator at end of hard lines. Condensation will build up in lines as the hot air from the compressor cools down. This water will run down to the lowest points. Having drains on the drop down line will allow the water to be bled off, or else the water will build up to the point of filling the air lines with water.

Water separator and filter system. The first filter removes water and larger debris. The second stage filter removes small particles. In some systems this unit may be replaced by an air regulator, or in some SATA systems the air regulator is the third device in the lineup.

25 feet of coiled air hose acts as a low-cost air cooler.

PAINTING TOOLS AND MATERIALS

Spray Guns

Paint spray guns used to be divided into just two categories: professional equipment and low-cost budget spray guns. Professional spray guns are just that, designed for professionals. If you paint every day, then a professional spray gun is the best choice. They are engineered to survive being used for hours on end each day. Their working parts are made from the best materials, and it takes a lot for those parts to wear out. Budget spray guns tend not to hold up through endless trigger pulls. If you're doing one paint job and never painting again, a budget spray gun might be the way to go. But for professionals, if we go into the paint booth and have a problem with a spray gun, the wasted labor hours and materials could cost much more than the most expensive spray gun, not to mention the disruption's impact on the shop's work schedule.

For the home enthusiast and painters on a budget, there's good news. With more folks doing their own work at home or starting their own shops, manufacturers have added midrange spray guns to the mix. Companies such as Eastwood and SATA have come out with paint guns that range from $350 to $600. These are multipurpose spray guns. And if you shop around, you can find good deals, under $700, on one of my favorite basecoat spray guns, Anest Iwata's LS400.

For smaller tasks, such as painting motorcycle parts or doing fades, smaller spray guns like Iwata's LPH-80 and SATA's Minijet series are essential. These smaller spray guns are known as jam or detail guns because they work great for painting small areas on vehicles, like doorjambs.

Good tools can make all the difference in laying down an even coat of candy, pearl, or metallic paint. Frank Tetro's '33 Speedster has a pearl silver base that's perfect. No streaks or blotches. Having a spray gun that works right makes it easier for a non-pro to get professional results.

Then there are the spray guns that are between an airbrush and a mini spray gun. The SATAjet 20 B has a large round pattern and is perfect for doing fades when painting flames and graphics. It has two cup variations—a gravity-feed cup or siphon-feed bottles—for quick changes when using multiple colors. Five nozzle sizes, from 0.5 to 2.0, allow for great versatility in spray patterns, from a fine line to wide fades. Iwata's LPH-50 is another super mini spray gun. This one has a fan pattern and can be adjusted from wide pattern to fine line. Some painters use these instead of airbrushes. They find them easier to use because they are held like a spray gun.

HOW MANY SPRAY GUNS?

Do you really need to have different spray guns for different tasks? If you're a professional, it can make all the difference. We'll use one spray gun for "clean" basecoats like black or white, another for metallics and pearls, and one that only sees clearcoat. And a spray gun for sealer and primer. Most painters will have an average of four to six spray guns, and each one has its task. Home shops and shops with tight budgets can get away with two spray guns, one for primer and sealer and one for everything else. But make sure to clean those guns thoroughly after each use. Take the gun completely apart and clean it.

Just a few of my favorite spray guns. From left to right: Their LPH400 spray gun was specially designed for sealer, but it can use an assortment of nozzles and needles to do just about any task. Anest Iwata's LS400 lays down the most perfect basecoat color, smooth, even, and flat. My favorite clearcoat spray gun was the SATA4000 RP. Recently SATA came out with the SATAjet X 5500 RP, and it's even better than the 4000.

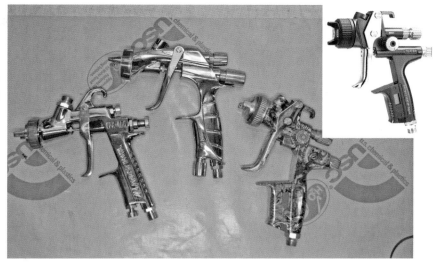

Eastwood's Elite P500 primer/sealer gun and Elite CC500 basecoat/clear gun are priced in the midrange around $350. SATA's 1500 RP is a top-line midrange spray gun that works great for most painting duties.

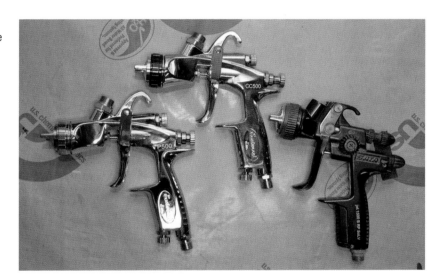

The custom painter needs to have at least one medium-sized spray gun, something in between a regular spray gun and an airbrush. On the left are two mini spray guns, Anest Iwata's LPH80 and the SATA Minijet 4400B. On the right are even smaller spray guns: the SATAjet 20B artbrush and Anest Iwata's LPH50.

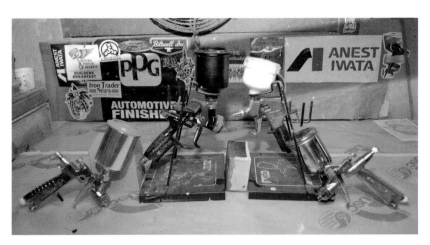

Airbrushes

Where would the custom painter be without airbrushes? Dual-action airbrushes are the best choice for custom painters. Dual action means the trigger serves two functions. To control the air, you push down. The air is fine-tuned by how far down the trigger is pushed. For less air, simply don't push all the way down on the trigger. Pulling back on the trigger controls the paint. A good-quality airbrush should give you a fine line, as well as spraying larger patterns.

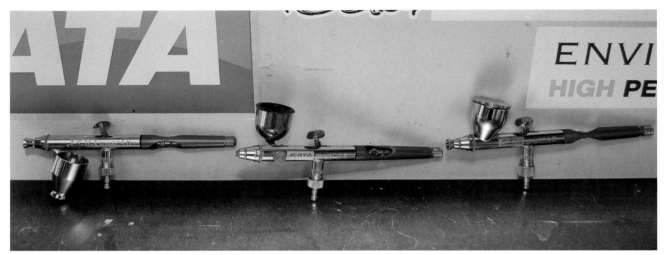

These SATAgraph 4 airbrushes are made in the USA and can spray from a fine line to a wide pattern. They are a workhorse airbrush and come in three styles—gravity, siphon, and side feed.

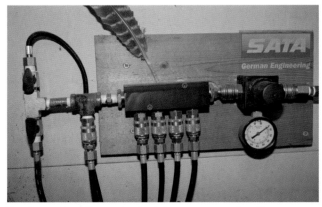

If you're working off a regular-sized air compressor, reduce the pressure right where it connects to the airbrush hose for an even flow of air like in this photo. If you adjust the air pressure 20 feet or more away from that point, the pressure might build up in the air hose and be inconsistent. This setup has a manifold that accommodates multiple airbrush hoses.

Airbrush holders are an inexpensive way to securely hold your airbrushes and keep them from falling. Dropping an airbrush can get costly. The tip and needle can get damaged and need to be replaced.

OTHER CUSTOM PAINT TOOLS

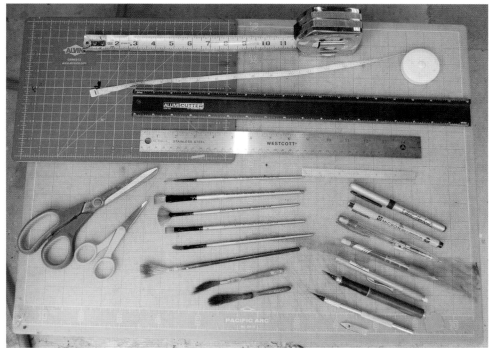

These hand tools are the backbone of my tool kit. Starting in the middle from the bottom, Mack Sword striping brushes, squirrel hair lettering brush, Mike Lavallee Pictorial Series brushes, scissors, always good to have several pairs. On the top are measuring tools: a 6-inch machinist scale, rulers for measuring and as cutting guides, a metal tape measure along with a soft tape measure for use on curves. Tweezers like Uncle Bill's Silver Grippers for grabbing onto the edge of a stencil or tape and to quickly remove debris or bugs that get into fresh paint. Next, fine line markers, mechanical pencils, erasers, and #11 X-Acto stencil knives. Keep plenty of spare blades and change the blade often as they get dull fast. The tools are sitting on two cutting mats, a small green one and a large light blue one.

A painter's easel makes it easy to hold parts like hoods or trunk lids for artwork. It puts the surface at the perfect angle for working and holds the part securely.

Colored pencils, markers, mechanical pencils, and erasers are low cost and extremely useful. Get more than one mechanical pencil. This way when you lose one, you have another immediately. They are very cost effective. Even though I do a great deal of drawing on the computer, I still do much of my drawing by hand. Make sure you get a good sharpener for the pencils.

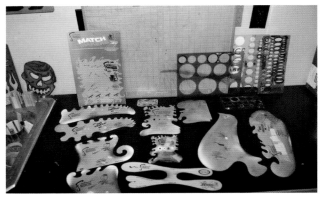

Artool Templates and drafting templates are great timesavers. They have ready-made curves that are multipurpose. Use them as a handheld shield to quickly mask off as you are spraying, or if you need a certain size curve, circle, or whatever shape. These templates can do it. And they are solvent-proof.

Artool Custom Templates can help anyone to get wild results. They are so easy to use. Just tape off your graphic or flame; then hold up the template and spray. Instant special effects for graphic artwork. Check out artool.com for a full list and pictures of their templates.

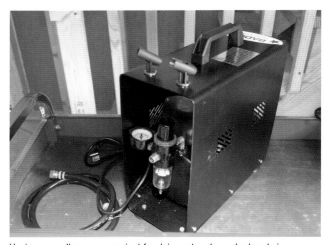

Having a small compressor just for doing artwork can be handy in situations where a large compressor is not available. Badger's TC910 Aspire Pro is small and portable, has a one-gallon air tank, puts out 57 psi, and has a regulator and two airbrush holders.

A rolling cart is very handy for custom paintwork. I clamp airbrush holders and lights on this Summit Racing cart. I can keep bottles of paint and other tools right there on the cart. The pressure regulator sits on the shelf below and I can roll it anywhere. It even fits a small Badger compressor on the bottom shelf if I need to bring my own air.

Keep your spray guns and equipment working great by keeping them clean. Brushes and cotton swabs clean out passages and paint chambers. Cleaning broaches are made of flexible triangular metal and can clean out air passages in a spray gun.

MAGNETS

Small, round ceramic magnets are super handy and can be used to attach design patterns to the project. Hold stencils in place while you're aligning them. They can hold reference pictures and drawings on the car. You can buy a pack of twenty-seven online for about $4.

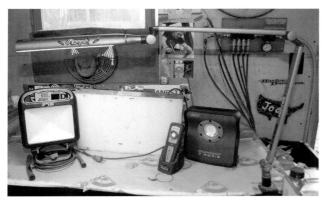

Custom painters need lots of light. From left to right: an LED portable work light and a light box for creating stencils. Scangrip's SunMatch 3 has two settings and a magnetic base to mount where needed. The larger MultiMatch III has a phone app that allows the user to replicate everything from a cloudy day to afternoon sunlight. Use these to match colors and as work lights. An articulating LED bench light is essential for doing artwork on motorcycle parts.

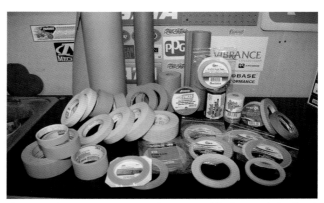

It's easy to skimp on masking tape, but tape used for house painting is not designed for the strong solvents in automotive paint. Have a selection of both automotive masking tape and vinyl fine line tapes. FBS ProMaskers that have masking tape attached to solvent-proof masking paper.

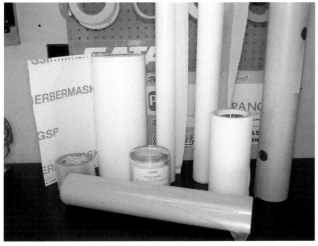

Stencil materials from left to right: Gerbermask Ultra II is easy to draw on, cuts clean, works great over fresh basecoat, and can be used for freehand and plotter cut stencils. TransferRite Ultra is a clear transfer tape to mask off already painted details. Liquid mask is brushed on and dries as a solid stencil that can be drawn on and cut. Artool's Frisket Film is transparent and cuts clean. Tracing paper is great for drawing and designing artwork and graphics. Wrap it on or around your project and sketch designs directly on the part. Flip it over to reverse designs. Transfer tape is for masking off flames and graphics. Artool's Ultra Mask is a thick, stretchable material, which is great for round and irregular shapes.

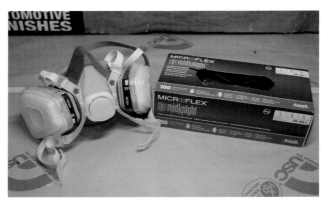

Don't forget to take care of the painter! Wear a cartridge respirator when painting. Keep it in a zipped bag when not in use. Nitrile gloves are cost effective and will not only save your hands but keep oil on your hands from getting on painted surfaces when sanding and cleaning.

Here's a low-cost way to save time and material. Use spray-out cards to test and design paint colors and get used to using unfamiliar materials. Number them when testing colors and keep track of the formula on the back of the card.

Chapter 3
Two-tone Paint

Most custom paint jobs rely on creative abilities, but two-tone paint jobs are all about precision—getting the lines straight and the curves smooth on cars and trucks and making curves that follow the body lines on motorcycles. Many people say they can't draw a straight line. So how do you get a tape line straight? It's easier than you might think. With patience and a few tricks, anyone can create paneled areas and split a vehicle into two differently painted colors.

One question is, does it make a difference which color is sprayed first? It can if the particles from one color can get onto the surface of the other color. For example, here we'll be spraying a solid black and a purple pearl. We don't want sparkles from the pearl getting onto the black. Pearl and metallic are difficult to clean up. They tend to get everywhere you don't want them to be. So, we'll spray the pearl color first, then remask the entire truck and spray the black. Another color you always want to spray second is white. White shows every little thing that lands in it.

So, when pairing solid colors with metallic and pearl colors, always spray the solid color last. Make sure to remove all masking from color one, then completely remask for color two.

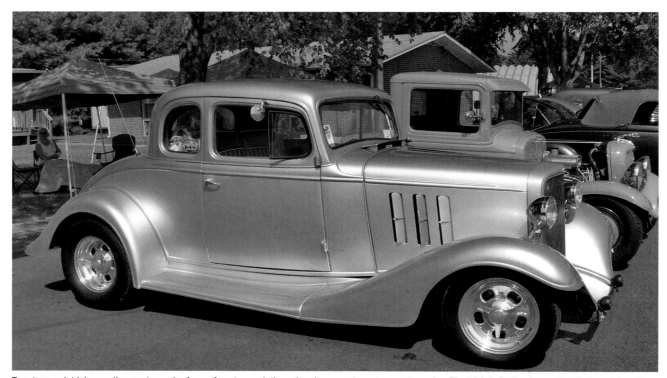

Two-tone paint jobs are the most popular form of custom painting when it comes to cars or motorcycles. The trick is finding two colors that work together and contrast effectively enough to create a powerful impact. The icy pearl colors on this classic car are similar in tone but just different enough to produce that impact.

TOOLS AND MATERIALS

PPG K36 Primer/Sealer
PPG Concept DCC9300 Black
PPG DCU2021 Urethane Clearcoat
PPG DCX61 Catalyst
PPG DT885 Reducer
PPG Deltron DMD1684 White Basecoat
PPG SX300 Precleaner

3M ¼ inch 218 fine line tape #06301
3M ⅛ inch 218 fine line tape #06300
FBS 48480 ⅛ inch red fine line tape
FBS 48218 7-inch ProMask
FBS 48238 12-inch ProMask
Assorted sizes of American Masking Tape and
 Masking Paper
Tracing paper
Gerson Blend Prep Tack Cloth

Anest Iwata LS400 Spray Gun
Anest Iwata WS400 Spray Gun
Anest Iwata LPH400 LVX Spray Gun with 1.8 nozzle

Iwata HP-CS Eclipse Airbrush
#11 X-Acto Knife
Mechanical pencil
Soft measuring tape
Compass
Uncle Bill's Sliver Gripper Tweezers
Magnets

THE PARALLEL TAPE METHOD

To get lines and curves smooth, we use the parallel tape method. This technique can be used for any tape line, straight or curved. It involves running a line of tape along the tape line you want to get smoothed out. When you try this, you'll see that the second line of tape makes it easy to see the bumps or imperfections in the first tape line.

For example, if there's a downward dip in a tape line, a second tape line run along the top of the first line will run right across the top of the dip and make it obvious. Then rerun the first tape, snugging it right against the second tape line. Then remove the second tape line and repeat the process along the bottom of the first tape line. Sometimes it takes a few tries to get the original tape line perfectly smooth. But eventually you'll get all the kinks out of your original tape line and will be ready to mask it off. This method can also be used for curved tape lines. See chapter 5 for how we get curved tape lines smooth and even.

DOING A TWO-TONE ON A CAR OR TRUCK

Two-tone paint jobs play on the body lines. Find the place you want to split the colors. On our 1955 Dodge panel truck project, we split the body along the line that divides the top half from the bottom half of the truck. Eventually, a pinstripe will separate the two colors. We start by running a length of 3M ¼-inch 218 fine line tape along the top part of the body line on the location of the pinstripe between the two tones.

Now to get the line straight. We use the parallel tape method to smooth out the line. Get at one end of the tape and sight down the line, looking for any waviness. Make a mark at each place the line is uneven. Now run a piece of ¼-inch tape along the top of the first line. Pull it tight. See the marks on the lower (first) tape line? Those are the flaws we'll fix.

Now the bottom tape line is lifted at one end and pulled tight, but not hard enough to stretch the tape. Just enough to keep the tape straight. Then, lower the tape back to the surface, snugging it up against the second tape line. The top piece acts as a straightening guide. Gently press down on the surface of the bottom tape line to attach it to the surface.

Repeat the process for any bumps that go downward on the first piece of tape. After each straightening attempt, sight down the line of tape, looking for waviness. It took about an hour of moving the tape around to get this line straight. Then the straightening tapes were removed, leaving the first tape line. The truck's body had a slight curve to it, which made it harder. We repeat the process on the other side of the truck.

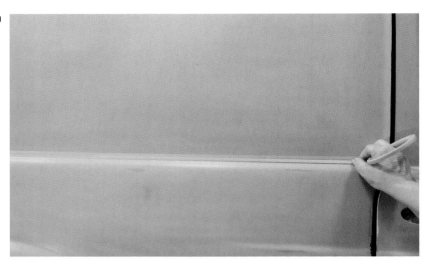

Now we're ready to mask off the two-tone. First, we'll spray the top color. We run a line of ¼-inch tape along the *bottom* of that original tape line. Then the first tape line is removed.

The tape line is run across the doors and onto the front of the truck.

The tape line also runs into the jams. Make sure to use care when running tape across sharp inward corners. It tends to pull up. Don't stretch the tape too tight or it will lift across the corner. The masking must run into and around the jams, not across them. Always mask off doors separately from fenders and quarter panels.

The jams were already painted black on this truck and the owner wanted to keep them black. So the pearl color will stop at a point in the jam. The ¼-inch fine line tape is run along a corner deep in the jam. Always use a fine line tape to mask off color separations to get clean, smooth lines. Masking tape will give a rougher line.

Paper and plastic are run down from the tape line. The back doors will also be purple pearl, so they were left exposed. Any windows or openings into the body are masked off also. We use a Gerson Blend Prep Cloth to remove any dust from the surface and then remove any static with the Pro-Stat antistatic gun. Now the truck is ready for some purple.

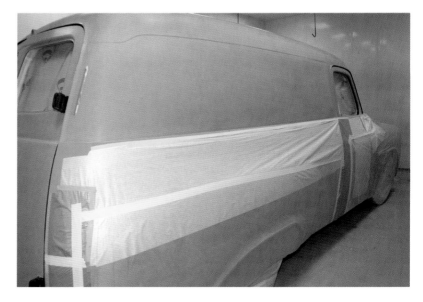

DOING A TWO-TONE ON A CAR OR TRUCK (continued)

We start out by spraying a coat of PPG sealer using an Anest Iwata LPH400 LVX Spray Gun with 1.8 nozzle. Our sealer is four parts PPG K36 primer, two parts DCU 2021, two parts DT 885 reducer, and one part DCX61 catalyst. We also could have used a black sealer, but at the time, this was the only sealer we had to use.

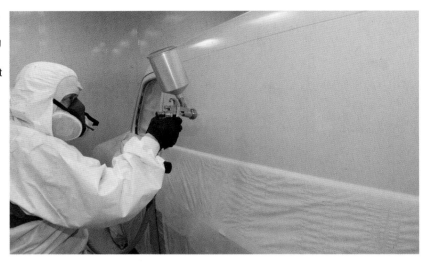

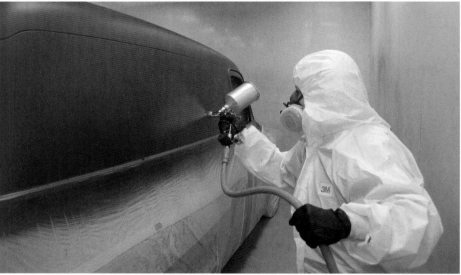

The purple pearl is very dark and it has better coverage when sprayed over a dark base. So, we start by applying a layer of PPG DBC9700 black basecoat using the Anest Iwata LS400 spray gun. Then we switch to the Anest Iwata WS400 and spray three to four coats of PPG Deltron #908423 Perfect Purple. The purple basecoat sits for 30 minutes before we spray three coats of PPG DCU 2021 mixed with DCX61 catalyst.

SPRAYING THE PERFECT PEARL

Pearl is a very tricky color to spray. Spray it incorrectly and you'll end up with a mottled, striped, or gritty finish. Here's the way to get a perfect pearl application every time.

1) Do any cleaning with precleaners twelve hours *before* spraying. The solvents in precleaners can take hours to completely gas out. Not a problem for solid colors but a big problem for pearl colors, which can be affected by the solvents trying to gas through the pearl layers. It can cause weird patterns in the pearl.

2) Test your pearl application on a spare panel that you've cleaned at the same time as the vehicle before spraying it on your project. Make sure the end result is smooth, not gritty. Check your coverage and make sure there's no mottling or tiger striping.

3) Use a slow reducer. This will help the coats to lay down flatter.

4) Change spray direction with each coat. Side to side with one coat, diagonal with the next.

5) Start out by spraying two medium super-flat coats of pearl. Check your coverage with a powerful light, and if needed, spray one more medium wet coat of pearl.

6) Follow these with one to two drop or mist coats of pearl.

We remove all the masking but leave on the fine line tape. We need to find the perfect time to pull those lines of tape. Pull them too soon and the paint will be too rubbery, not dry enough to get a clean line. It will look like the example in the top of the photo. Wait too long to pull it, and the paint edge will be brittle and broken. We waited about 90 minutes and pulled the tape straight back and the paint on the tape cleanly separated from the paint on the surface as seen in the bottom half of the photo.

The next day we paint the lower part of the truck. Make sure the area is clean and remove any leftover adhesive. All the masking is removed from the truck and replaced with fresh masking materials. To apply the second color of your two tone, start by running a piece of fine line tape along the bottom edge of the first color.

Then mask off the entire top of the vehicle. We use FBS 12-inch ProMask and plastic sheeting.

TWO-TONE PAINT

The bottom is sprayed with a darker PPG sealer. We mix four parts K36 with two parts PPG DCC9300 Concept Black, two parts DT885 reducer, and one part DCX61. We spray one wet coat using the Iwata LPH400 LVX gun. This dries for an hour and then we spray four coats of PPG DBC9700 black basecoat using the LS400 spray gun. This cures for an hour and we apply three coats of catalyzed DCU2021.

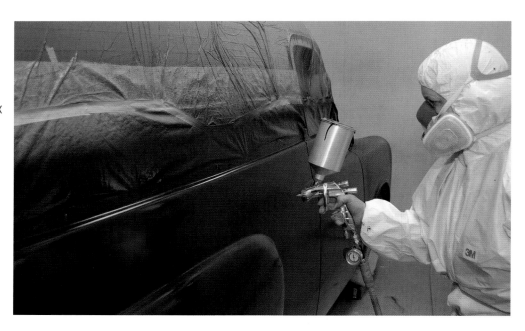

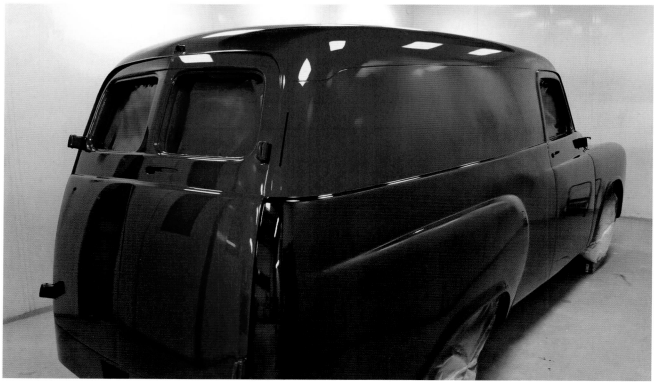

Here's the result after all the tape is removed. If you're just doing a two-tone with no artwork, you could be almost finished at this point as it looks so good. But there's more work to be done on our truck. See chapter 5 for the next steps in our Dodge truck project.

Where to split the two-tone is the biggest question when painting two colors on a vehicle. On this hot rod, the two-tone split runs along the hood opening, along the doors, and down under the trunk area.

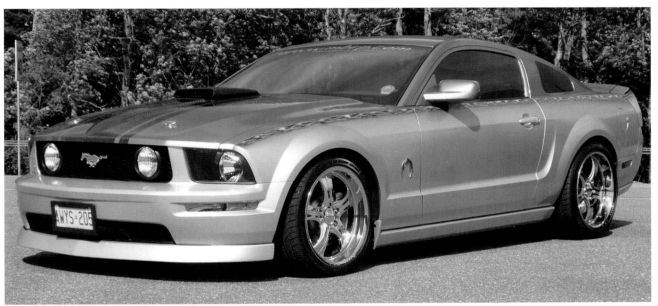

Two-tones aren't just for older cars. This modern Mustang has a two-tone paint job combined with rally stripes on the hood and a flame separation between the colors.

Here's a sweet white and pearl orange two-tone on a truck. These colors complement each other and the pink flames with green pinstripe give the paint a nice zing.

PAINTING A TWO-TONE ON A MOTORCYCLE

We start with the front fender and tools and materials we'll be using—7-inch and 12-inch ProMaskers, ¼-inch 3M 218 fine line tape, ¾-inch American Tape Aqua Mask, scissors, Uncle Bill's Sliver Gripper tweezers, a 6-inch ruler, and a soft measuring tape. The fender has been wet sanded with 800 grit.

There's no bodyline, so where do we start? We find a place where the fender starts to curve inward and run a tape line along that point, keeping the tape on the last of the flat area. Don't get too picky at this point. You can use the parallel tape method to get that curved line smooth! This line is pretty bumpy.

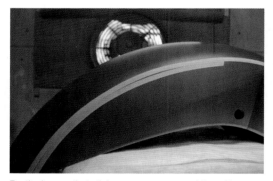

For the bumps that stick up, we run a second line of tape along the bottom. See where the hump is in the top (first) piece of tape? Now we can rerun the first piece of tape snugged against the second piece. Then we remove the second piece of tape. Repeat on both sides of the first piece of tape until you have a smooth, bump-free line.

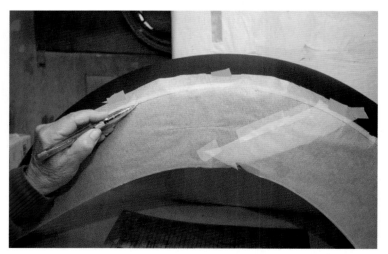

Now to make a pattern for the other side of the fender. Place a piece of tracing paper on the side of the fender and trim it until the bottom edge matches the edge of the fender. This will be the placement guide. Now use a pencil to trace along the bottom edge of the tape line. Then remove the tracing paper and cut along the pencil line.

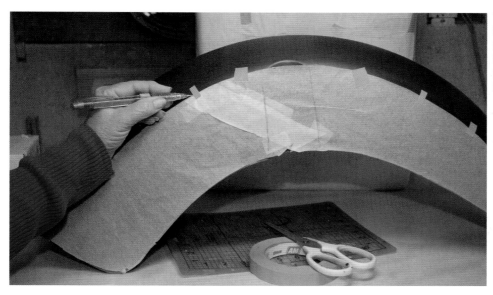

Turn the tracing paper over and place it in position on the other side of the fender. Use a pencil to trace along the top of the tracing paper. Run a piece of tape along this line. Now mask off the top or middle of the fender.

Now we'll lay out and tape off the panels on the tank. Start by finding the location of the bottom of the panel and run a tape line. This will act as guide. We'll be taping along the top of this tape line.

You can freehand the front curve on this panel, but we use a compass. We create a pad of masking tape to rest the point on. It's located at the center of the curve. Then we adjust the compass until we find the best size of the curve and draw a perfectly rounded curve with the compass.

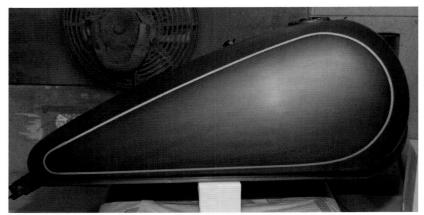

Using the pencil line from the compass and the bottom tape line, we run ⅛-inch 3M 218 fine line tape to create the panel. FBS red 48480 tape is used for the rear curve as it holds tight curves and doesn't lift or pucker. We use tracing paper to create the tank panel pattern we'll use to lay out the panel on the other side of the tank.

To help in placement of the panel on the other side, take measurements from the first side. We measure from the center point on the top of the tank to the top edge of the panel and from the front of the panel to the front edge of the tank using a soft measuring tape.

The pattern is put into place on the side of the tank using the measurements and the magnets. We trace around the edge of the pattern using a pencil.

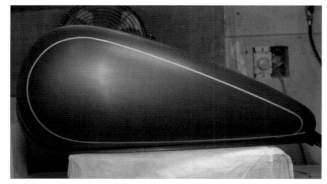

Tape is run along the pencil line. Any bumpy areas are smoothed using the parallel tape method.

Now the panels are masked off and the tank and fenders are ready for paint!

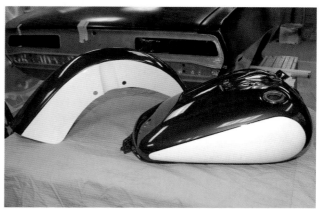

The panels have been sprayed with white basecoat. Then they were pinstriped with black and clearcoated.

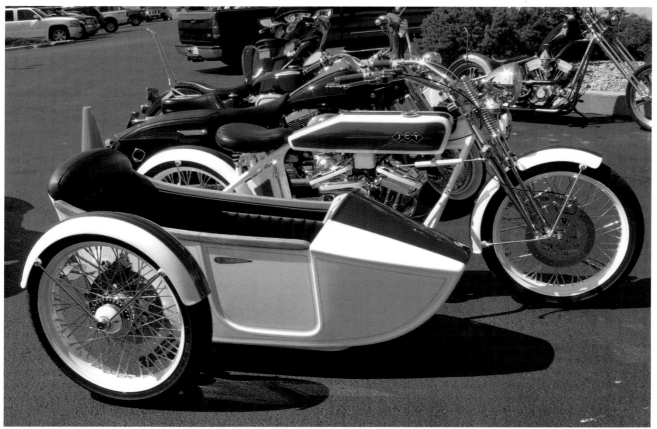

Here's a vintage-style custom Harley Davidson with a sidecar. Both bike and sidecar have been two-toned. Note how the line of the two-tone follows the shape of the parts. Bike by Shadley Brothers.

Chapter 4
Rally Stripes

Nothing says classic muscle car more than rally stripes. Rally stripes came as a factory option on many classic muscle cars, including Camaros, Chevelles, Corvettes, Challengers, Mustangs, and even the iconic Cobras. But rally stipes are not just for vintage muscle cars. Automakers offer rally stripes on modern Camaros, Challengers, Chargers, and Mustangs.

Laying out and masking off factory-style stripes seems simple enough. That is, until you're standing in front of the car, tape in hand, wondering, "Where do I start?"

There are stencil kits available, but the quality and overall stripe dimensions can vary. Plus, stripe specifications in the kits are sometimes different from the factory specs.

Several factors play into reproducing clean, accurate stripes. First, know the style of the rally stripe you want, then find the correct dimensions. Gather as much information as possible. Factory stripe layouts and dimensions can be found online for nearly every style of rally stripe. To be sure about the figures you've found, check several different sources. If a dimension varies between two sources, then research that particular figure until you're satisfied that you've found which one is correct.

The Chevelle rally stripe kit consists of each end of the two hood stripes, the two trunk stripe ends (six total pieces), a roll of stencil tape, a squeegee, and a printout of the factory stripe dimensions. These kits range in price

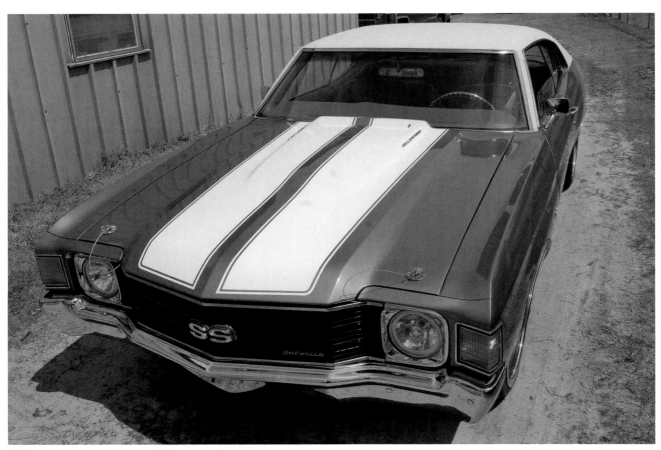

Nothing says classic muscle car more than rally stripes.

Here are the tools and materials that will be used:
- ProMasker comes with masking tape already attached to the masking paper
- 3M 218 fine line tape in ¼- and ¹/₁₆-inch widths for the straight lines
- FBS ProBand Green Fineline in ¼- and ¹/₁₆-inch widths for the curves

- Tweezers for handling the tape ends, mechanical pencil, X-Acto knife, and squeegee
- 6-inch and 15-inch rulers and measuring tapes
- Nitrile gloves to help keep surfaces clean and fingerprint-free
- PPG SX330 Wax and Grease Remover (precleaner)
- Lint-free wipe cloths . . . plus lots of masking tape!

from $40 to $70. Keep in mind, however, that the quality and stripe dimensions in kits can be inconsistent. Fine line tape gives a cleaner edge than stencils. I had a stencil kit when painting some of the stripes shown in this chapter, but the only parts of the kit I used were the corner pieces as a reference. Plus, it helps to have the radius for any curves in the stripes.

Another important consideration when painting rally stripes is taking the time to achieve straight lines and an even radius on all the curves. It's very tempting to dash through the masking and grab that paint gun too soon. Painting stripes is all about the layout and the masking!

Also, take the time to create a test panel before spraying stripes on the car. Discarded sheetmetal parts work great. A test panel will give you an idea of how many coats of paint you will need to spray to get the right coverage. And don't forget about paint edges. Thin edges of the stripe may tend to break off in places. Test your paint and find the right combination of paint coverage and paint edge thickness. Once you feel confident with your technique, you're ready to paint.

STRIPE KITS

Stripe kits remove much of the guesswork when it comes to layout and measurements. The kit stencils can be used as a reference. But not all kits are created equal. If you have a kit, closely examine the cut edges of the stencils. Are they clean or are they a little ragged? Do all the curves have the same radius? I use these stencils as *reference guides only*, using fine line tape for the actual layout and masking. The fine line tape can provide a cleaner edge than the kit stencil, and the kit's stencil tape can pull out of shape and distort more easily than the tape.

PAINTING THE STRIPES

Here's a simple way to get great stripes every time. The techniques explained here can be used for any car or truck striping project, not just rally stripes. We're using a Chevelle for this tutorial. The important thing is planning the layout and triple-checking the measurements from multiple angles. For each step of the stripe layout, complete the stripe on one side of the panel or vehicle, then repeat it on the other side. Because of the math involved, it's best to lay out the stripes when your mind is sharp. Don't start on a project like this after a long day at work. Remember to take your time, and after all the measuring is done, take a break. Walk away from the project for a while, then come back and recheck the measurements and the masking. You'll be surprised what a fresh set of eyes will find.

FINDING CENTER

No matter what kind of vehicle you're working on, painting rally stripes always starts with finding the center of the area being worked on. Every measurement will be based on that centerline.

Complicating the issue is the fact that the centerline isn't always where it should be. For example, say there is a ridge or raised trim line running down the hood. It seems that would be the "center" of the hood. Not always! If a ridge or trim line creates an apparent center of a panel, find the exact center of the trim line, then measure to each panel edge from that line. If it's not the perfect center, then find a happy medium for your rally stripes.

After you've taped off the centerline with ¼-inch tape, step back and take a look. When you have the line where you want it, walk away and take a break for a while. Then go back with a fresh set of eyes and examine it again. Because this first measurement is so important, don't rush through it. Sometimes it's a matter of moving a line back and forth sixteenths of an inch until it's exactly where it needs to be.

The hood of this 1970 Chevelle was precleaned, wet-sanded with 800, and wiped down again with precleaner. First, find the centerline of the hood. This hood measures 56½ inches across. I measured 28¼ inches from the edge of the hood and ran ¼-inch 3M fine line tape from top to bottom. Doublecheck the measurement from both sides. The centerline might need to be adjusted as some hoods are not the same on each side (see sidebar).

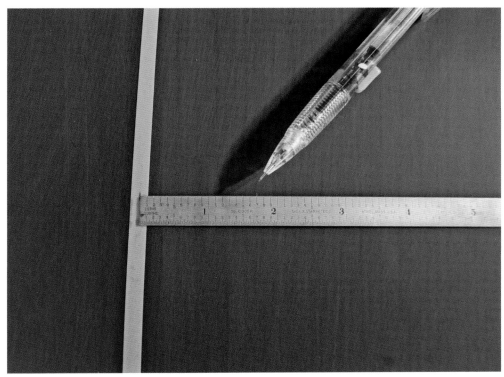

Pencil marks are made down the center of the ¼-inch tape in 1-foot increments. The inboard edge of the rally pinstripe is 1¹¹⁄₁₆ inches (or 1.7 inches) from that centerline. Mark off the 1¹¹⁄₁₆-inch measurement down the length of the hood on both sides of the centerline. Then run ¼-inch tape from the back of the hood to the front, following those indication marks. When you're running tape, make sure to attach the tape end securely to the surface, then pull hard enough to make it taut without stretching it. All the other tape lines will be based on this inboard line. We'll call it Tape Line A.

STRAIGHTEN THOSE LINES!

Here's an easy way to get straight tape lines. Get your eyes at an angle where you can sight down the length of the line. Look for any unevenness and mark those on the tape. Next, run a second line of tape along the line and pull it tight. Running this second line along the first will show where the bumps are in the first tape line. Now just lift the first tape line and rerun it along the second, adjusting it to be perfectly straight. Do this on both sides of that first tape line.

Here's where it gets tricky. Each rally stripe consists of a large main stripe area and a ⁵⁄₁₆-inch stripe (or the pinstripe, in factory parlance, see sidebar) with a ¼-inch gap between them. Here's where you start to build the stripe along that ¼-inch tape line (Tape Line A) that runs on each side of the centerline. The ⁵⁄₁₆-inch stripe is taped off first. Run a line of ¼-inch (⁴⁄₁₆-inch) fine line tape along the outer facing edge of Tape Line A. Next, run a line of ¹⁄₁₆-inch next to it, resulting in the needed ⁵⁄₁₆ inch. Then run a line of ¼-inch alongside the ¹⁄₁₆-inch line, covering the gap between the ⁵⁄₁₆-inch stripe and the main stripe area. Then remove the tapes covering the ⁵⁄₁₆-inch stripe.

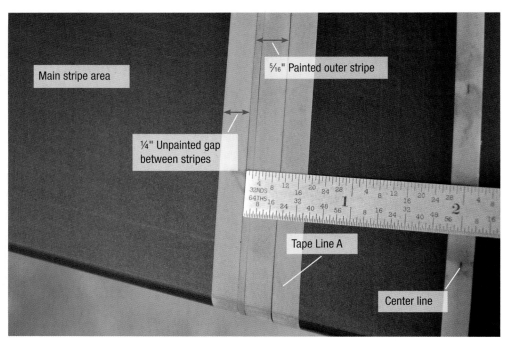

Main stripe area

⁵⁄₁₆" Painted outer stripe

¼" Unpainted gap between stripes

Tape Line A

Center line

EARLY 1970 CHEVELLE SS FACTORY STRIPE DIMENSIONS

I went a bit thicker with the outboard stripe.

Main stripe width, hood: 10.64
Main stripe width, deck: 10.64
Pinstripe width, hood: 0.30
Pinstripe width, deck: 0.30
Gap between stripes, hood and deck: 0.28

Gaps from edges of panels
Main stripe, hood: 1.53
Main stripe, deck: 1.23
Pinstripe, hood: 0.95
Pinstripe, deck: 0.80

Distance to stripes from centerline:
To pinstripe, hood: 1.77
To pinstripe, deck: 1.68

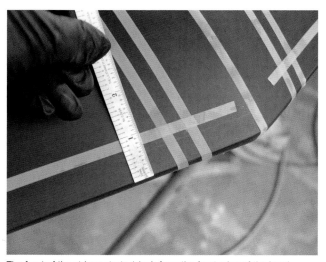

The front of the stripes starts 1 inch from the front edge of the hood. Using the 6-inch ruler, run ¼-inch tape so that the back edge of the tape is 1 inch from the hood edge.

I measure across the front and rear ends of the factory stencil in order to plan out the width of the main stripe. The main stripe at the rear of the hood is 13⅞ inches while the front is 10⅞ inches.

Using the soft measuring tape, mark off 13⅞ inches from the outer edge of the gap between the pinstripe and the main stripe area at the rear of the hood. Soft tape is used because it fits against the curve of the cowl.

The front measurement of 10⅞ inches is marked off on the tape.

At the rear of the hood, the edge of the ¼-inch tape is lined up on the mark and firmly attached. It's rolled out toward the measurement at the front of the hood without it touching the surface. It's pulled tight, but not enough to stretch it. The tape's lowered until the edge of the tape lines up with the front measurement mark. Then it's pressed down.

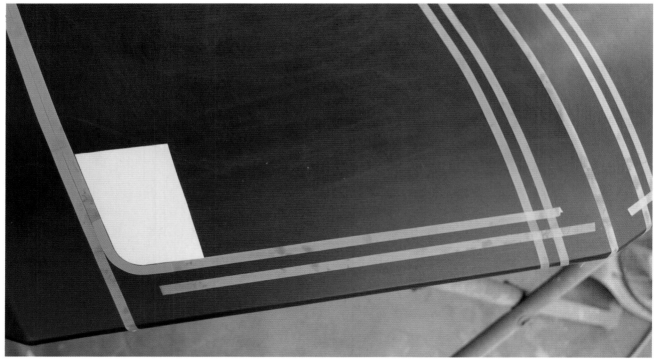

The corner from a kit is cut out and used only as a curve reference. It's placed at the intersection of the outer and front tape lines. The tape lines are cut back about halfway down the stencil piece. FBS ProBand green ¼-inch fine line is very flexible and creates a perfect curve along the radius. Next, the outboard and front part of the ⁵⁄₁₆-inch stripe and ¼-inch gap are laid out and taped off using the same method.

MAKING IT MATCH!

You don't need a kit to get accurate stripe corners. Create your own pattern! Practice running the tape around a curve until you have a radius you like. Lay a piece of paper over it and trace along the tape line. Cut out the curve. Now you have a template. Flip it over to use for the other side. Use magnets to hold it in place as you're taping.

Tape from the gap stripe is trimmed away from the inner corners using an X-Acto knife or razor blade. Apply gentle pressure and take care to cut only through the tape, not into the surface of the paint.

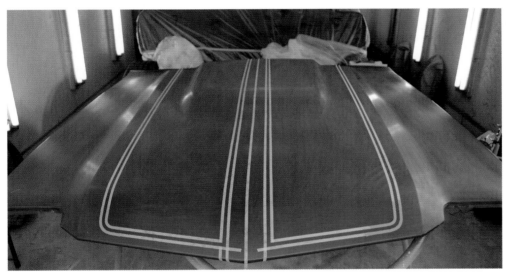

Here is the completed tape layout. The corner stencil piece is removed, as well as both pieces of tape covering the pinstripe. Take your time sighting down the lines and straightening any that need fine tuning. Then use the same procedure on the trunk area and roof area. Be sure to run the squeegee over all the tape lines, making sure they are pressed firmly on the surface.

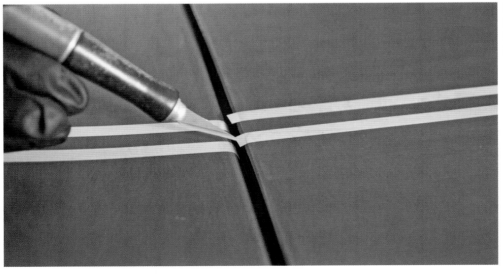

Cleanly cut the tape bridge across panel gaps. Here, I cut the tape that runs from the trunk deck filler panel to the trunk lid.

RALLY STRIPES

Figure where you want the stripe to end on parts like decks and doorjambs. Here I ended the stripe ¼ inch over the edge of the trunk deck filler panel.

This is also the time to check all the tape connections. Paint likes to sneak in between pieces of tape. Use the squeegee or your fingernail to firmly secure the connections so no paint sneaks under them.

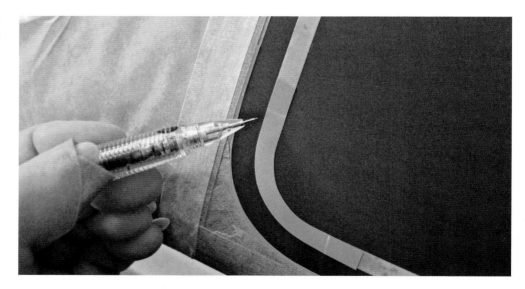

The area around the stripes is papered off.

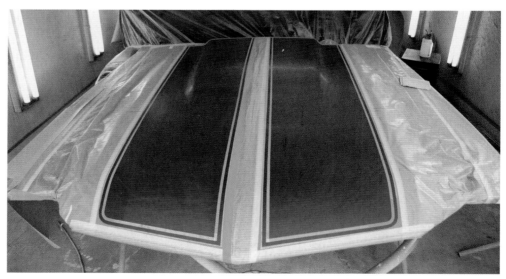

Give the areas one last look before applying the paint. Check for fingerprints and if you find any, spray a little precleaner on a cloth and carefully wipe them away. Don't spray precleaner directly on the surface after taping. Try to stay away from the edge of the tape, and wipe along the tape, not against it. Then go over the surface with a tack cloth to remove dust; as with the precleaner, don't push the tack cloth against the tape edge. Now you're ready to spray the stripes!

When removing the tape after spraying, use care to avoid damage. For example, white paint is more brittle than black paint and the edges break more easily. Always pull the tape back against itself. Never pull the tape directly up.

Another factor to consider is the timing of the tape removal. Remove the tape too soon and the edges will be gummy because the paint is still soft. Wait too long and the edges will be brittle and break. The trick is finding the time when the paint is dry enough to separate cleanly yet soft enough to not splinter. Thirty minutes after spraying, remove only the masking paper—do not remove the fine line tape! When the

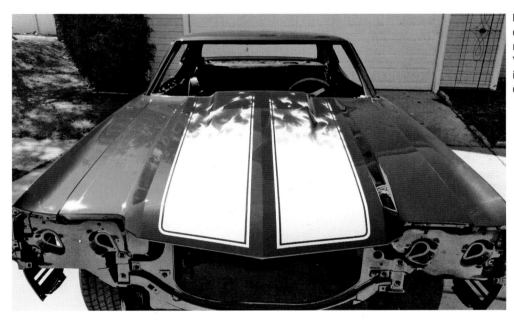

For this Chevelle, I got a little creative with the rally stripes and morphed them into real fire flames. You can create graphic effects inside the stripes, layering shapes or airbrushing faux effects.

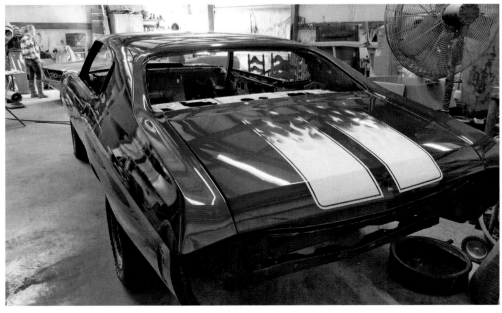

Here are the finished stripes on the trunk area.

paint is dry enough, do a test pull of less than an inch of tape. See how the edge reacts. If the tape leaves a clean paint edge with the paint on the tape separating sharply from the paint of the stripe, you can remove all the tape. But watch closely; some areas might be drier than others.

Examine the surface after the tape has been removed. Using 800 grit sandpaper, carefully wet sand away any paint blow-throughs and leftover pencil lines. Use a bright flashlight to help find them. Look closely for leftover adhesive from the tape and use a wipe cloth wetted with precleaner to remove it. But wipe *along* the paint edge, never against it.

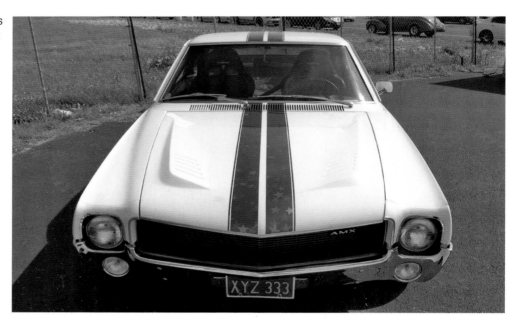

On this 1969 AMX, the rally stripes have factory dimensions, but I got a little creative, painting layers of stars in the metallic blue.

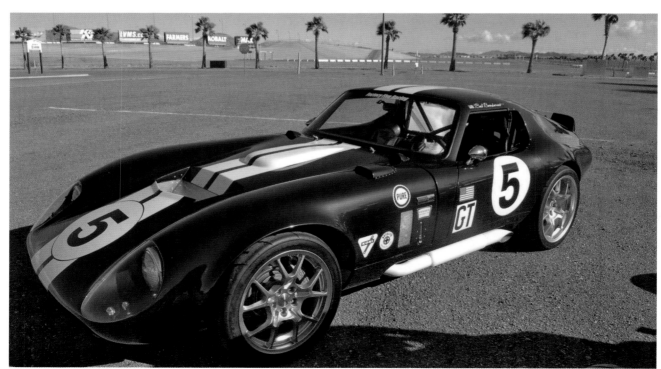

This Factory Five Racing Daytona Coupe features a classic Daytona paint scheme, including rally stripes.

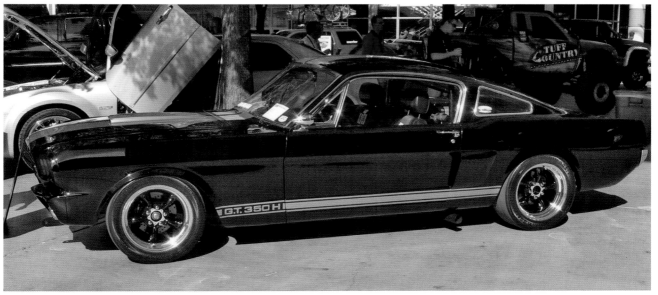

The rally stripe technique described in this chapter can be used to reproduce any kind of factory striping graphic, including racing stripes on the sides of the car, like on this Mustang GT.

Vintage Mustangs had a few different styles of rally stripes. On this 1970 Boss 302, the stripes run from the top of the car down to the doors.

Mopar racing stripes are often referred to as "hockey sticks."

The 1968 Charger R/T featured stripes that wrapped around the rear end of the car.

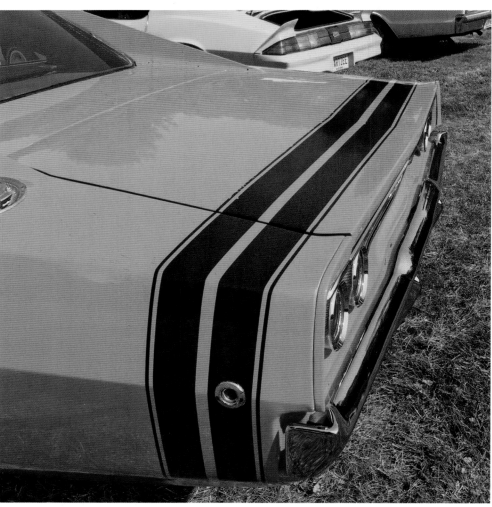

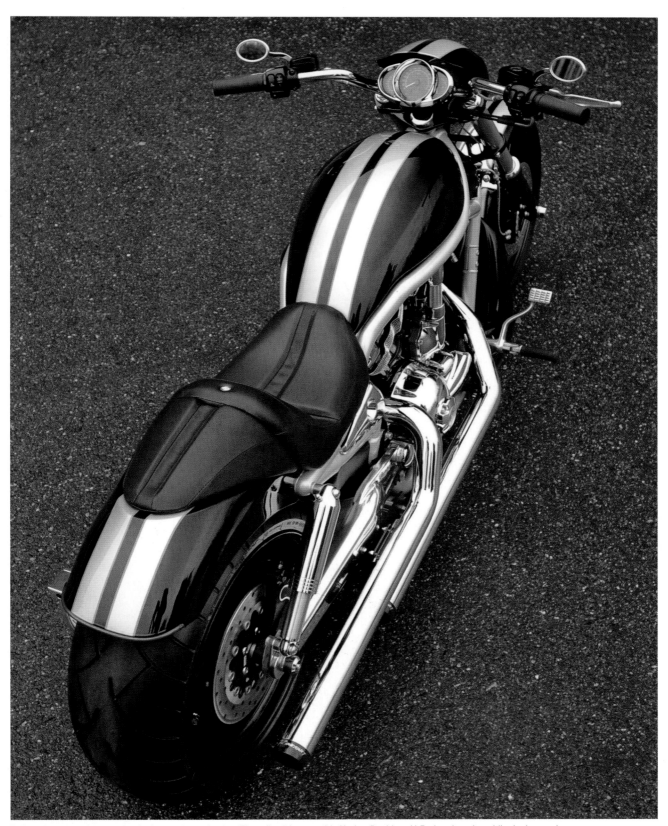

Rally stripes can give a racing look to motorcycles too. The rally stripes on this Harley-Davidson V-Rod make a lean bike look even longer.

Chapter 5
Flames

Flames have been around for as long as people have been hot rodding cars. They come in many styles, from long slender Ohio flames to transparent ghost flames to fat hot rod flames to real fire flames. And even within a given style, each painter's flames have a slightly different look, unique to the individual hand and eye behind them. Flames can give a hot rod look to anything: toolboxes, doors, refrigerators, coolers, and more. For first-time flame painters, find a style that appeals to you, then practice laying out flames until your paint work matches your vision.

In this chapter, you'll learn how to lay out and spray hot rod flames. The layout and masking technique can be used for any style of taped-off flame, including ghost flames. For multiple flame layers, simply add a new layer after the first layer is unmasked. You can even mask off the whole or parts of the first layer to add dimension to the flames, overlapping and intertwining them.

I'll also explain how to spray real fire flames. This is another technique that can vary widely, depending on the color and the painter's approach. This style differs from traditionally applied flames in that the flames are not masked off. Multiple layers of flames are freehand airbrushed onto the surface. Templates are used to create any hard edges.

TOOLS AND MATERIALS

PPG Deltron DMD1684
PPG Deltron DBC83034 Lemon Ice yellow
House of Kolor KK12 Pagan Gold Koncentrate
PPG DMX 211 orange dye
PPG DMX 212 red dye
PPG Deltron 500 basecoat clear
PPG Deltron DMD 1605 magenta toner
PPG SX300 precleaner
House of Kolor KC-20 precleaner

FBS ⅛-inch orange fine line tape #48610
FBS ⅛-inch green fine line tape #48510
FBS K-UTG gold masking tapes 3-inch #48090 and
 2-inch -#48080
3M ⅛-inch 218 fine line tape #06300
FBS 48218 6-inch ProMask
Assorted sizes of American Masks and Masking Paper
Tracing paper

Iwata LS400 Spray Gun
Iwata HP-CS Airbrush
SATA 20B Artbrush
SATAgraph 4 Airbrush
#11 X-Acto Knife
Mechanical pencil
Artool Original True Fire templates
Artool True Fire 2nd Degree Burn templates
Squeegee

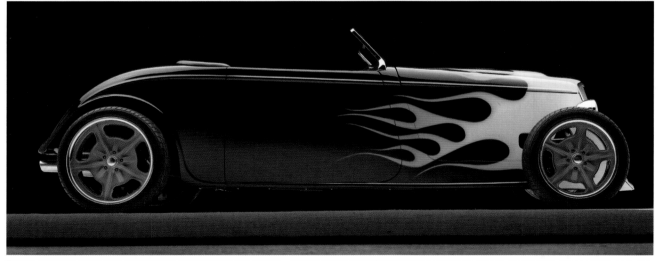

This Factory Five Racing 33 Hot Rod has classic traditional flames—simple single-layer flames with a yellow-to-orange-to-red fade. When you're spraying your first flame project, keep it simple. Concentrate on producing flames that have a random symmetry.

HOT ROD OR TRADITIONAL FLAMES

Chapter 1 explains the design process for these flames. Now we'll learn how the flames were masked off and sprayed onto this 1955 Dodge panel truck. Always try to predraw your flames and have a printout of the drawing. It saves time and tape! For the driver's side of the truck, I'll reverse the drawing.

I'm starting with the hood as the flames will flow down from the hood and onto the sides. This hood has three panels. The tape will have to be wrapped around the edges of each panel. Find a point on the hood where the flame will loop, the lowest point of the flame, and mark it with tape. This is the starting point.

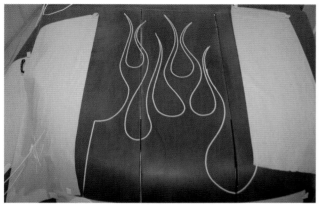

I begin by playing around with the ⅛-inch FBS orange fine line tape, laying out flame shapes until I have something that has a random, but balanced look. Masking paper is taped onto the hood and fenders on areas that I need to lean on as I work. This will help keep those surfaces clean until they have flames on them. The paper is moved over as the flames progress.

To smooth or straighten any unevenness in the flame tape, use the parallel tape method. 3M ⅛-inch fine line tape is run along any bumpy areas. The FBS tape has the flexibility to make tight curves with minimal lifting, but the 3M is more rigid and great for getting a straighter line. Both tapes are used to create a smooth line.

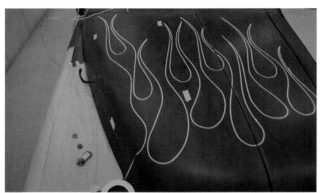

The tracing paper pattern technique is a great way to edit any kind of graphic or flame. I used this technique throughout this paint job to edit the flames as I worked. Here the last lick of flame on the left is too far away from the flame lick next to it. It needs to be moved closer.

Tracing paper is placed over that last lick of flame and the flame is traced with a pencil.

HOT ROD OR TRADITIONAL FLAMES (continued)

Now I can move the flame lick around and find the perfect place for it. The old lick is left in place for now. The old location can be compared to the new location. I find a better location and mark the edges of the tracing paper with blue masking tape. That way I can put the tracing paper back in the exact location.

Remove the old tape from the surface. Then use a pencil to trace the flame on the underside of the tracing paper. This creates a sort of "carbon copy." Now I reapply the tracing paper on the surface and trace along the pencil lines. This transfers a pencil line of the flame onto the surface and the new flame lick can be taped.

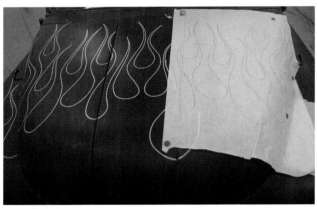

To have mirror images of the flames on each side of the hood, the tracing paper method is used to create a pattern. Once the flames are finished on one side, place some tracing paper over the flames and trace them. Flip the tracing paper over, align it, and trace along the pencil lines. Then run your tape.

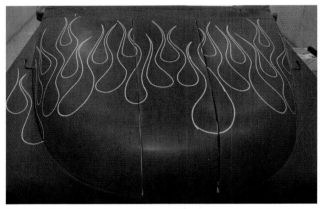

Here's the finished tape lines on the hood. The tape has looped down low on the driver's side due to a problem with the hood. This problem was fixed later and the tape was moved up to create a more symmetrical design.

Smooth out any lumps in the taped curves using the parallel tape method.

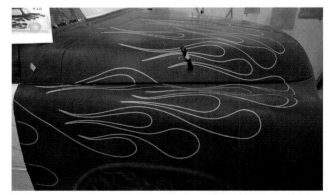

It's a little tricky making the transition from the hood to the sides, so take your time. If you look closely at this photo, you can see tape shadows on the surface. That's where I applied and removed tape many times until I had a tape layout I was happy with.

More line straightening and smoothing. Keep going over your tape lines until they are smooth and fluid.

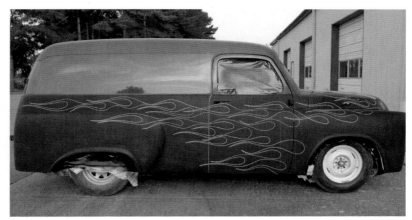

The flame layout is completed on the passenger side. But there's still lots of work to do before the driver's side is masked off.

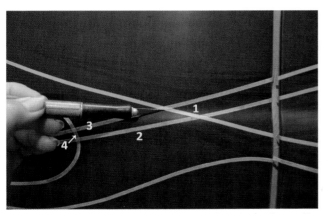

The tape must be trimmed at the flame overlaps. Four pieces of tape will be removed.

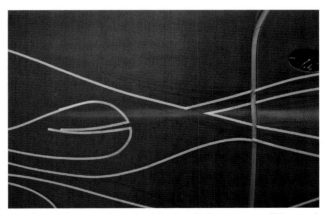

Once the overlaps are trimmed, cut the tape that runs across all the panel gaps like on this door gap. Then wrap the tape ends around any edges, and use a squeegee to press them down.

For the flames on the other side of the vehicle, you can tape off flames that differ from the passenger side or use the tracing paper transfer method to create a matching set of flames on the driver's side. Start by taping a piece of tracing paper on each panel of the passenger side. Align the top of the tracing paper with the body line between the two tone. Now carefully trace along the inside edge of the taped flames.

Take the three flame patterns from the passenger side's three panels, flip them over, align, and tape them to the driver's side. Then trace along the pencil lines. Now you have a flame pattern ready to tape off.

HOT ROD OR TRADITIONAL FLAMES (continued)

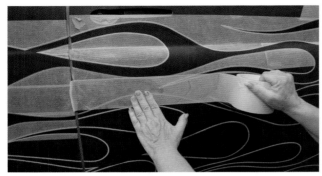

Once the flames are taped, it's time to mask them off. You can see where some of the other flames have already been masked. This is how that's done. Start by applying a piece of FBS K-UTG gold tape across an area of flame and firmly press it down. Transfer tape can also be used.

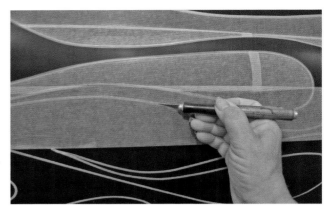

Use an X-Acto knife with a new #11 blade to trim away the excess gold tape. Press down hard enough to cut through the gold tape, but not too hard. Don't cut into the flame tape below.

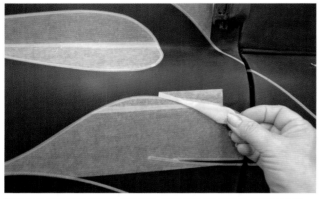

Now peel away the excess gold tape, revealing the flames. When laying down another piece of gold tape, have a slight overlap of the piece next to it. You can also use transfer tape or regular masking tape. Once you get the hang of it, this process goes fast.

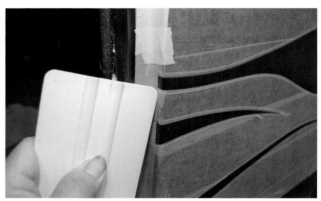

Wrap the tape and masking into the corners of the jams. Remember to get the masking securely into any recessed areas. Use a squeegee to press them down. The flames don't go all the way into the jams on this project. You can have your flames run all the way across the jams or end them like this. It's up to you.

Here's what the door to fender jam looks like. The masking wraps around the edges of the panels and across the jam. Use common sense to make the jams as neat as possible.

Now here's where it got tricky with that three-piece hood. Each tape end had to get tucked down into the gap between the hood panels. But I also had to fine tune the ends of the tape, so the flame loop appeared round. In the upper photo, the tape on the right side of the gap doesn't align with the left side. The bottom photo shows the loop after the tape on the right side was moved.

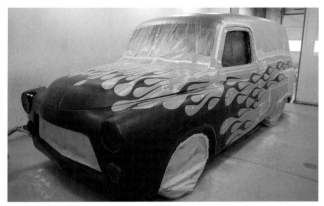

The flames and the truck are masked and ready for color. It took a few days to get to this point.

These flames will be mostly yellow. Yellow is a very transparent color and covers much better when there's a white basecoat under it. Using an Iwata LS-400, I lay down several coats of PPG DMD1684 white.

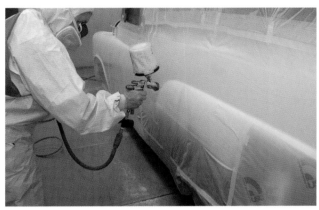

The white is followed by several coats of PPG DBC 83034 Lemon Ice yellow. Make sure to apply medium wet coats. Do not apply dry, gritty coats. If the surface starts to get gritty, stop, sand the paint with 800 grit, and reapply the basecoat.

The nose of the truck will have a yellow-to-white fade on it, so the yellow ends about a foot back from the flame loops. That fade will be done later using an airbrush. The flame loops are hard to see, so I use a black marker on the masking material to show where the loops are.

Use candy basecoat colors to create the fade on the flames. Mix candy concentrates with basecoat clear. I tested the colors and application on several test panels *before* I sprayed the flames. I start at the rear of the truck and work my way forward. Start by airbrushing thinned-down candy orange basecoat along the edges of the flames until you have a soft, even fade into the yellow flame. Then use a candy red or magenta along the edge.

It took a few passes to get the desired amount of fade. I airbrush candy purple basecoat on the tips. Airbrush one flame lick at a time and use smooth motions for your fade. Steady your hand on the surface.

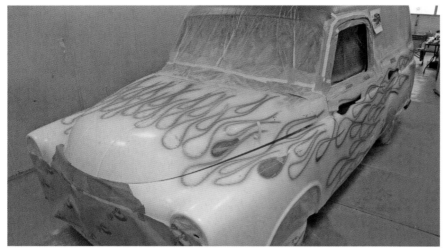

It took the better part of two days to get these flames just right. The flame color also fades lighter as it moves forward. By the time I get to the front fenders, there's almost no red or magenta on the flames. For those front flame loops in the white, I airbrush reduced yellow and some orange. I tested it in several places, then removed the masking to see how it looked before airbrushing the entire hood. You can see those two places where there's very little paint on the tape.

Before removing all the masking and tape, check a few places on the vehicle to make sure you have the desired fade. Here I've removed the tape and masking on the driver's rear quarter. The fade is a little too light and needs more orange and magenta. So, I make a note on some blue tape above the area. I retape any areas that need more work and make the changes.

Removing the tape too soon after painting will result in a torn, ragged edge. Wait too long and the paint will be too brittle and result in a broken edge. The thicker the paint, the more time it will take to dry. For the best result, pull the tape in one area and see if the paint on the tape separates cleanly from the paint on the surface. Pull the tape straight back over itself. The FSB vinyl tape results in a cleaner paint edge than any other kind of tape I've used.

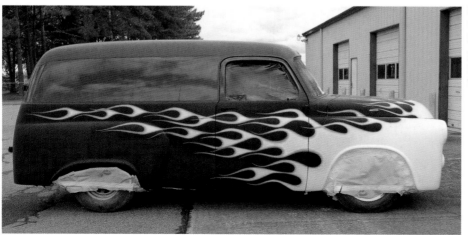

Here is the result of that week of hard work! The flames look exactly like they do in the drawing. Now they just need to be pinstriped. The pinstriping will bring this paint job to another level. Check out how the flames were pinstriped in chapter 9.

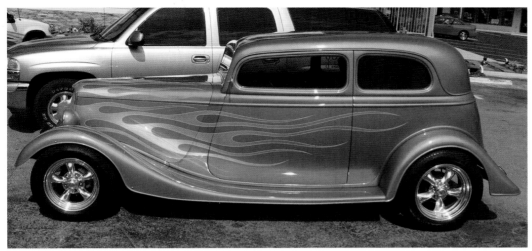

Here is simple but wild flame paint. Simple because the flames only have one color. But the silver works very effectively with the basecoat pearl blue. You don't have to get wild with color to have wild flames. These are known as Ohio flames.

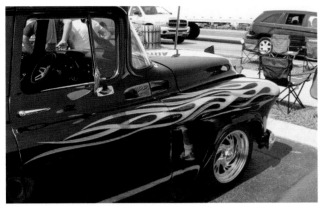

Sometimes a flame accent is all you need. Ohio flames sweep along the fender and door body feature on this pickup. The green pinstripe provides a powerful transition between the yellow orange faded flames and the black of the truck.

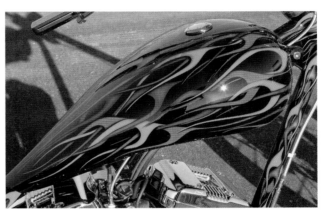

Use the layout and masking technique to lay out multiple layers of flames. Note how areas of each layer are taped off so that flames overlap and wind around each other.

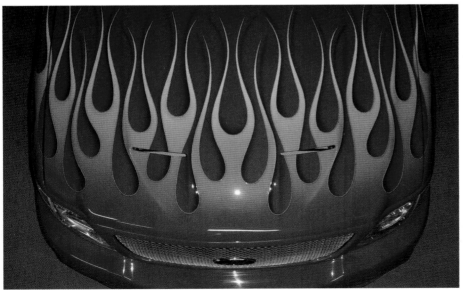

Ron Gibbs painted these beautiful flames on this F150. His flame style has an incredible symmetry. He went with a reverse fade. Using the original color at the start and fading into lighter tones at the flame ends. Don't be afraid to try something different with your flames.

GHOST FLAMES

There are many kinds of ghost flames. Ghost flames are basically any flame that is not completely filled in with color. Ghost flames are not usually seen from all viewing angles. One part of the car will look like solid color, while the flame will tend to show up on areas of the car that the light is hitting. Any flame that has some degree of transparency can be a ghost flame. Ghost flames are usually done using pearl or metallic colors, as they have a finer, less grainy paint pattern.

Ghost flames are laid out exactly like any other flames. It's the application of the paint that makes the difference. To try out ghost flames, start by thinning down the color you want to use, then airbrush it on a test piece. Look to see if there's a smooth, gradual transition. Find the color that has the effect you're looking for and work with it until you have the desired results.

Ghost flames work great for multiple layers of flames. Here the blue pearl layer is more ghost than the lavender pearl layer.

These ghost flames were done over a charcoal black metallic. Black basecoat was thinned down about 200 percent and then two passes were made with an airbrush. Go easy and smooth when you airbrush ghost flames. Any unevenness or rough starts and stops will show up.

This tank features ghost flames with a medium amount of transparency. See how the flames tend to go dark once they reach the curve at the front of the tank.

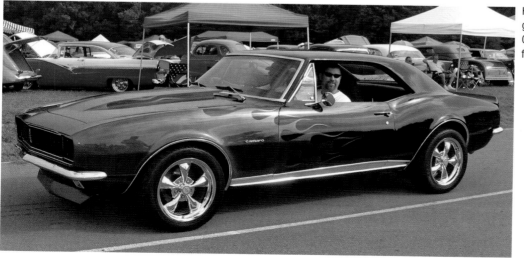

Here's some multicolored ghost flames on this 1968 Camaro RS. Note how the flames go dark in some areas.

Mike Lavallee was the artist who pioneered realistic flame paint. I was lucky enough to have him show me his technique. He developed special Artool templates and even released a DVD showing how he painted his fire flames. He painted this hot rod back in the early 2000s.

REALISTIC FLAMES

Realistic flames are painted to look like actual fire. The ability to paint "real-fire" flames is a very handy skill to have in your wheelhouse. They can be airbrushed relatively fast. There's not much of a paint edge, so they don't require many thick layers of clearcoat to level them out. Plus, the freedom of the design allows for a great deal of creativity. This freedom also makes it easy to make a change midway through the paint job.

Real fire flames are often seen as a standalone featured graphic on a car with the whole frontend on fire. But they can also come in handy when you want to separate a two-tone or simply accent areas on a car. Just a few licks of real fire can add some zing to any paint job. And one of the best things about painting real fire: You don't have to be an experienced airbrusher to get good results.

Real-fire flames are basically a series of fire shapes. Look at photos of actual fire and design a few different flame shapes. Then repeat them over and over in the various layers of colors. Practice airbrushing those shapes until you get them down. They won't come out exactly the same each time, but that's what you're aiming for. Another trick is to not overuse the stencils or templates. Draw out a shape with the airbrush, then use the template to give a hard edge along several sides of the shapes. The best real fire is a mixture of freehand airbrush and template edges. For example, the average flame shape has four sides. Sometimes I'll stencil two or three sides, and leave a side open, with no hard edge at all. Mix it up when you're practicing.

The only real rule for these flames is to start out big and loose, then with each layer, go tighter, sharper. Look closely at the photos. See how the red layer is

almost blurry? And try not to aim the airbrush directly at the edge of the template. Direct the paint inward of the template edge. There also will be areas when you'll softly fog in paint.

Real fire flames can be painted in any color, from blue to purple to green or even white. But the most common ones are red, orange, and yellow. For this example, I'll be using three solid basecoat colors—red, orange, and yellow—and three candy colors—candy red, candy orange, and candy golden yellow. The candy colors are made using PPG Deltron DBC500 clear basecoat and their DMX toners. And how much toner do you mix into the clear basecoat mix? Dip a paint paddle into the candy mix and see how dark or light the candy is against the wood grain. Find a good medium between too light and too dark.

To help give the fire its free-flowing shapes, the technique requires templates. Some painters make their fire templates, but I use the same templates designed by the True Fire man himself. Mike Lavallee of Killer Paint developed his own line of True Fire templates: The Original True Fire and True Fire 2nd Degree Burn.

Make sure to practice on a spare panel or old fender first. Get your technique down and work out any problems you might run into. And know that all painters will develop their own style. Relax while you're practicing and allow your style to flow. Find some fire photos and print them out. Hang them close by while you're painting, so you can refer to them as you work.

Another style of real-fire flames. This fire sparks across the surface.

FLAMES

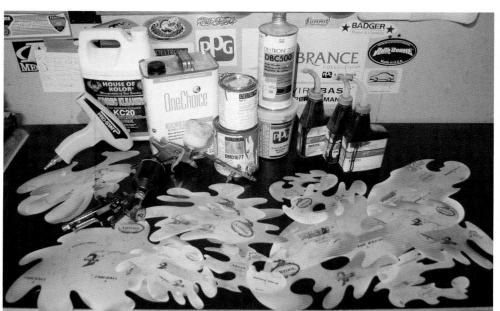

Here are the materials and tools that were used for these flames. For the solid colors, its PPG Deltron DMD 1677 Scarlet, DMD 1608 Organic Orange, and 83032 Sunburst Yellow. For the candy colors, DBC500 is mixed with candy toner. The yellow is House of Kolor Pagan Gold, red DMX 212, and orange DMX 211. SX330 precleaner is used to remove overspray. House of Kolor KC-20 and a ProStat gun for antistatic. The Artool templates scattered here are Original True Fire and True Fire 2nd Degree Burn.

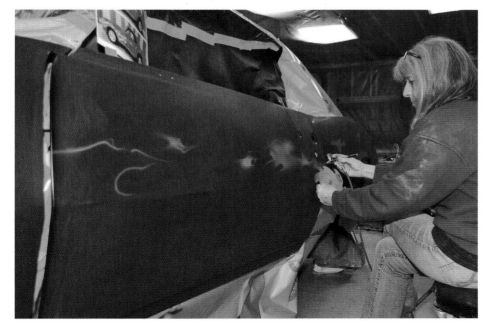

Work from the back of the fire to front, laying and spacing out the embers that will be at the end of the fire. Start out with a tiny flick of red, then go larger with each ember. Don't put them in a straight line. You want them to randomly "dance" across the surface. Next, sketch the outlines for the various flame shapes, going larger as you move forward on the car. Once the shapes start to develop, find a curve or shape on the template that matches up to the curves that were freehand airbrushed. Little by little, the shapes start to fill in. Notice how open and loose these are. I'm using a SATAgraph4 airbrush with 45 pounds of air pressure.

This is an example for the layering of the different shapes and how the open sides of the shapes allow them to run together. The biggest curves of the templates were used here. Note the "fogginess" of the color application. In some areas, the red paint is solid, but in other places, it's very thin. And in some of those thin areas, freehand lines were airbrushed, creating a side to those shapes.

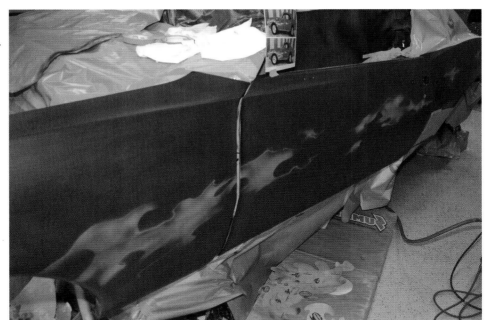

THINNING YOUR PAINT

One of the most asked questions is: How much should the paint be thinned down? This will vary from painter to painter, depending on the kind of paint used and the painting style. But here's an easy way to know how much reducer to add. When you're practicing, look closely at the way the paint is landing on the surface. Is it grainy looking? Are there lots of tiny dots of paint? Too grainy means the paint needs to be thinned down. You're looking for a clean but soft application. For artwork, it's better to have the paint too thin than too thick.

Realistic Flames (continued)

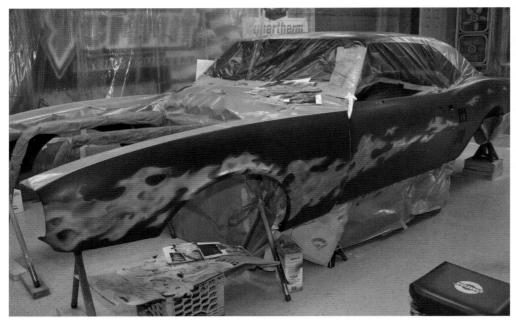

The red fire is completed and ready for the application of the red candy. See how the fire flows up and down along the car? Never paint fire in a straight line. Closely examine the red fire and make sure that the overspray didn't travel too far from the flame area. If it does, try to wipe it away with precleaner or use a 3000-foam disc to gently wet sand off the overspray.

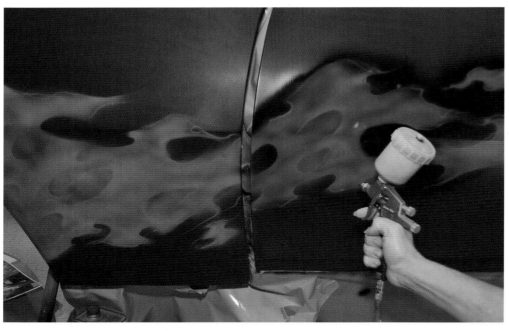

A SATAjet 20B art gun is used to spray on a coat of red candy. Note the difference between the right side with the candy and the left side without. The candy brings out the depth of the layer, giving contrast between the solid and thin areas of the red. Use care and don't spray the candy too far from the edge of the fire.

FLAMES

The orange layer goes on next. Try to visualize this next layer. Remember your shapes and airbrush them in. Build off some of the red flame shapes. Notice the orange curve to the left of the template. I sprayed orange against one curve on the template and left it at that. Keep the color application random. Some shapes will have orange only on one side; other shapes will have it on two or three sides. Leave plenty of red showing through and around the orange.

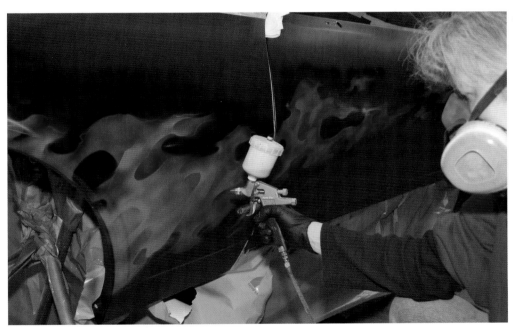

After using precleaner to wipe away any overspray, orange candy is applied. The fire is starting to really take form! After spraying the orange candy, I'll remove the overspray again.

DEALING WITH OVERSPRAY

There are two options for dealing with real-fire overspray that has extended past the flame area. If the vehicle is a nonmetallic color, then you can use that color to blend in the edge of the overspray area. Use the airbrush to make the transition. For pearl or metallic colors, it gets a little tricky. If working over a candy base, then you should pay close attention to the overspray during the fire application. Aim the airbrush toward the fire and use less air pressure. After applying each layer, take extra time to wipe down the area with precleaner, then use a 3,000-grit foam pad to wet sand back the edge of the overspray.

Realistic Flames (continued)

Now for the yellow! The one thing to remember when airbrushing the yellow layer is to not overdo it. Concentrate the yellow at the front of the vehicle. Then build off the orange layer, but take care not to completely cover it. Aim for a ratio of 65 percent orange to 35 percent yellow or something close to it. This is the place to use some of the smaller and medium curves on the templates. In some places, a short lick of yellow fire works great; in other places, longer licks fit the space. Keep it random, yet balanced.

After checking for and removing any yellow overspray, airbrush orange candy on some but not all the yellow. Then spray a medium coat of candy Pagan Gold over all the fire. I use an Iwata LPH80 spray gun for this. Be careful not to oversoak the fire as it will soften and mottle the layers, causing them to melt into each other. Don't apply too heavy of a coat.

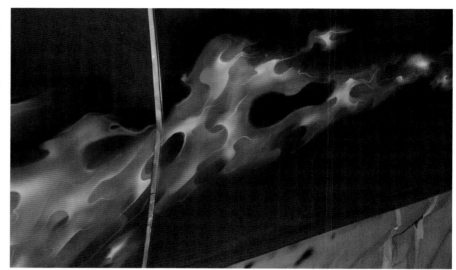

Airbrush yellow paint to highlight some of the yellow areas. This will add depth to the fire. Remember to spray away from the edge of the template.

Now a yellow and white paint mixture is used to add a slight highlight to some, but not all the yellow areas. Just a tiny touch! Some painters will use white for this step. Try it and see if white works for you.

Here's the fire ready for clearcoat. See what I mean about the shapes in the fire? The shapes should be flame like, yet indistinct.

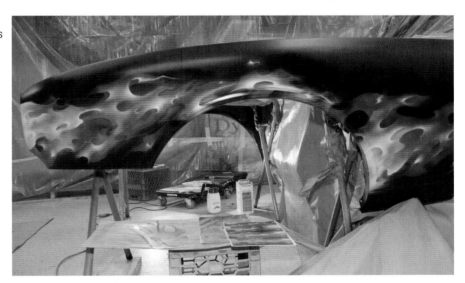

Don't forget about the embers! The little embers are what really give the fire its spark and realism.

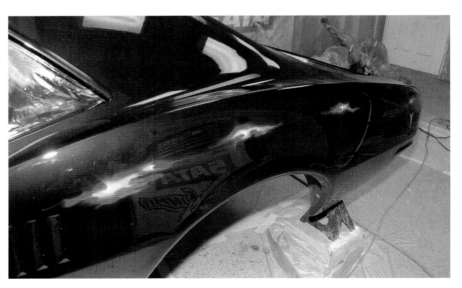

Realistic Flames (continued)

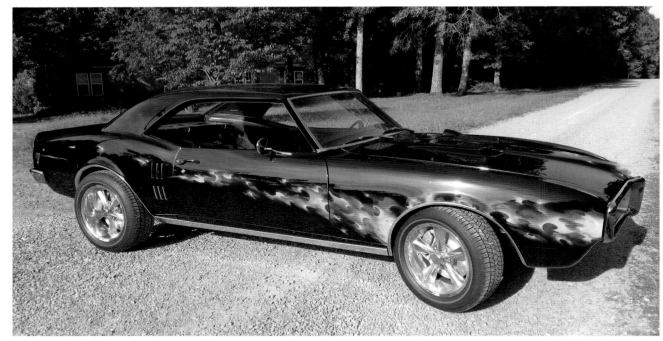

And here is the finished fire on the Firebird!

Green real-fire flames have a powerful impact.

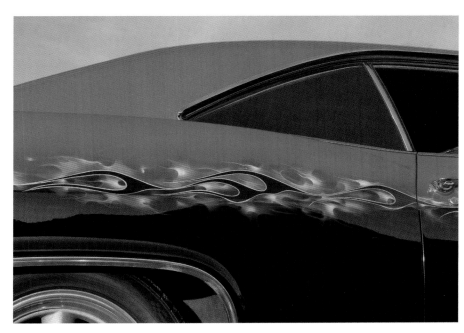

Combine traditional flames with real fire to add even more dimension to your flame paint. Here they're used to separate a two-tone.

Create creatures from real-fire flames. I airbrushed a Firebird on the hood of a Trans Am using real-fire flames.

Chapter 6
Graphics

Designing and painting graphics is one of the hardest tasks in custom painting. This chapter has several examples of painting graphics on a car or bike. These techniques can be used with any design. The trick is to take your time and *think* your way through the process. Plan your design and process before you spray any paint. When painting multiple layers, take the time to paint each one with the same high level of care and precision.

Using a few basic steps, you can reproduce almost any graphic on a painted surface.

Method One—Freehand Layout

1) You can freehand tape a design on the surface being painted.
2) Paint that area of the graphic and remove the tape and masking.
3) Repeat the process for each layer or area of the graphic.

Method Two—Pattern Layout

1) Make a pattern created from a drawing. Use a computer and printer to resize the design to fit the surface area. Or draw it out on tracing or white masking paper. Transfer the design to the surface being painted.
2) Use fine line and masking tape to tape off a layer of the graphic or use a stencil.
3) Paint that area of the graphic. Then remove the tape and masking.
4) Repeat the process for each layer or area of the graphic.

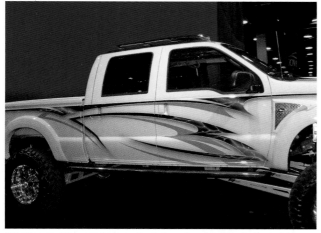

Graphics don't have to be complex to have impact. This design is fairly simple. Two layers. One layer of black with lightning airbrushed in it. The second layer is just gray and acts as a shadow for the first layer. The graphics contrast strongly against the white basecoat.

TOOLS AND MATERIALS

Mechanical pencil
Magnets
Lightbox
Cutting mat
Measuring tape and rulers
Iwata Eclipse HP-CS Airbrush
Anest Iwata LS400 Spray Gun
Uncle Bill's Sliver Grippers
X-Acto #11 Stencil Knife

PPG Deltron Basecoat
PPG DCU2021
PPG Envirobase Waterborne Paint
3M #06300 and FBS #48510 ⅛-inch fine line tapes
FBS #48218 ProMask
Masking tape and paper
Tracing paper

SIMPLE MULTIPLE LAYER GRAPHICS: WORKING OVER A BASECOAT/CLEARCOAT

There are several ways to do a graphic paint job. Some painters apply their basecoat and apply the graphics directly over it. Other painters spray a basecoat clear over their basecoat and apply their graphic layers over that. And some painters spray basecoat followed by several coats of urethane clear, sand it, and then do their graphics. In this first example, I'll be using the urethane clearcoat method. For more information on basecoat versus urethane clear, refer to chapter 14.

In this example, I'm using enlarged copies of a drawing, but in other projects I'll lay out the design directly on the surface using tape. Each project is different, so use the layout technique that works best for you and your project. Have fun picking out the colors or effects for your graphics. Mix it up and experiment. Here I'm doing three layers, two metal effect layers and a checkerboard layer. These layers won't need pinstriping. But most graphic paint layers will be pinstriped. So, make sure to include the pinstripes in your paint plan. See chapter 9 for information about pinstriping your graphic layers.

Here's the design that will be painted on this Harley race bike. There are two layers of metal effect graphics and one layer of checkered flag graphics. I started with a photo of the bike. The frame, tank, and fenders were whited out and copies were made on a printer. The design was drawn in pencil on the copies and the colors were filled in.

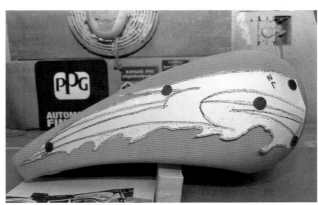

The parts were painted with PPG Deltron 61456 Brite Orange basecoat, cleared with DCU2021 urethane clear, and wet sanded with 800 grit. I enlarge the tank section of the drawing until it's the same size as the actual tank. The graphic part of the drawing is cut out and placed on the tank to check the size.

I flip over the paper design and use a pencil to trace along the backside along the lines of the design.

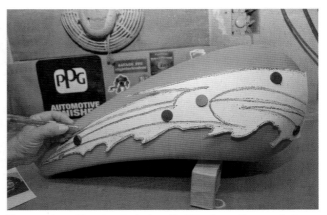

The paper is positioned on the tank and held in place with magnets. I trace along the lines. This will transfer the design to the tank surface. The pencil lines on the back allow the paper to act like a carbon copy.

SIMPLE MULTIPLE LAYER GRAPHICS: WORKING OVER A BASECOAT/CLEARCOAT (continued)

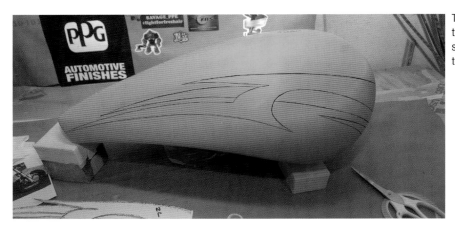

The pencil lines are actually much lighter than this. They have been enhanced so that they show up in the photo. Here's the design. Now to tape it off.

I tape off the two metal effect layers of the design using 3M ¼-inch and ⅛-inch fine line tape. FBS ⅛-inch orange fine line is used for any curved areas.

Now to create the pattern for the other side of the tank. When you need to reproduce a copy of a taped-off design, tape a piece of tracing paper over the design. Trace along the inside edges of the tape with a pencil. Now you have a design pattern for the other side of the vehicle.

GRAPHICS

To position the pattern on the other side of the tank, I need to find reference location points. The gas cap hole acts as the center point of the tank. The top edge of the design is about 6⁵⁄₁₆ inches from the edge of the hole. On the opposite side of the tank, I measure 6⁵⁄₁₆ inches from the edge of the other side of the gas cap hole. Opposite sides and panels aren't always the same as the other side, so use the measurements as guidelines. Place the pattern or design in place, stand back, and look. You might have to find a happy medium by moving the design around until it's correctly positioned.

To find the positioning at the front of the tank, I use a ruler to line up the pattern, creating a straight line from one side of the tunnel to the other.

The pattern was flipped over to put the side with the pencil lines against the surface. Now I can trace along those lines, transferring the design to the surface. Then I'll remove the pattern and tape off the design.

After taping the design, it's masked off using FBS ProMask.

The second layer is covered up with tape so only the first layer is revealed. I ran ⅛-inch fine line tape along the edges of the first layer. This will be the bevel for the metal effect. Reduced black basecoat is airbrushed along the top edges of the design. White is sprayed along the bottom edges. When spraying a metal effect, think of the way light reflects along the surface. Refer to chapter 11 for more detailed instructions on airbrushing metal effects.

SIMPLE MULTIPLE LAYER GRAPHICS: WORKING OVER A BASECOAT/CLEARCOAT (continued)

I remove the ⅛-inch tape on the edges and start to spray the reflections on the beveled edges. Each section of the edge is masked off and airbrushed. Black along the top and white along the bottom. Create highlights by airbrushing a few white reflections.

Once the first layer is done, allow it to dry. To spray the second layer, start by covering the first layer. Tape any hard edges with fine line tape and cover the rest of it with masking tape. Now spray your second layer. Repeat the process with any other layers. Here's what I have after both metal layers have been sprayed.

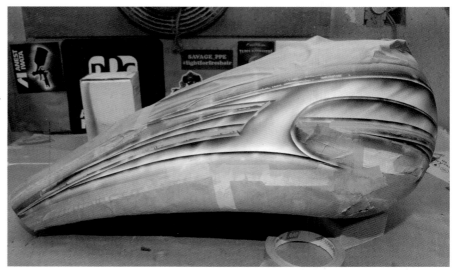

The masking has been removed. Now the top half of the two-tone will be painted. The top lines of the design were taped and masked off. Four coats of PPG Deltron #908423 Perfect Purple were sprayed and allowed to dry. Then the masking was removed. Next, four coats of urethane clear will be sprayed over the tank. This will help to level out the paint edge from the purple pearl.

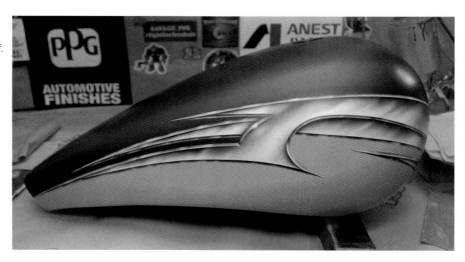

CHECKERED FLAG GRAPHICS

Spraying a checkerboard pattern seems simple, at first. Yet, it's hard to tape off. Painting a checkerboard pattern can be easy if you use stencil film for the checks. Trace your checkerboard pattern onto a piece of stencil film. Then use an X-Acto knife to slice along the lines of the checks. Check the positioning of the stencil, then place transfer tape over the stencil. The transfer tape keeps those checks in place. Apply the stencil on the surface and you're ready to spray your checkerboard. This next step in our drag bike project shows how to use this technique.

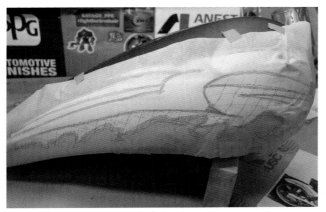

The tank is sanded with 800-grit sandpaper and the paper pattern is positioned on the tank. Tracing paper is laid over it. The checkerboard is redrawn to best fit the two layers of graphics.

Two stencils are created. One is for the white background for the checkerboard. The second stencil will be for the checks. Stencil film is placed over the checkerboard drawing and traced using a lightbox. In order to best accommodate the bend of the tank, I use three pieces of stencil film. This will help in adjusting the film to fit the round surface.

Here I'm cutting along the lines of the checks on the second stencil. Using the stencil is the easiest way to create a checkerboard pattern. Just trace your checkerboard lines on stencil film or paper and then smoothly cut along the lines.

The three stencil pieces for the white background of the checkerboard (the first set of stencils) are put into place on the tank and sprayed with white basecoat.

Once the white dries, I find the position for the three checkerboard stencil pieces. Leaving the backing on the stencils, I put them into place and mark their locations with a pen. These will help in lining up the stencils. Note how the stencil is rippled at the front of the tank. The stencils will be adjusted further once they are stuck to the tank, by moving the check pieces around. It's much easier doing a checkerboard on a flatter surface.

After the locations are marked, the stencil pieces for the black checks are removed and covered with transfer tape. Use a squeegee to firmly press down the tape over the stencil. Trim away any transfer tape that overhangs the edges of the stencils. Use the location marks to line up the stencil pieces, remove the backing, and put the stencils into place. Here I start at one end and work my way across the tank. The stencil is pressed down firmly. Every other check is peeled away, and the checks are sprayed with black basecoat.

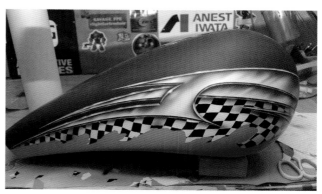

Once the black checks are sprayed, the checks covering the white are removed. Next, I spray a drop shadow along the bottom edges of the two metal layers. Once the paint is dry, all the stencil pieces are removed. I'll do a drop shadow under the checkerboard later in the project.

OVEREAGER STENCILS

If the stencil sticks to the car before it is supposed to, take care. Remember, any stencil film will stretch. Do not pull it hard. Carefully peel up the areas that are sticking. Take your time or else you'll be cutting another stencil. For a large stencil, have someone hold the stencil up while you carefully peel. And if you have to cut another stencil, then do it and remember that most custom painters have been there many times. Be patient and don't lose your cool over a stencil!

TRANSFERRING AND REVERSING GRAPHICS

Here's a quick and easy low-tech way to transfer graphics. This example uses a motorcycle fairing, but the technique can be used for any size of graphic or panel. Just tape together the tracing paper and have plenty of magnets or tape pieces to hold the pattern in place. Be sure to take reference measurements around the graphic to reference points on the part or vehicle.

Ever wonder how painters get those amazing mirror reversed graphic effects to look so perfect? Using the tracing paper technique makes it simple. For this motorcycle fairing, I need the graphic on the right side of the fairing to match the left side. A piece of tracing paper is taped over the design. I trace along the edges.

Then the paper is flipped over and put in place on the other side of the fairing and I trace along the pencil lines. The paper is removed. Using those pencil reference lines on the surface, now I can just tape, mask, and spray the design.

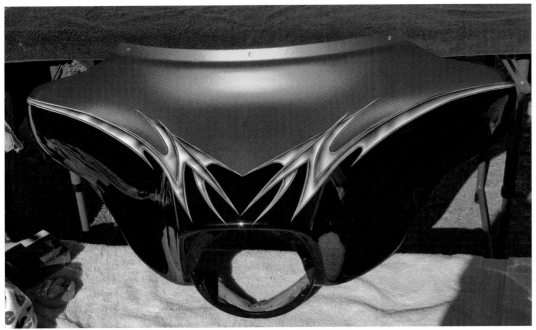

And here is the end result. You don't have to be an expert artist to get great results. Make the most of traced drawings and reference measurements. Just be sure to go back and *remove any pencil marks that are left before you clearcoat*. This transfer method is a great way to transfer designs from one side of a vehicle to the other side. Simply flip over the drawing on the other side of the vehicle or part.

COMPLEX MULTIPLE LAYER GRAPHICS

Some painters will work entirely in basecoat, starting with a primered surface. The main color of the vehicle is part of the graphic layers. PPG's Paul Stoll and Frank Ruiz use this technique to paint a race car body using PPG's Envirobase High Performance waterborne. But this technique can be used with any kind of paint.

Whenever painting multiple layers of graphics, be sure the paint is dry before you start taping off the next layer. The thicker the paint is, the longer it takes to dry. If you're using candy coats for your graphic layers, it might take a few hours before you can mask off the next layer. The paint might feel dry, but if the paint is not truly dry, the tape might leave marks in it.

The guys have started to lay out the design on a funny car body in primer. The dark areas are where they sanded through the primer into the dark epoxy primer underneath. The highly concentrated waterborne paint will cover any tonal inconsistencies in the surface and flow right over any sanded-through edges without irritating them.

The first layer has been taped and masked off. Note how wide the layer is compared to the previous photo? The second layer is also included. The first layer is white. It will be sprayed and masked off. Then the second layer will be applied.

Frank sprays the first coat of white on the car, applying a medium to light coat. As soon as he is finished spraying, he turned on the air blower towers in the booth to dry the paint. He also could have used a handheld air dryer to dry out the water. The average flash time for solvent basecoat is ten minutes, and that is about how long it would have taken to use a handheld dryer to dry the first coat of white until it's completely dry, not just flash dry.

Frank has applied three coats of white EHP T400 (Envirobase High Performance), reduced 30 percent with T494 waterborne thinner, to the body. It covered any color differences in the undercoat. This was followed by a few coats of a waterborne white pearl. This formula consisted of 150 parts VWM 5556 Vibrance waterborne midcoat clear mixed with fifty parts T 4000 Crystal Silver and two parts VM 4141 White Flamboyance. This was also reduced 30 percent with T494. All the masking has been left in place, and the second part of the graphic has been laid out and masked. The second layer will be silver and will use the white, which was just sprayed, as an undercoat.

Be careful when applying basecoat clear. The rule is, don't apply too heavy or too much. If in doubt, leave plenty of time between coats. Check the tech sheet for your product's specific rules concerning application.

Waterborne paint dries quicker than solvent borne. Once waterborne is dry to the touch, it's dry all the way down and tape will not leave marks on it, as it sometimes does on solvent borne. But unlike solvent paint, all the water must be dried *completely* from each application of waterborne paint before you apply the next layer.

Frank next sprayed the silver using PPG's EHP T 475 mixed 1:1 with T 476 Coarse Lenticular Metallic. Note the gun's distance to the car. Gun distance is critical when it comes to spraying pearl and metallics. It dries fast, and if the gun is too far away, some of the paint droplets might dry before they reach the surface. Next the masking over the white is removed and waterborne midcoat clear is layered over the two colors.

Here's what they have so far. It can seem confusing, but once you break down the elements of a design, it becomes easier to understand. The midcoat clear over the pearl white and silver was sanded with 800 grit. Now, it's time for the black tones.

All the silver and white have been masked off, leaving the areas for the black tones. Paul mixes up 100 parts EHP T409 black with 1.5 parts T 476, reduced 30 percent with T494.

Two coats of the dark metallic black mixture have been sprayed onto the car. Now they do several simple stripes in the black. Different widths of fine line tape are run side by side across the black areas. Then the wider middle sections are removed.

COMPLEX MULTIPLE LAYER GRAPHICS (continued)

Paul mixes up a lighter black metallic and sprays a light coat over the taped off area. This picture shows what it looks like after that tape was removed. Look closely to see the darker striped areas where the tape was.

All the masking has been removed. Now a red candy will be sprayed. This will be the primary color of the car. A gold pearl will be used as base for the red candy. Having a warm color under the red candy will give it a bright, hot glow. We'll mix thirty parts EHP T477 Extra Coarse Metallic with thirty parts EHP T479 Coarse Silver Dollar Metallic and forty parts EHP T426 Warm Yellow, reduced 30 percent with T494.

Frank masks off the white, silver, and black graphic layers and sprays three coats of the gold base mixture on the car.

Picking a point halfway down the side of the car, Frank tapes off the bottom portion of the yellow and does several fade stripes. These are pretty easy. Simply line up a few rows of fine line tape. Using an airbrush, spray along the top edge of the top piece of tape. Then remove that piece of tape and repeat the process, spraying and then removing the tape. Frank used forty-three parts of EHP T479, twenty-three parts EHP T435 Salmon Red, and six parts EHP T409 Black mixed together and reduced 30 percent with T494.

GRAPHICS

Frank repeated this process all around the car, creating what will be a slick ghost effect, once the red candy has been layered over the yellow. In fact, many very cool graphic paint jobs are done using only this kind of effect, painting the graphics directly on the basecoat under the candy. This can also be done with flames or murals.

Frank's not done yet. He masks off another series of stripes and paints them with the white pearl waterborne mixture.

The finishing touch is five coats of candy red. Vibrance solvent base paint is used. For the first three coats, 600 parts of VWM5555 is mixed with nineteen parts of DMX 212 Red Candy. For the last two coats, the amount of DMX 212 is doubled. Both of these mixtures are catalyzed with 3610 hardener according to the P sheet. Then all masking was removed, and Frank sprayed four coats of EC 700 Clear, which he let dry and then dry sanded smooth with 600-grit paper. The car shell was then recleared.

Here's a look at one of the ghost effects. The silver stripes on top appear darker than the candy. The white and silver graphic layers will be pinstriped later.

COMPLEX MULTIPLE LAYER GRAPHICS (continued)

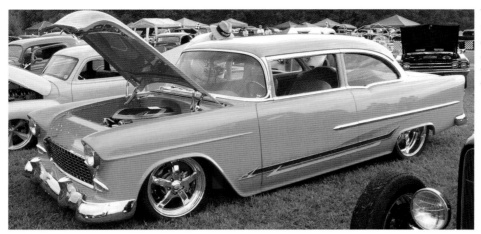

The techniques in this chapter can be used to create just about any kind of graphics you want, like these very sleek graphics on this classic Chevy. Graphics with impact don't have to be overwhelming. Sometimes less is more.

Or graphics can be over the top, like the multiple layer graphics on this wild mini truck. Complex graphics are easier than they look. Just handle it one layer at a time.

The multiple layers of graphics on this Harley-Davidson effectively enhance the design of the motorcycle. The aggressive style of the graphics makes the bike look like it's moving when it's standing still. The white layer pops against the red and gold layers. All the layers jump off the dark burgundy basecoat.

One cool detail is to make the graphics go into the doorjams on both the doors and quarter panels.

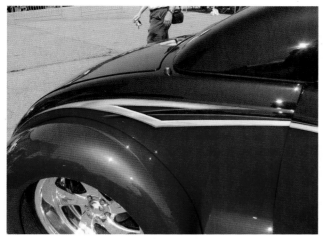

This beveled edge graphic separates a two-tone paint job. Simple, yet highly effective.

The scallops on this Harley-Davidson tank were done with red candy applied over silver marbleizer. This paint job got more "Likes" on my Facebook page than any other paint job I've done. That's how popular scallops are.

Scallops are a popular style of graphics. Some people refer to scallops as a style of flame, but scallops stand in their own category. The blue highlight under these scallops makes them pop.

Chapter 7
Retro Styles

Back in the '60s and '70s, flake paint with crazy graphics was everywhere—on vans, cars, speedboats, and motorcycles. It was wild and bold. Painters experimented and created many techniques and styles. Then it faded away. But recently, custom painters are rediscovering retro paint and its endless possibilities.

Many paint companies have their own line of flake and some companies are completely devoted to flake paint. Most of the time, flake comes dry in a jar and needs to be mixed with paint, usually clear basecoat paint. But you can also add flake to candy colors or to pearl or metallics to give them extra pop.

Modern flake comes in many colors. The flakes are made from a very thin polyester that lays down flat, requiring less clear to level out the surface. Sizes range from ultra micro, which is a little bigger than pearl particles at 0.002 inch, to bass boat big flakes 0.062-inch wide. Popular with many painters and vehicles is a flake of 0.015 inch.

These days it's easier than ever to spray flake paint due to better spray equipment and better materials. Urethane clearcoat is much thicker than the old lacquer clears, which makes it easier to level out the bumpy surface of the flake. In fact, the two biggest problems with painting flake colors are the rough surface of the freshly applied flake paint and the mess from the application. Make sure to wear a disposable paint suit with a hood. And maybe even shoe covers or junk shoes, because you and your shoes will be covered in flake.

This Sucker Punch Sally chopper features a full-on metal flake paint job with scallop and lace graphics straight out of 1967. French Kiss painted this bike and specializes in next-level retro paint.

MATERIALS AND TOOLS

PPG Ditzler VM4402 Big Flake silver
PPG Ditzler VM4425 Purple Flake
House of Kolor F33 Fine Rainbo Flake
PPG DBC500 color blender
PPG DBC9700 black basecoat
3M 218 6300 ⅛-inch and 6301 ¼-inch fine-line tape
FBS Proband Fineline 48410 ⅛-inch orange tape
FBS ProMasker 48218
Basting spray
House of Kolor KC-20
Lace
Poster board

SATAjet 100 BF HVLP spray gun
SATA mini jet 4400b spray gun
Iwata Eclipse HP-CS airbrush
X-Acto #11 Knife
Dot magnets

Flake is heavy stuff and it lands everywhere. If possible try to paint your flake outdoors. But if you're using a booth, plan your clean-up time into the paint time. Flakes are heavier than metallics or pearl colors and they tend to land everywhere. The floor will be covered with them, and no matter how thorough you clean up they'll try to get in every coat of paint you spray in the months after.

One trick to help keep the oversprayed flakes under control is to cover the floor with masking paper or plastic to catch any loose flakes. Simply roll up the paper when you're done. If you're attempting to spray flake in a garage, go out and get some disposable drop clothes. Drape them over everything, toolboxes, benches, and so on. In fact, if you choose to spray any paint in your garage, cover everything with drop clothes and hang up plastic to cover the walls.

To clean up from flake, first grab the shop vac and vacuum the floor and walls, and any cobwebs that might have gathered in the corners. Then I sweep with a soft bristle broom; carefully looking to see how much flake is still there. The next step is mopping the floor; again looking to see how much flake remains. If spraying in a booth, check the intake filters in the booth and see if they need to be changed.

NON-FLAKE RETRO DESIGN

Retro doesn't always mean flake paint. You can use retro techniques without flake too. Check out the gallery at the end of this chapter for examples of nonflake retro. Unlike most graphics where layers go on and cover parts of the base color, many retro paint techniques use the base as part of the graphic itself. For our step-by-step tutorial, we'll be painting a very rare GME classic chopper tank. Four techniques will be explained: lace, fish scale scallops, a sunburst, and a layered line technique.

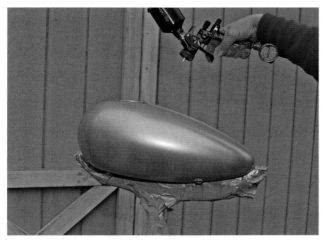

To help the flake cover the surface, paint a coarse metallic that is similar in tone and color to the flake being used. For example, if spraying a red flake, use a red metallic. This way, any spaces between the individual flakes won't be noticeable. Sealer is sprayed on this tank and three coats of PPG Deltron DMD1696 Course Silver Dollar Aluminum are applied.

For the flake, PPG's VM4401 Ditlzer big flake and House of Kolor's Rainbo mini flake are mixed with PPG DBC500 Color Blender (clear basecoat). The Rainbo flake is a hologram flake that gives a prismatic effect. The DBC500 is mixed 1:1 with reducer. Look closely at the tank and you can see the areas in between the flake. This photo was taken after two coats of flake. Four coats will be sprayed. Before spraying each coat of flake, hold a cloth over the end of the business end of the spray gun and gently pull the trigger. This will back flush the paint passages and clear out any flakes that have settled in the tip of the spray gun.

NON-FLAKE RETRO DESIGN (continued)

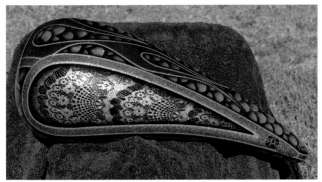

Here's the paint job I'll be re-creating. Check out the silver pinstripes around the various graphics. Those pinstripes will be the first thing taped off. Use ⅛-inch fine line tape and create the different sections on the tank. Use the tape to create the flame sections on the top, the teardrop section on each side, and the separation line between the panels on each side of the lower front. With this method, instead of painting on pinstripes after the graphics are done, the pinstripes are the basecoat showing through.

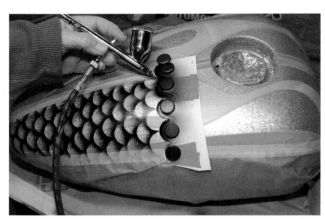

Mask off the flame area, covering the side panels and the lower front sections. Cover the inside area of the flames. Next, create a fish scale scallop template. Cut a line of scallop shapes in posterboard. Starting at the bottom of the tank, line up the scallops and airbrush black along the edge. Move the scallop template over and up until the bottom curve of the scallops lines up with the top of the sprayed scallop line. Now spray along the bottom again. Repeat the process until the section is covered in scallops. Magnets can be used to hold the template down.

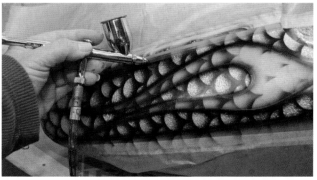

Once the scallops are done, airbrush black along the edges of the tape that borders the panel with scallops. Repeat this with each section or panel that is painted with scallops. Mask off and cover these graphic sections when dry.

MIXING THE FLAKE

A variety of different clearcoat paints can be used. Many painters use basecoat clear, and that's what I'm using here. But clear urethane can also be used. When using urethane as a midcoat (that is, over a basecoat and under a finish clear), a medium solid–clear works great. For example, when a urethane clear is used, the finished product will be smoother than if you were doing the job with the flake mixed in basecoat clear or waterborne midcoats.

For PPG's Ditlzer Big Flake, they recommend using 14 ounces clear to 0.2 ounces flake or for those with a paint scale 400 grams of clear to 8 grams of flake. For the DIY'ers, I'm using 2 (level) teaspoons (1 ounce) to one mixed quart of clearcoat. But remember, too much flake in the mix will tend to clog up your spray gun and will lay down pretty rough. You want the flakes to lay down nice and flat to reflect the light effectively. Make sure to leave time in between coats for the coats of paint to flash off. Whatever paint and flake you use, get the product sheet for the flake and paint and follow the directions closely.

There are a number of tools for spraying flake. Most folks use a primer spray gun with at least a 1.7 tip. The flakes need room to get past the needle and tip. SATA makes an agitator mixing cup that keeps the flakes from settling in the bottom of the cup. There are also dry flake spray guns that spread an even coat of dry flake over a wet coat of clear.

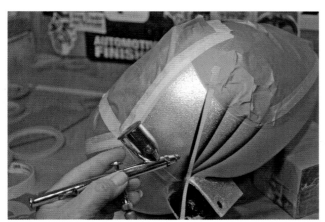

Next, spray the lower sections on the front of the tank. Sunburst lines are a popular retro technique. The lines are taped off starting with the lowest line. Spray black along the top edge of the tape. Then move the tape up, creating an even space to the bottom line, and spray black. Repeat the process until the lines fan out across the panel, evenly spaced. There was a piece of 2-inch tape that ran along the bottom of the ¼-inch fine line seen here, but it was removed for the photo so you can better see the lines.

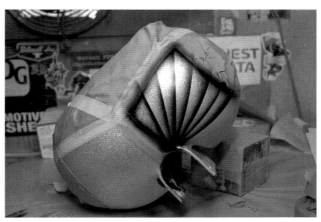

The finished sunburst section. The point where the lines start is sprayed with black, as are the edges of the section or panel.

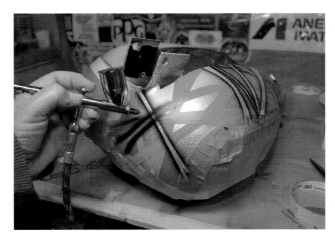

The other side will be layered lines. Start by masking off the line that will appear to be lowest, under all the others. Then mask off each successive layer, working your way up. Make the lines vary in thickness and shape. Spray black along the sides of each line. Pull the tape from that line and spray the next one, working your way down through the taped-off layers.

The lace panels are sprayed next. Arrange the lace on the panel and figure out exactly where to best position it. Then trace around the panel edges with a marker. This helps when lining up the lace in the next step.

NON-FLAKE RETRO DESIGN (continued)

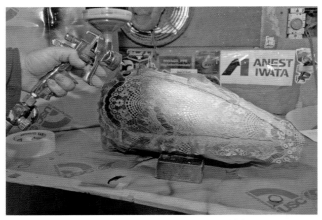

Remove the lace, flip it over, and the spray the lace with basting spray. This will help hold it in place. Let the basting spray dry for five minutes. Then carefully place the lace on the panel. Press it down and use tape to hold the edges in place. Then softly spray black basecoat over the lace in a light medium coat.

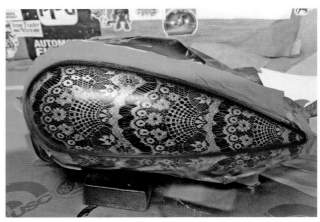

Then remove the lace and wipe the surface with a water-based cleaner like House of Kolor KC-20 to remove any basting spray from the surface. Airbrush black around the edges.

Next, the wide stripe areas are masked off. The ¼-inch-wide stripes are painted using the House of Kolor Mini Rainbo flake mixed with DBC500 basecoat clear.

Once that area is dry, the purple flames are masked off and sprayed using PPG VM4425 purple flake. A coat of purple candy is sprayed over the flake to give it a deeper look. Now remove all the ⅛-inch tape that covered all the pinstripe borders.

DON'T REMOVE THAT ⅛-INCH TAPE!

Remember that ⅛-inch that was placed on the tank in the beginning? You're going to be taping and masking along it as you work through the steps. Use care when removing any masking, making sure that the ⅛-inch isn't stuck to the bottom of the masking and getting pulled up. If it is, remember to retape those lines.

RETRO STYLES

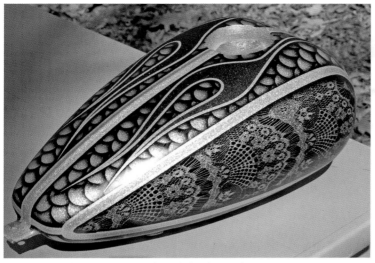

And here is our finished chopper tank ready for clearcoating.

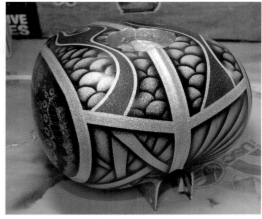

Here's the front of the tank and the sunburst and layered lines techniques.

The roof of this car features a metalflake retro paint Celtic cross framed by sunburst sections.

Another French Kiss flake paint job. The twisting shapes are a popular retro design.

NON-FLAKE RETRO DESIGN (continued)

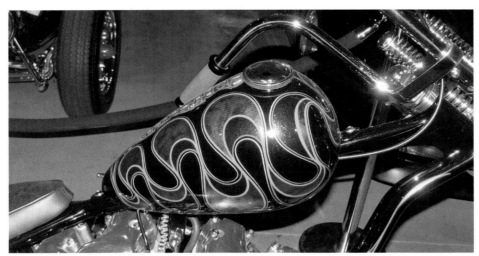

This chopper tank features a stacked curve design.

Here are two very retro chopper tanks. One tank features scallops, ghost shapes, and even straight line fades. The other has two layers of twisting shapes. Bikes from XsSpeed.

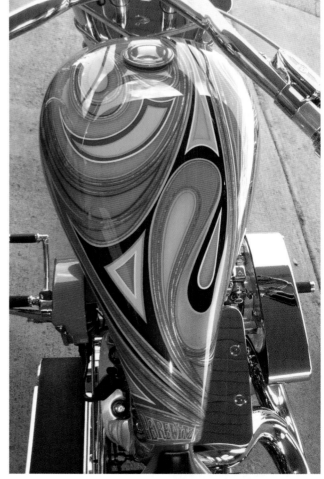

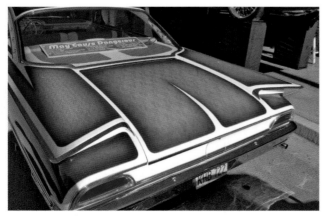

This 1960 Ford Starliner has lace panels that make the most of the car's design. Check out those fins!

Now for some flakeless retro paint. This Perewitz chopper features a wild design straight out of 1970.

Look closely at the lines down the center of this hood. Endless lines was a popular paint technique back in the day. They are usually done one of two ways. They can be taped off and sprayed. Or fine line tape can be laid out and the paint sprayed *along* the tape edges. Once the tape is removed, the taped-off area becomes the stripe.

This cover features twisting shapes over lace panels. Note the way the shapes layer over and under the paneled sections. Paint by Andy Anderson. Although it looks complex, this design uses the same techniques explained in this chapter. If you're doing layered twisting shapes, be sure to shadow where one layer crosses another.

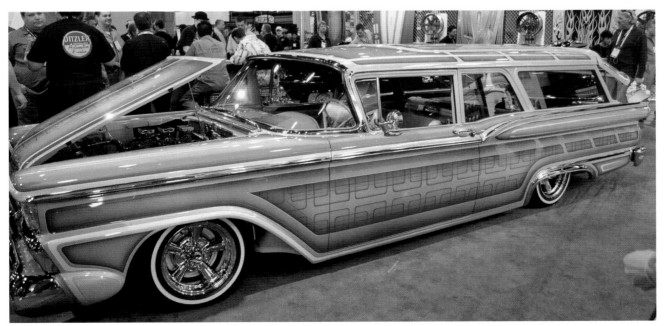

Retro paint gives this station wagon some serious style.

Chapter 8
Lowrider and Flake Paint

Lowrider graphic paint features many paint techniques, such as metalflake, gold and silver leafing, panels, detailed striping, sunbursts, fades, water drops, and lace. These elements are put together in a way that is dramatic and, at times, over-the-top spectacular. And that bold look is what gives lowrider graphics their unique style.

While lowrider paint can feature airbrushed murals and freehand striping, this chapter will focus on the graphic aspects of this style of custom paint. At first glance, lowrider paint designs seem complex, overwhelming with detailed lines. But if you look closely and break them down into sections, the designs are simpler than they appear. Lowrider paint is all about lines and shapes—lots of straight and curvy lines.

As with any graphic paint style, find examples of the style that inspire you. Print them out and use them for inspiration for your design when drawing. Study the various elements of lowrider style. One of the great things about this style is that it mixes together so many different techniques.

Lowrider style involves some of the more time-intensive paint jobs. Know that this will require more time than flames, retro, or other kinds of graphic paint. Be patient and don't hesitate to walk away and take a break. Carefully plan out your colors. Most lowrider paint jobs stick with one color family . . . "cool" colors like blues, purples, and greens or "hot" colors like oranges, reds, and yellows/golds.

For the step-by-step example in this chapter, we'll be painting lowrider graphics on a 1972 Chevelle trunk lid. For this project, the silver flake is mixed with urethane clearcoat. For the artwork colors, I'll be using House of Kolor Kandy Koncentrates: Oriental Blue

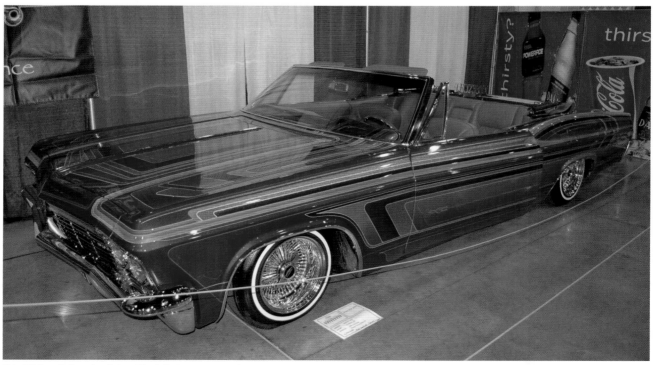

This '65 Impala is a classic lowrider. It features spectacular paint by legendary lowrider painter DannyD. Intricate paint design and the techniques are what make lowrider paint so distinctive.

KK-04 and Cobalt Blue KK-05. To deepen the shadowing and the fades, a little black basecoat will be mixed in. The two blue candy tones will alternate with each section and stripe in the design: Cobalt Blue for one section, Oriental Blue for the next, and so on.

Keep in mind, this is just one style of lowrider paint. There are many more, but this should give you a good idea of how to apply the various layers most lowrider paint uses. And while this example is done on a topside flat surface, the taping, masking, and artwork techniques can be used to create graphics on an entire vehicle.

MATERIALS AND TOOLS

PPG Deltron Metallic Silver Basecoat #908418
Paint the Huffer Silver Bullet .015 metalflake
PPG Deltron DBC500 color blender
PPG Deltron DCU2021 DCX61 catalyst
PPG DT885 reducer
House of Kolor KK04 Oriental Blue Kandy Koncentrate
House of Kolor KK05 Cobalt Blue Kandy Koncentrate
House of Kolor KC-20
FBS ⅛-inch orange fine line tape #48410 ¼-inch #48420
FBS ⅛-inch green fine line tape #48510, ¼-inch #48520
FBS ¼-inch red fine line tape #48485
3M 218 fine line ¹⁄₁₆-inch #06306, ⅛-inch #06300,
 ³⁄₃₂-inch #06308, ¼-inch #06301
800 DA paper
Basting spray
Tracing paper
Lace
Mesh bag
SATAjet 100 BF HVLP Spray Gun
SATA mini jet 4400b Spray Gun
SATA 20B Artbrush
Iwata Eclipse HP-CS Airbrush
Badger Omni 4000 Airbrush
X-Acto #11 Knife
Trulers measuring tools
Dual-action sander
Dot magnets

LOWRIDER PAINT AND METAL LEAF

A common element in lowrider paint is gold, silver, and variegated metal leaf. It is used as one of the main features of the paint and/or in the striping.

The trunk lid was painted with two coats of PPG Deltron Silver basecoat followed with four coats of Paint the Huffer Silver Bullet flake mixed with catalyzed urethane clearcoat. Four coats of urethane clear were sprayed on after to help level out the flake. See chapter 7 for more information on mixing and spraying metalflake paints.

If this is your first time painting the lowrider style, keep the design simple. If the design is for a flat surface where both sides will be mirror images, start by drawing a line down the center of the paper. Note how the design is drawn on the left half of the paper.

To draw the mirror image of the design, I fold the paper along the centerline and flip it over. Using a lightbox or a window, I can see the design and trace it onto the other half of the paper.

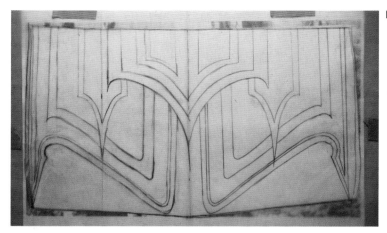

Here is the finished design.

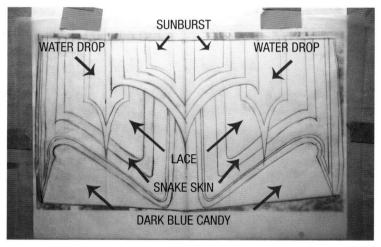

SUNBURST

WATER DROP

WATER DROP

LACE

SNAKE SKIN

DARK BLUE CANDY

Plan out the different effects that you want for the various sections of the graphic. I've chosen water drops, a sunburst, snakeskin, and lace. There will also be fades and candy smears in the narrow-line areas of the graphic.

The trunk lid is sanded using a DA sander and 800-grit paper and wiped off with KC-20. Tape off the centerline of the panel. Then, start transferring your design to the surface. When working on a vehicle, use reference points such as body lines or taillights. Lay out the initial line or shape and build off that by using different sizes of tape.

SPRAYING METALLICS

Remember to change direction each time you spray a coat of metallic. One coat back and forth, the next up and down, then spray a coat diagonally. This will help avoid streaks or tiger stripes.

TRANSFERRING DESIGNS

How do you get the design from the paper to the surface? Some painters will draw out the design directly on the surface, while others will just start taping while using the drawing for reference. Other painters will create a pattern the same size as the panel.

Some painters will run a pounce wheel over the lines of the pattern, then place the pattern on the panel. Chalk dust is put in a cheesecloth bag and dabbed on the holes of the drawing. The powder is forced through the holes, leaving an outline on the surface. Another method is to flip the pattern over. Then the design is traced on the underside with a pencil. The pattern is then placed on the surface and the painter traces the long the lines. The pattern acts a carbon copy, transferring the drawing to the surface. This is the method I use. Just be sure to check for leftover pencil lines once the drawing is taped off.

TRULERS

Trulers are magnetic and stick-on measuring tapes that come in very handy when laying and taping off graphics. They come in various widths. Their right-angle L tool is magnetic and 1 inch wide. It was used throughout the layout in this chapter.

For sections such as the hood and trunk, lay out the design on one side first. I start by taping off the main sections of the design, beginning with the square shape on the upper right. I use a right-angle Truler to check the 90-degree angle of the lines.

Here I'm taping off the dagger section on the right side. I'm going to use a little trick to help make the curves on both sides of the dagger the same.

Place a piece of paper on the curve you want to duplicate and trace along the edge of the tape.

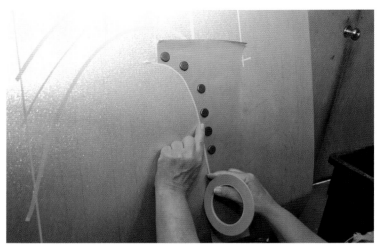

Cut out the curve and align the paper on the other side of the section where you want the curve. Tape it or use magnets to hold the paper in place. Now run tape along the curve.

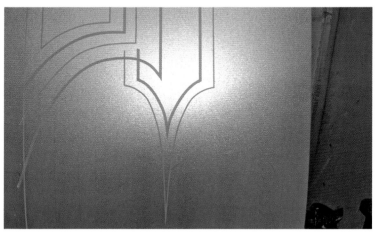

Here's the dagger section with curves that match. I use this paper technique to match all the curves to one another. Look closely and you can see the pencil lines for the design I drew on the trunk lid.

LOWRIDER AND FLAKE PAINT

WHAT TAPE TO USE?

Painters have different tapes they prefer to use for various tasks. Lowrider painters tend to use 3M High-Performance green masking tape. It bends easily and comes in many sizes. I prefer to use a combination of 3M 218 fine line tape and FBS vinyl tape as they leave a very clean edge. I like the way the 218 holds a straight line, but FBS vinyl tape is great for laying out curved lines.

106

The design is all taped off on the right side of the lid. Now, it needs to be reversed onto the left side.

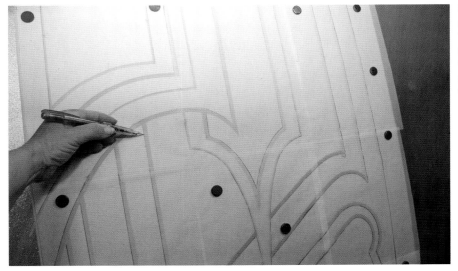

Cut masking or tracing paper to be the same size as the panel and place it over the design. Trace along one side of the tape. Keep track of what side of the tape you're working on, the inner or the outer side. Most of my lines are traced along the outward-facing side of the tape.

The tracing is completed. Make marks for reference points, like along the centerline and the edges of the panel to make it easier to line up on the opposite side.

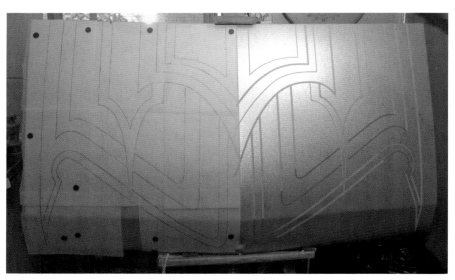

Line the design up on the left side and trace along the lines. This will transfer the pencil lines on the backside onto the surface.

Run tape along the lines. Laying out the tape goes much quicker on this side. Remove the centerline and connect both sides along the middle.

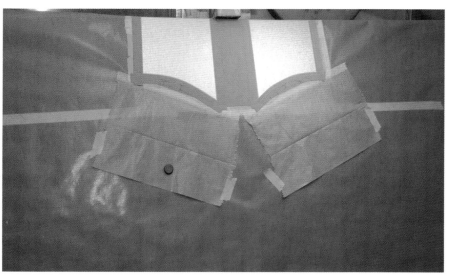

Work on one section at a time. Mask the graphics so only those sections are revealed. I'm starting with the two sunburst sections at the top.

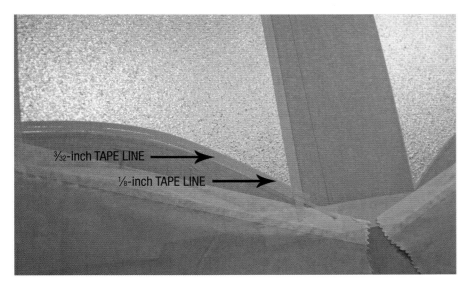

Once each section is masked off, the detail lines that border each section are taped off. Most of the sections will have three lines around them. One line is the already-taped line that outlines the sections. The other lines will be inboard of this line. Here, I want two lines added around the sunburst section. I lay down a line of 3/32-inch and a line of 1/8-inch.

3/32-inch TAPE LINE

1/8-inch TAPE LINE

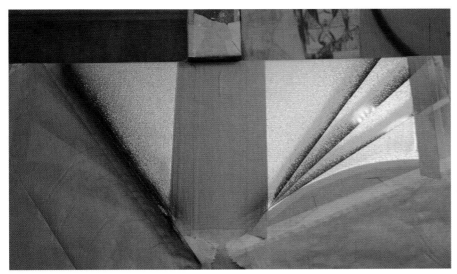

Lay down a line of tape on the lowest part of the section and spray a blue candy fade. The House of Kolor Kandy Koncentrate is mixed with clear basecoat. How much concentrate to use depends on how dark you want the color. I'm using the Oriental Blue. Then shadow with some very reduced black. The left side of the photo shows one line taped off and airbrushed. The right side shows the results.

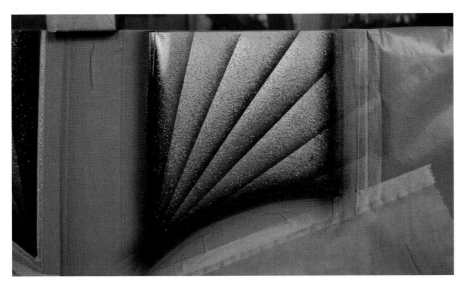

Work your way up the section doing the fade lines. Shadow the edges of the panel with blue and black. Here's a finished sunburst section.

The ⅛-inch tape line right next to the sunburst will be silver flake. This tape line needs to be trimmed in order to paint the ³⁄₃₂-inch line next to it. This mockup photo with fresh tape best shows how to trim the tape for the detail stripes. Where the tape lines cross, use the overlapping tape as a guide and cut the tape that runs under it and remove the cut end.

Now cut through the middle of the overlapping piece of ⅛-inch tape and remove that end.

This is what it should look like. It forms a clean corner for each stripe that will remain silver. This process will be repeated on each detail stripe that remains in place in order to paint the stripe next to it.

TAPE LAYOUT HINT

To help better understand the lowrider paint technique, look at the silver flake you see in most lowrider designs. All that silver was covered up during the artwork process. Unlike most graphics, lowrider graphics are kind of taped off backwards—like the negative format of a photo. Any silver sections or stripes need to remain covered or masked off throughout the paint process.

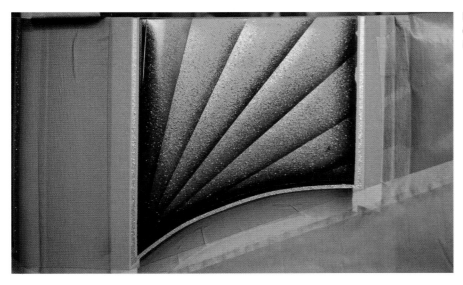

Remove the ³⁄₃₂-inch tape. When spraying detail stripes like this, always work from the inside outward.

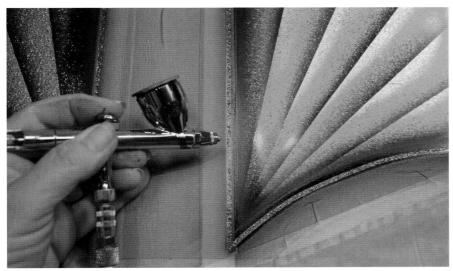

House of Kolor Kandy Oriental Blue is sprayed along the line.

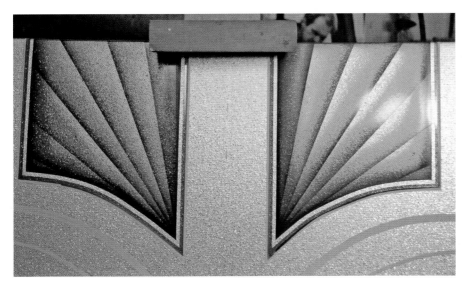

Here are the completed sunburst sections with the detail stripes. Note that the ⅛-inch tape that borders the section remains in place. *Make sure not the remove your initial tape,* as it will be the silver flake stripe that forms the outer border around each section.

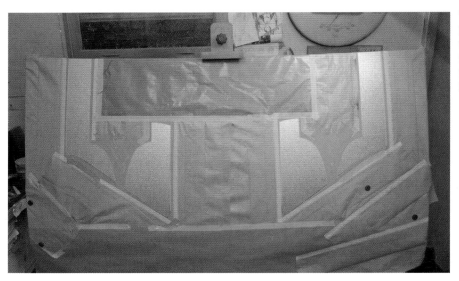

This process will be repeated for each section. Mask off the section, add the detail stripe tape. Paint the effect for the section. Shadow the edges. Trim the silver flake tape lines, remove lines of tape, and paint detail stripes. Next the lace sections are masked off.

Here, I add four lines of tape for the detail stripes.

Cut pieces of lace to fit those sections. Use magnets or tape to hold the lace in place when checking the sizing.

Remove the lace, flip it over, and the spray the lace with basting spray. This will help hold the lace in place. Let the basting spray dry for five minutes. Then, carefully place the lace on the panel. Gently press it down.

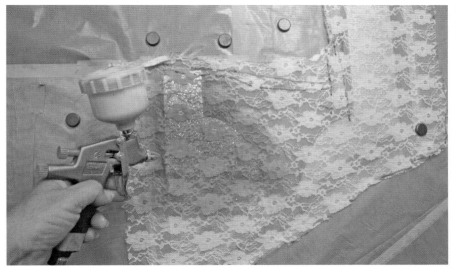

Softly spray the candy color over the lace. I'm using Cobalt Blue. Use a low air pressure. Here I'm using a SATAjet 20B Artbrush.

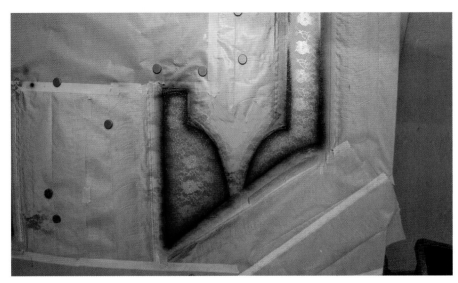

Remove the lace and once dry wipe the surface with a water-based cleaner like House of Kolor KC-20 to remove any basting spray from the surface. Check to make sure all the basting spray is removed. Blue and black are airbrushed around the edges. For more info on lace painting, refer to chapter 7.

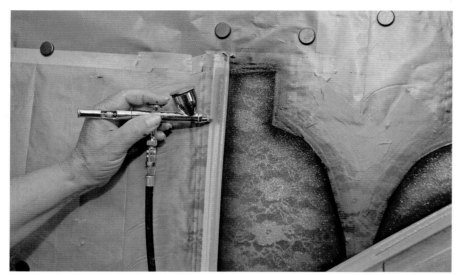

Now to spray the detail stripes around the inside edge of the section with Oriental Blue.

One stripe will be a dark Cobalt Blue, so I need to protect the lighter Oriental Blue stripe. Masking tape is placed over several of the stripes to keep the Cobalt Blue off that stripe. Then the 1/16-inch Cobalt Blue stripe is painted. And the detail stripe paint process is repeated.

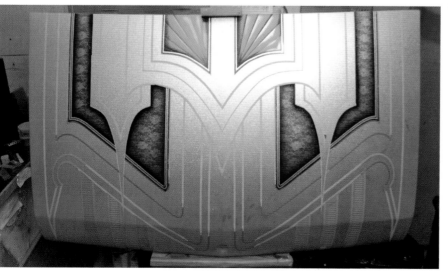

Two sections down and many more to go!

I'm going to do a candy wipe on the section around the sunburst section at the top of the panel. I mask off the section and lay down the detail stripe tape lines. The section is sprayed with several wet coats of candy Cobalt Blue. While the paint is still wet, I wipe across it with a microfiber towel, creating streaks in the blue.

The edges are then shadowed with candy blue. A black detail stripe is sprayed, and this section is complete.

Next, the border sections for the daggers are masked off. The completed sections are covered with masking. They will remain covered until the artwork is complete. These sections are marked with an X so that I know not to unmask them. I also mark each section to note which color has been or will be sprayed there. O is for Oriental, C for Cobalt.

This section will be a Cobalt-to-Oriental fade: Cobalt on the inside edge, Oriental on the outer edge. First, the Cobalt is sprayed.

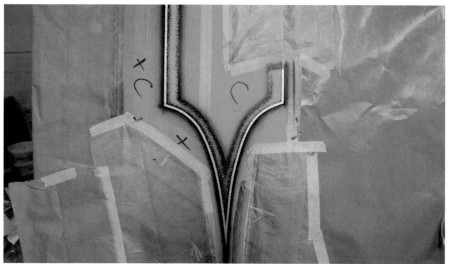

The Oriental Blue on the outer edge is sprayed along with the detail stripes. This section is complete.

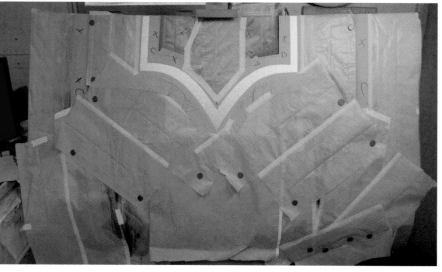

Now the section around the candy wipe section is masked off.

I lay down the tape for the detail stripes. Play around with stripe size and assorted colors. Mix it up.

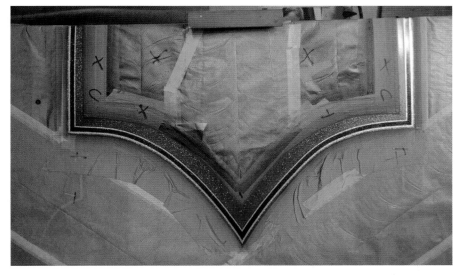

Oriental Blue is sprayed, and the detail stripes are done.

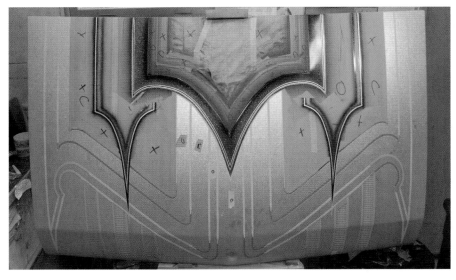

The lid is two-thirds complete. I plan out the rest of the colors and use tape to notate the color for each section.

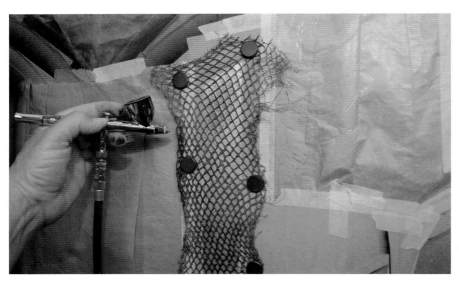

One section will be a snakeskin effect. I use the mesh bag from a sack of onions, stretch it out over the surface, and airbrush Oriental Blue over it.

The edges are shadowed; here is a closeup of the completed effect. Please note this photo was taken after the lid was finished.

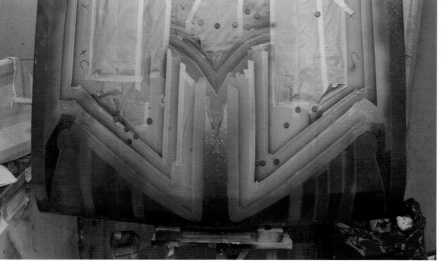

All but one of the sections have been painted and covered with masking. The unpainted section is also covered. Now to paint the actual background color of the lid. I start to apply layers of candy Cobalt Blue.

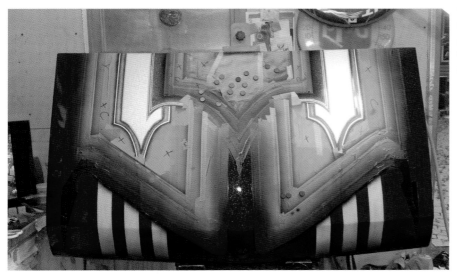

The tape is removed from the wide stripes at the bottom, and candy blue tones are faded into them. A black shadow is airbrushed along the bottom section. Now the principal areas of the dagger sections will be painted.

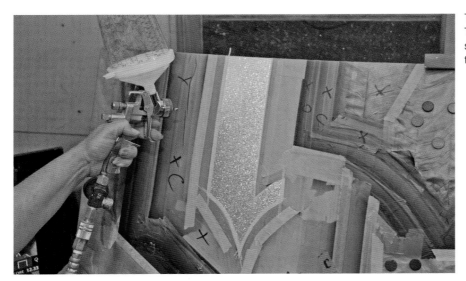

These sections will be a waterdrop effect. To paint the waterdrop effect, first spray the surface with clear basecoat. This will help the water to bead up.

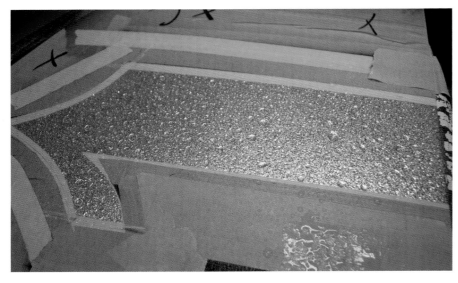

Lay the panel flat and spray water on the surface. Try for a mix of large and small drops.

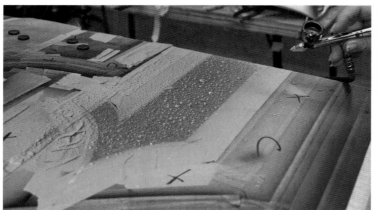

Use low pressure to carefully and gently spray the paint at the surface from a low angle. Do not spray the paint directly on the water drop area. You want the water to land on the side of the drops. Aim the airbrush or spray gun at the masked-off surface just before the revealed surface so that the mist from the paint lands on the water drops. The water drops capture just the overspray of the paint.

Let the panel dry overnight. All the water needs to be evaporated. Once the water's dry, spray several dust coats of clear basecoat over the waterdrops. Then spray a couple of light to medium coats to lock down the paint on the waterdrops. Then airbrush some of the darker tones along the edges of the section and paint the detail stripes.

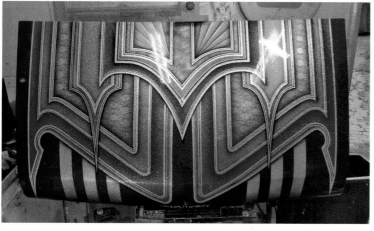

I remove all the masking and paint drop shadows under the dagger sections. Here's the finished result. It was sprayed with some pre-cleaner to show how it will sparkle once it's clearcoated. Don't be intimidated by the lowrider paint process. It's much simpler than it looks . . . it's just time intensive.

THE 3D EFFECT

One way to get more dimension when painting these graphics is to mix candy sections and solid color sections. While I opted to do all candy sections on this example, I could have painted some of the sections with solid colors. I also could have done one or more of the stripes with metal leaf. Mix it up and have fun with this paint style!

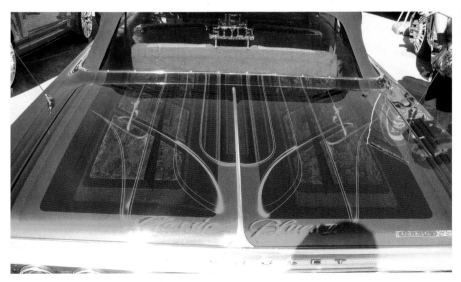

Here is a classic lowrider paint job. This car features paneled sections along with freehand striping.

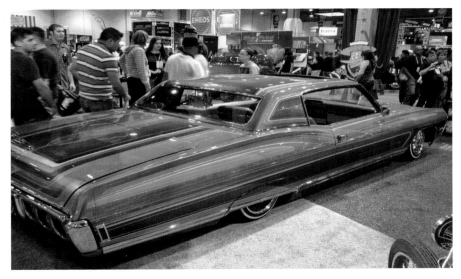

Gold and silver leaf are often used in lowrider paint, like on this gorgeous '68 Chevy. Custom work by DannyD.

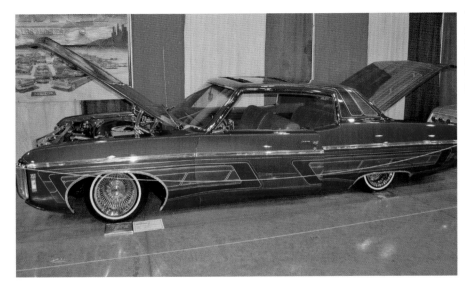

The incredible paint design on this 1969 Caprice makes a long car appear even longer. Effective paint design accents the features of a vehicle. The car was painted by lowrider paint wizard Sorel Knobler. Striping by DannyD.

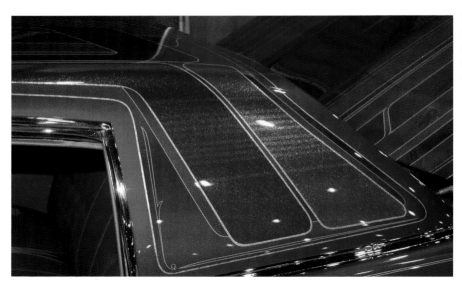

Here's a closeup of the sail panel. The metal-leaf pinstripe is so crisp. Check out the ghost striping on the candy flake panels. Painting subtle effects to sections of the graphic is an easy way to add detail.

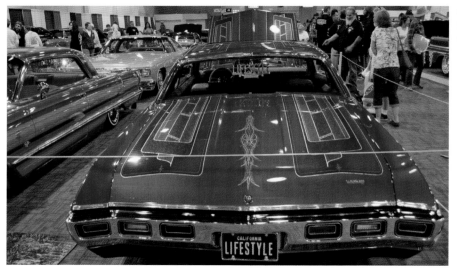

Another view of this wild car. Note how the metalflake panels add dimension to the overall design.

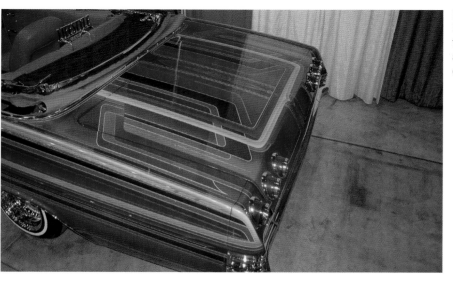

Layers upon layers of striping on this '65 Impala by DannyD. Note the red candy engine-turned gold leaf stripes. They're narrow but add even more dimension to the paint. Small details make a big difference in lowrider paint.

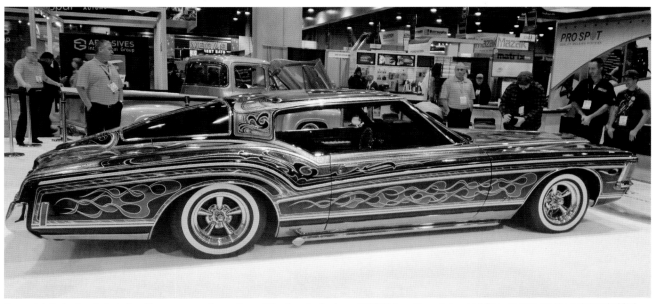

Super-detailed artwork, including flames, covers the surface of the Count's Kustoms 1973 Riviera. Ryan Evans and Gary Jenson are the painters behind this amazing creation.

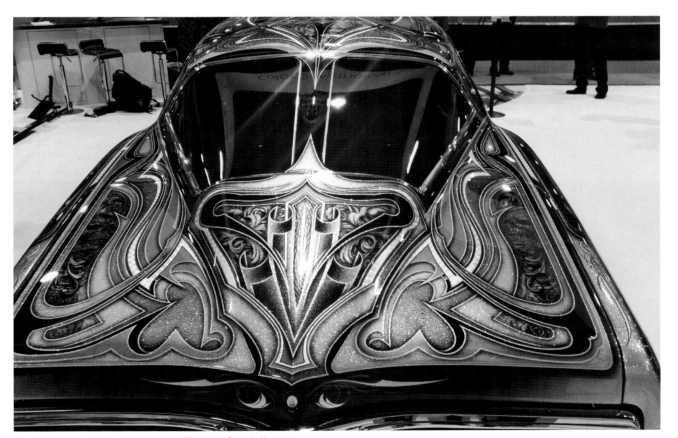

Just some of the exquisite detail on this Riviera by Count's Kustoms.

You don't need to have insane artwork to have cool lowrider paint. This Caddy is completely flaked with subtle artwork. Look how that trunk lid sparkles, even from a distance.

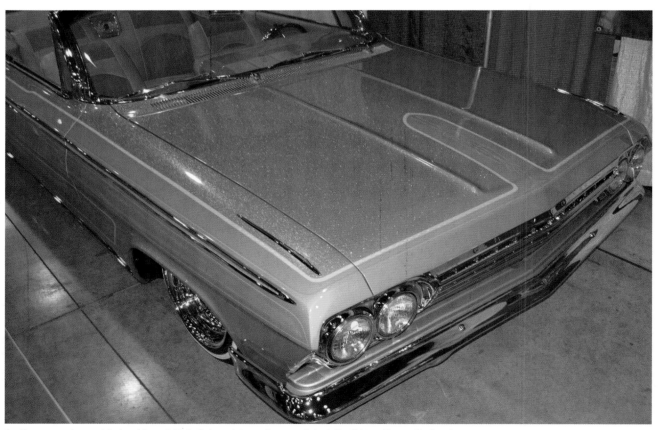

Another super-clean subtle lowrider paint job. Only certain sections are flaked, like this section on the hood.

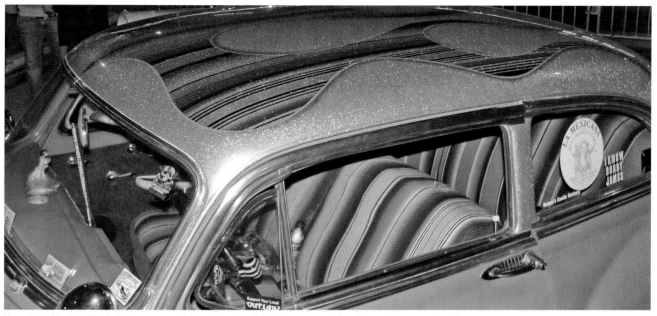

How about Mexican blanket flames on a rainbow flaked roof? The flames were done in candy tones and black.

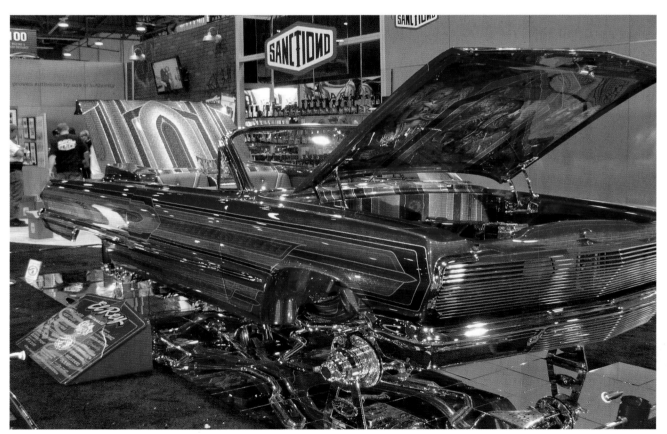

But most lowrider paint is over-the-top amazing. Every metal surface of this car is painted with extreme detail, even the engine compartment and frame.

Chapter 9
Pinstriping

Classic freehand pinstriping adds beauty to almost any paint job.

It would take a whole book to thoroughly cover the incredible art of pinstriping, so here's a crash course in this time-honored craft. Pinstripes are used throughout the custom paint process. Create simple or complex designs with freehand striping. Use pinstripes to split a two-tone or as borders around graphics or flames. Striping artwork also cleans up any ragged or uneven paint edges.

There are two ways to do striping: freehand and taped-off striping. Pinstriping can be done under clearcoat or over clearcoat. Basecoat or urethane striping enamels are used when the striping will be clearcoated. House of Kolor Urethane Striping Enamel pulls a smooth line and is easy to clearcoat over. It can also be used for stripes that are not clearcoated when mixed with KU200 catalyst. 1 Shot Striping Paint is a modified alkyd enamel and is popular striping paint. 1 Shot dries slowly and can be used under or over clearcoat. Alpha 6 Corporation is a new company that has an amazing line of striping paint and tools. Their paint is quickly becoming a favorite for freehand striping and lettering, as it's designed to pull a smooth line and dries in about an hour. Always read the product information for whatever paint used so you know exactly how to use it, how long it takes to dry, and what to reduce or mix it with.

SMOOTH THOSE EDGES

When possible, try to stripe over *cleared and sanded* artwork. Paint edges are never level. If you stripe over sharp paint edges, the stripe paint will settle into the edge and that sharp ridge might show in the stripe. Protect your artwork with urethane clear and have a nice, fresh surface to work on. This also allows for mistakes. Uneven stripes? Simply wipe them off with mineral spirits or wet sand them away.

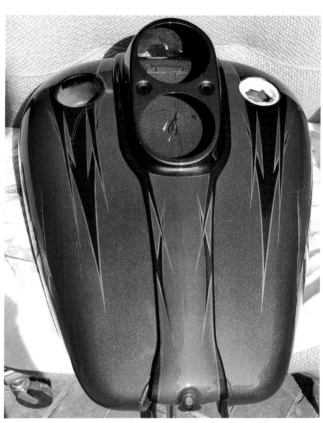

Before-and-after striping. These charcoal pearl graphics were incomplete before the gold pinstripes were done. Pinstripes give definition to paint designs.

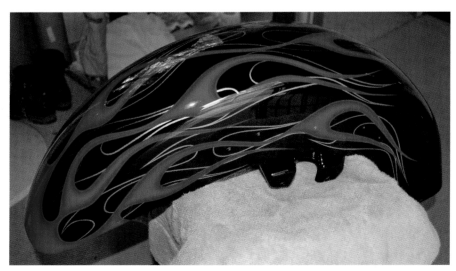

This fender features pinstripes as borders around the solid flames and as a second layer of flames.

FREEHAND STRIPING EQUIPMENT

Striping brushes come in two types: natural and synthetics. While natural brushes hold more paint due to the microscopic scales along the shaft of the hair, synthetics are said to be more durable and easier to clean. But most artists use natural brushes, most of which are made of squirrel hair. The most-used brushes are classified as 00 or a 000, depending on the desired width of the stripe. Most stripers use Mack Sword Striping brushes. Check out www.mackbrush.com and look over their extensive line of brushes.

Mack Brush's website is a library of information about striping brushes. Every striper will find the brush that works best for them. The two main kinds of brushes are swords and daggers. Swords have their longest hairs on the top and taper back to a short length on the underside or belly. Daggers are double-edged and come to a point and work well for small, curved work. But most artists use the swords. Costs of brushes range from about $6 to $30.

Each company has their own system of numbers for brush size. The bigger the number, the more paint it holds. For example, a Mack 00 is bigger than a 000. Most stripers trim and reshape their brushes. But too much trimming can take away the softness of the brush. Some stripers trim their brushes right down to the tip, taking about 1/32 off the tip, giving it a blunt shape rather than keeping the sharp point. Find what works best for you.

For this book, I spent time with two amazing pinstripers, Zac of Faulkenberry Designs and Ryan Young of Indocil Designs.

Zac has been striping for around five years and has become one of the top stripers in the Carolinas with his super fine line designs. But his lines didn't start out that way. It took countless hours of practice and patience. Do not expect good results without hours of practice.

One of Zac's favorite tools is a butter knife with the end cut off. He uses it to open paint cans and also to stir paint directly in the can.

See the two little hairs sticking off the very tip of the striping brush? Those will be trimmed off.

Zac uses a razor blade to trim off the two little stray hairs. Now the brush will provide smooth transitions when starting and stopping lines.

PREPARING THE PINSTRIPE BRUSH

A new brush always needs to be cleaned before it is used. Hold it under a stream of water and wash it out with dish soap. Then dry and oil it. To trim it, wet down the hair, run the brush between your fingers to shape it, and then lay it flat on a palette. Look for stray hairs or little nibs. Trim those off with a razor. Take care not to trim too much from the belly or midsection of the brush, as it will change the way the paint flows through the brush. The brush will leave dry stripes if there's too much hair at the tip. Zac seldom trims the belly section of the brush.

Zac explained more about how trimming the brush can improve the quality of the stripe line: "Trimming just a little bit off the end will give the brush the ability to turn tighter corners. Sometimes you have to stop a line and then restart it. A properly trimmed brush will have a smoother transition. I typically go back and rework the lines in a design, and if the tip of the brush is carefully trimmed, you won't notice all the places that were reworked." Once the brush is trimmed Zak oils the brush with Kafka Design Brush Oil. Use an oil made for striping brushes.

STRIPING BASICS

Palleting the Brush

Loading paint into the brush is called palleting. It determines how the paint will flow off the brush and onto the surface. Proper palleting is all about consistency. You want the paint to flow smoothly off the brush, not too slick or the brush will not hold a smooth line. Not too dry or the brush will grab the surface. You can feel the brush glide over the surface while holding onto the surface, like sticky tires on a curvy road. Once you learn how to pallette the brush, it's all about practicing your strokes.

There are two ways to pallette or load a brush. The first way uses posterboard or glossy magazine or catalog pages. Dip the brush in the reducer, then in the paint, and brush it back and forth on the surface. You're looking for a certain amount of drag. If it is too dry, dip it in the reducer and repalette. You want consistency. Paint not dripping off the brush but pulling easily out of the brush, leaving a smooth line.

This Alpha 6 Easel Pallett clips pallete materials in place and has six cups to hold paint. Zac uses disposable nonwax paper cups as cup liners. Cat food cans or cut-off bottoms of drink cans also can be used to hold paint materials. Have two tins to hold solvents. Fill one with thinner or mineral spirits for cleaning brushes, the other with reducer.

Zac palettes his brush by dipping it into the paint and transferring it onto the posterboard surface. He does this several times, then wipes the brush back and forth across the surface until the brush is fully loaded with paint.

Then he wipes the brush across a fresh section of surface, evening out the load of paint on the brush. Note how he steadies his right hand with his left. It's one of Zac's main tricks to even striping, keeping his striping hand steady by supporting it with his other hand. It's become automatic.

The second method of palleting, and the one Ryan uses, is to use his fingers to load the brush. Dip the brush in the paint, then in the reducer and pull the brush through the forefinger and thumb until you feel the paint consistency you want. Ryan likes the added control to form the bristles, as it is being palleted. Once the brush is loaded, start striping.

Practicing the Strokes

Learning to pull a straight line starts with running a tape line down the length of piece of posterboard. Then find a comfortable position with the brush and start striping a line alongside the tape line. The tape acts as a guideline. Note how Zac is holding the brush while steadying his hand on the surface. You want your hand to be in a locked position or motion, using your finger as a guide.

Next, practice striping curves. Zac supports his hand by placing a finger on the surface and pivoting the brush around it.

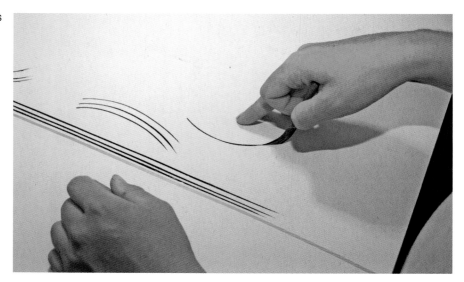

Zac creates a design using the practice strokes. Most of the time he's striping, he supports his striping hand to steady it. Practice lines on posterboard or test panels. Learning proper paint consistency and line quality is essential for successful pinstriping.

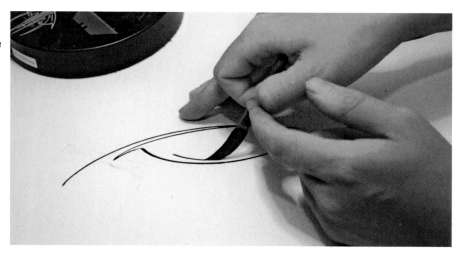

Continue to run lines alongside the first line. Your lines won't look like this on your first try. Be prepared to spend hours doing these exercises until you get even, straight lines.

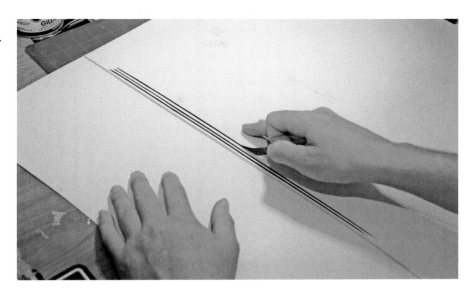

Now start running the lines together at the top or bottom of the stroke.

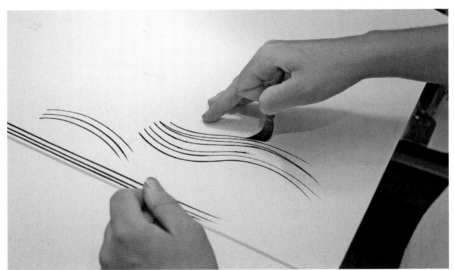

NO FEAR

Beginners are often intimidated by trying to get that line as smooth, straight, and as perfect as a piece of tape. Not true. Part of the lure of freehand striping is that it is done by hand. It is a craft and as such is not perfect. Try to concentrate on design strength rather than putting down that perfect line.

PINSTRIPING

133

Find the Best Striping Position

The more comfortable you are while striping, the better your stripes will be. When your arms are in an awkward position, they tend to shake, or their movement is not the smoothest. When possible, move your project so you can pull the brush at an angle that's comfortable for you. But that's not always possible. So just like you practice the strokes, practice your striping angles and find a way to angle your body and/or use a mahl stick to support your striping hand.

Zac explains, "Most of the time when striping on cars or trucks, you're going to be working on a vertical surface, so get used to it in advance and find a technique that works for you. Find a panel or something to hang sideways, mimicking the side of a car. And then do your practice strokes on that. Work your body and find a

striping position that's comfortable. Practice this until you feel comfortable with vertical striping."

"Same thing with striping direction. Practice changing the direction you stripe. Sometimes you have to stripe in different directions. So, get used to these situations by practicing in advance."

FREEHAND STRIPING A DESIGN

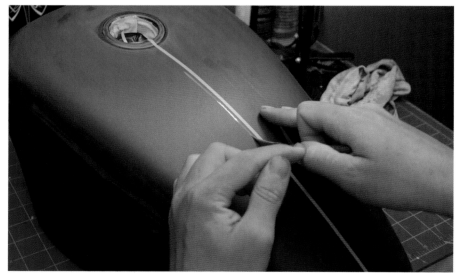

Zac starts a three-color freehand striping design by running a ⅛-inch tapeline down the center of a bike tank. This will serve as the midpoint of the design. Zac starts with teal using a 000 Mack Sword Striping Brush and 1 Shot enamel. He stripes about ⅛ inch away from the left side of the tapeline, pulling a line down the length of the tank.

Once the first line is run, he starts a small line at the top of the first line. Then he runs a curved line off that. Next, he starts running a new line toward the bottom of the first line.

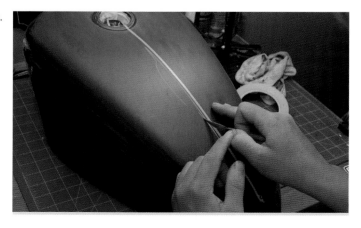

Then it's just a matter of running short lines off the preceding stripe. You can always predraw your design using a Stabilo pencil, but Zac tends to create as he goes.

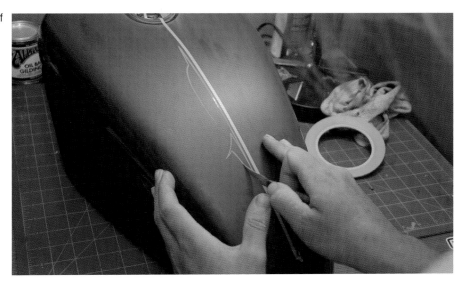

The left side of the design is complete. Now he can start working on the right side of the design. It starts off the same way, with a line running alongside the tapeline.

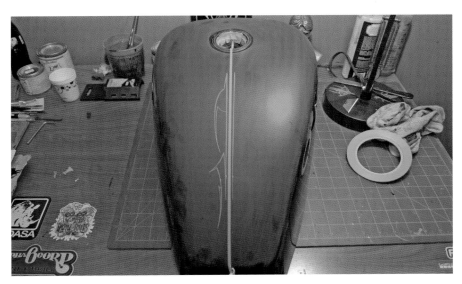

It's easy to remove a mistake when pinstriping. Zac wraps a cotton cloth around a squeegee, dips it in mineral spirits, and wipes away any flaws or lines he doesn't like. Use care when doing this. Make sure to completely wipe away the unwanted paint. Don't leave any ghosted bits of smeared paint behind.

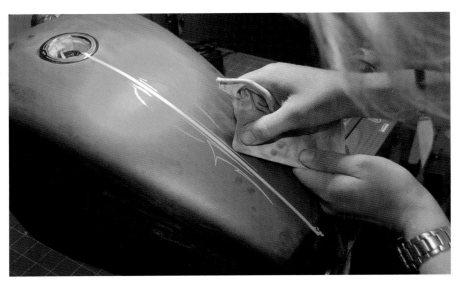

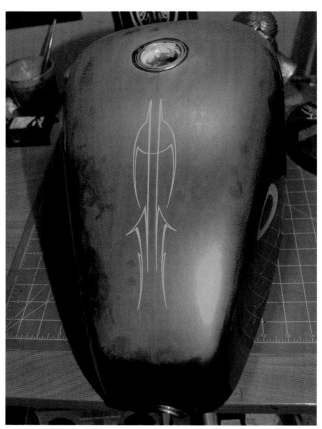

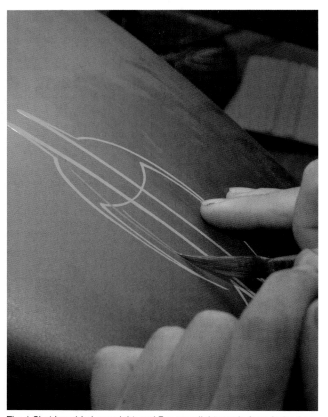

The tapeline has been removed and Zac striped a curved line that connects the two sides. He'll let this first color dry completely before striping the next color.

The 1 Shot has dried overnight, and Zac uses light purple from Alpha 6 as the second stripe color. He lines up the brush under a corner of the teal and pulls a curved line, then pulls a shorter line next to it, connecting the two lines at the bottom.

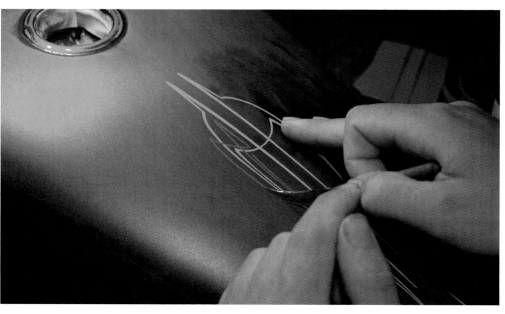

Next, he paints a line that matches the curve of the teal horizontal line. Zac continues to build the purple lines by painting a line that matches the curve of another teal line.

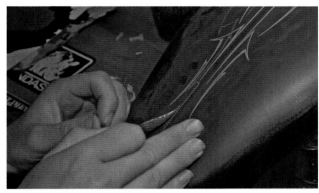

Line by line, Zac builds the purple part of the design. Use that approach when striping freehand designs. Build your design one line at a time.

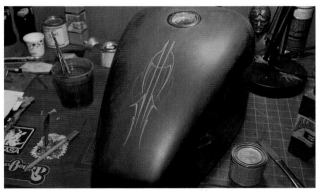

The purple stripes are matched on the right side of the design and the second color is complete.

To help pick the third color, Zac tests three different shades of lime green against the other colors. He applies three tiny dots of various lime greens directly on the tank near the design, but in an area that can be cleaned off. He picks the top color and cleans the dots off the tank.

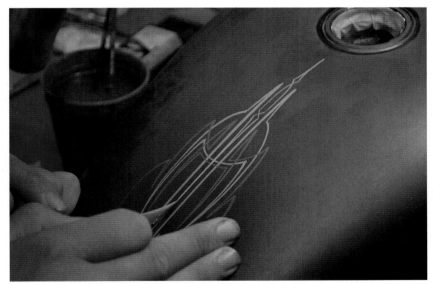

The middle area of the design will be used for the green. Zac starts at the top with a little arrow design. The lines twist twice and then run together. This long lime-green line will slenderize the design. The last color is usually the thing that gets complicated. Be patient with the last color and be prepared to wipe away flawed lines and start over.

ZAC'S TIPS FOR STRIPING

- Don't stripe too fast. If you start pulling the brush too fast, you might get ahead of yourself. Give yourself time to think as you stripe.
- Once you learn how to pull a consistent line, the brush will do most of the work for you. Learn how to work the brush.
- Wipe away mistakes with mineral spirits. You can also use mineral spirits to thin 1 Shot.
- The first side of the design is easier than the second side. Take your time when striping the second side of the design.
- Paint consistency is everything.
- It's all about the angle when you stripe. If possible, move things so that they are at a comfortable angle. Your hands will move smoother.
- Striping designs are just a buildup of lines to fit the space.
- Learn how to work your design to hide any mistakes.

FREEHAND STRIPING A DESIGN (continued)

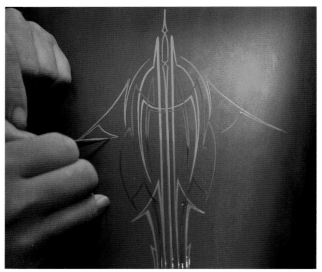

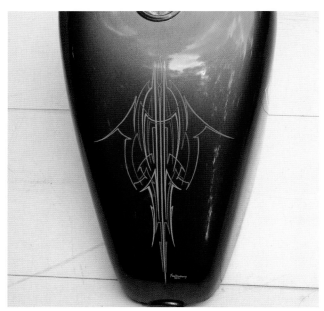

To work some green into the outer part of the design, Zac matches a curve in the teal design and starts to build new lines. Look closely and you can see a darker green fade at the top of the green lines. Zac ran the brush through the lime green, then dipped the tip of the brush in a darker green, and then started running the line.

And here is the completed design. When Zac started the design, he had no idea what the final result would look like. He makes it up as he goes along, connecting line to line.

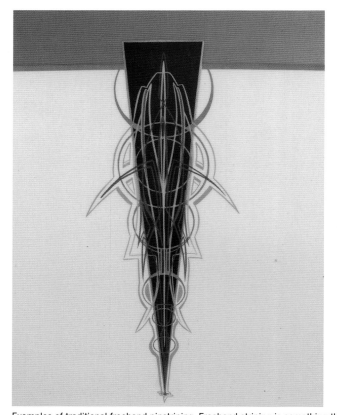

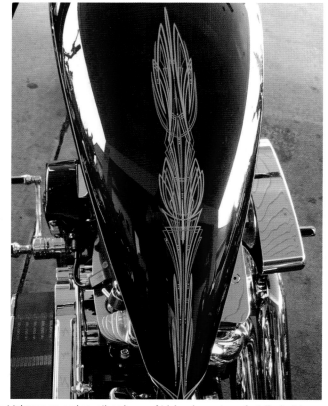

Examples of traditional freehand pinstriping. Freehand striping is something that takes years and countless hours of trial and error to perfect. Each striper develops their own distinct style.

Freehand Striping Over Graphics

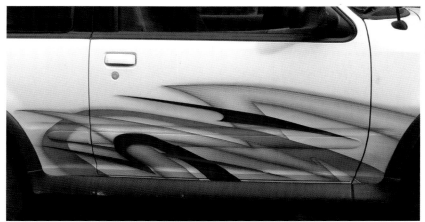

Here are some graphics on a Ford Explorer, but something is missing. Striping will help bring these layers to life. Ryan Young agreed to freehand stripe these graphics.

Ryan mixes a custom yellow from three different stock yellows that stands out against the orange. The yellow stripe shows up great against the yellow/orange graphic. Unlike a helmet or a motorcycle part, you can't adjust a vehicle to get a comfortable striping position. So, the striper must position their body so they can relax and concentrate on the stripe. Cardboard is laid on the ground and Ryan stretches out on it to stripe this bottom area of the truck.

A custom lime green is mixed up to stripe the blue with. Note how Ryan is using his pinky against the surface of the truck to steady his hand and act as a guide. His other hand also helps to keep his striping hand steady.

Freehand Striping Over Graphics (continued)

A custom purple mix is used for the dark purple stripe. See the way the brush twists as the handle of the brush is rolled as it goes around the curve? To stripe some curves, Ryan rolls the handle as it moves through the curve.

The finished result. What a difference the striping makes.

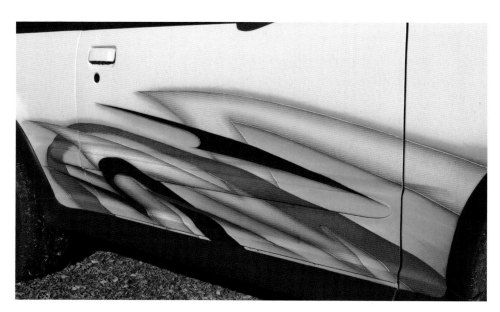

POSITION IS EVERYTHING

Note how Ryan has the helmet on its side so it's in a comfortable position to stripe. Always try to find a striping position where you're at ease, so you can relax and concentrate on pulling a clean line. Ryan is striping a free-floating line on a helmet. There is no graphic or flame line to use as a reference. Half-inch masking tape is run around the helmet just below where the stripe will be. Leave about a $\frac{1}{32}$-inch gap above the tape. Start your stripe, keeping the pressure steady and smooth, pulling the brush across the surface. Ryan supports his striping hand with his other hand, pulling both hands across the surface.

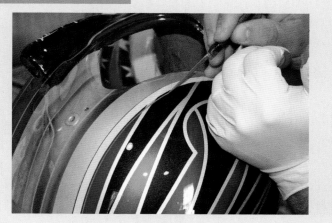

TAPED-OFF STRIPING

Not everyone can freehand pinstripe. But if you can lay out fine line tape, you can stripe two tones, graphics, and flames. It takes longer, but the end result is a smooth, even stripe. You can use a stripe brush to apply the paint between the lines of tape or you can spray it with an airbrush. Airbrushing the stripe will have less of a paint edge than brushing on the stripe, but it takes longer as there's much more masking to be done.

Taped-off Striping a Two-tone

To separate a two-tone, use fine line tape to lay down a line between the two tones. Here a ¹⁄₈-inch 3M 218 fine line tape divides the two colors. Use whatever width of fine line is needed for the stripe.

Run a second line of fine line tape along one side of the first tape line.

Then repeat on the other side of the first line. There are now three lines of tape.

Taped-off Striping a Two-tone (continued)

Remove the first tape line and mask off the rest of the panel. Then spray the desired stripe color with an airbrush. Here I'm spraying PPG DBC9700 black basecoat.

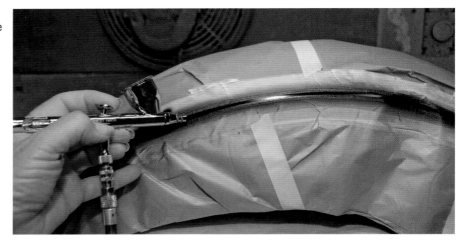

Here's the finished fender in clearcoat.

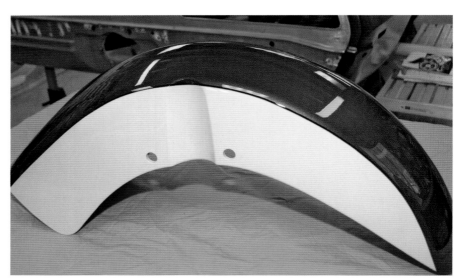

Here's our Dodge panel truck project. We need to stripe the flames and the two-tone.

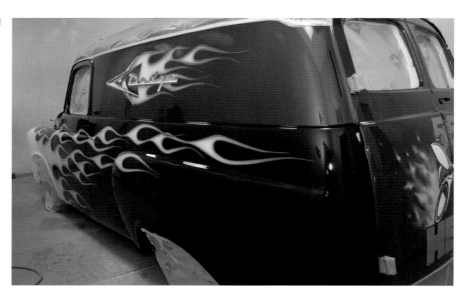

Quarter-inch 3M 218 fine line tape is run along between the two colors. It was tricky getting that tape line straight on that long truck as the sides had a slight curve. See chapter 3 for hints on taping long lines. A ¼-inch 218 tape line also was run on both sides of the first line of tape.

The first line of tape is removed, and the stripe is masked off. Look how long that line is!

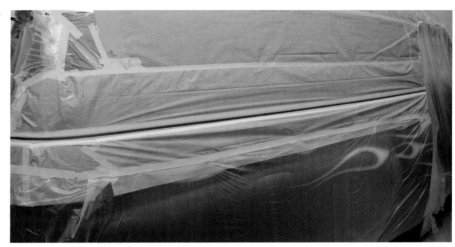

Purple basecoat is sprayed along the line. Spray enough to get good coverage but not too heavy. Keep the paint edge thin. Remove the tape and masking when the paint is dry enough to cut cleanly from the tape, but not dry enough to be brittle and break.

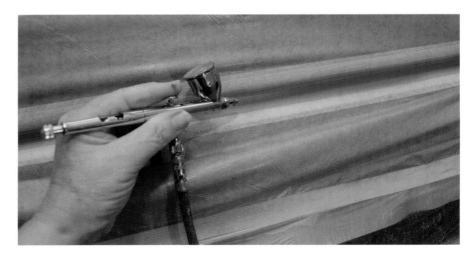

USING STENCIL TAPE

When striping on a flat surface like the side of a car, stencil stripe tape is a real time saver. Finesse Striper tape is easy to use. Pick the stencil tape with the size of the stripe you want, apply the tape, pull up the protective clear film to reveal the surface, paint over the revealed area with your stripe brush, and then pull up the stencil tape. For more information, go to finessespinstriping.com.

Tape-striping Flames

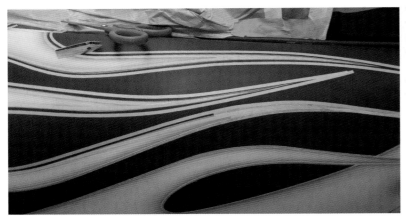

We repeat the process on the flames of the Dodge truck. Tape-striping flames takes time. The process is seen here in this photo. The bottom flame lick shows ⅛-inch fine line tape along the flame edge. The next flame lick up has fine line tape run on each side of the ⅛-inch tape. The ends of the inner tape lines are trimmed to a point at the end of the flame. The top flame lick shows how the outer tape ends are adjusted to form the tip of the flame stripe.

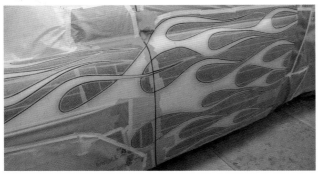

The surrounding areas are completely masked off using FBS K-UTG Gold Tape. Refer to Chapter 5 for more on this masking method. This was a lot of work but well worth it. Next, purple basecoat is airbrushed.

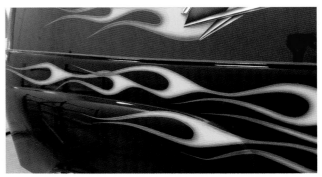

Here's a closeup of all those hours of taping and striping. Both the two-tone stripe and the flame stripe look great!

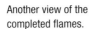

Another view of the completed flames.

ALLOWANCES FOR LENGTH

Remember, stripes will add length to your flames. Take that into account when you're painting flames that will be striped later.

The blue pinstripe makes these hot rod flames really pop against the dark pink pearl basecoat.

Before and after striping: Flames Edition. Solid flames look good, but adding pinstripes around the flames can give them more dimension and definition.

FINAL FINISHING AND CLEAN UP

House of Kolor recommends doing the final wipe down with their water-based KC-20. Solvent-based precleaning wash products might affect or even remove the artwork.

Never apply heavy or hammer coats of clear over your striping. The weight of the clear can literally drag down the stripe. Spray a light coat of lockdown clear for your first coat. Refer to chapter 14 (Clearcoating)

for more information. Cleaning the brush is very important. Rinse the brush in the lacquer thinner, acetone, or mineral spirits until no paint comes out. Then dip it in mineral oil or an oil made especially for striping brushes, such as Kafka Design Brush Oil. The oil keeps any remnants of the paint left in the brush from drying up and helps the bristles retain their natural oils and shape.

A FEW MORE EXAMPLES OF STRIPING

This sweet, one-color design is located at the very front of a hood. A small, very effective detail.

A wild stripe design from Ryan Young. The gold and cream color stripes are bold and work well together. The thin dark-red stripe is subtle and ties the design into the black base color.

You don't have to get crazy with striping to make a statement. This simple design goes great with the stock paint colors on this bike.

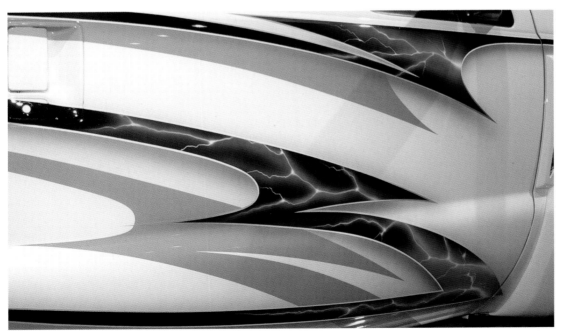

Check out the way the striper faded the colors on the border stripe around this lightning graphic. The stripe gives a 3D look to the graphics and makes them pop off the surface.

Chapter 10
Gold and Metal Leaf

Metal and gold leaf may seem intimidating. But with a little patience and some insider tricks for working with the materials, doing metal leaf work can be fun. A key step for success is to have all the tools and materials laid out and ready. Well-done metal leaf is all about timing.

LEAFING MATERIALS

Several metal leaf materials are available. Variegated metal leaf is the easiest to use. It has a gold appearance, but it is streaked with various color effects depending on the main color. Red, black, blue, and green all provide unique effects. The sheets of leaf are easy to handle. This kind of leaf is a good choice for beginners.

MATERIALS AND EQUIPMENT

Speedball Mona Lisa Variegated Black Metal Leaf
 (Any color or kind of leaf can be used.)
Speedball Mona Lisa Leaf Adhesive Size
HOK AP-01 Adhesion Promoter
1/8-inch 3M 218 fine line tape
1/8-inch and 1/16-inch FBS ProBand orange and green fine line tape
3/4-inch masking tape

Squirrel hair lettering brush
Scissors
Tracing paper
Steel ruler
Piece of velvet cloth

No other material in custom painting has the distinctive look of metal or gold leaf. This is variegated metal leaf.

Real gold leaf is a little harder to work with. It comes in smaller booklets and the sheets break much more easily than metal leaf sheets. It will take a few practice tries to get the hang of using real gold leaf. Silver leaf is very much like metal leaf in that the sheets are larger and easier to handle. Whatever kind of leaf you're using, keep in mind the amount of leaf that will be needed for practice. A booklet of leaf will go a long way when working on smaller projects.

Leafing "size" is a glue-like material that is brushed on to the surface you want the leaf to stick to. There are two kinds of size used for custom paint, oil-based and water-based size. Oil-based is ready for leaf application in about one to two hours and remains tacky for one to two hours afterward. Water-based size is ready for leaf as soon as it dries clear but can remain tacky for twenty-four or more hours. For the example in this book, I'll be using a water-based size.

APPLYING THE LEAF

For this step by step, I'm applying a variegated metal leaf design on the sides of a motorcycle tank. Metal leaf comes in several colors—green, black, blue, and red. The tank I'm using is painted with black basecoat, clearcoated with urethane, and sanded with 800. I'll use black metal leaf on it.

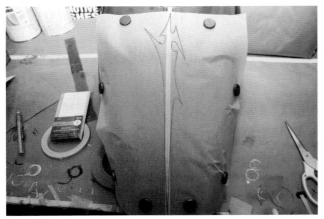

I start by drawing the design on a piece of tracing paper on the tank. Once I have a design that best fits the space, the tracing paper is flipped over, and the design is traced on the back of the paper with a pencil.

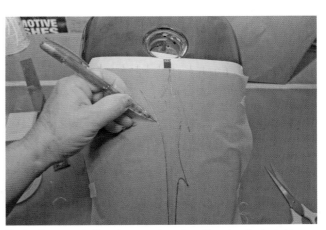

The tracing paper is flipped over again and positioned on the tank. I trace along the lines. This transfers the design to the surface of the tank.

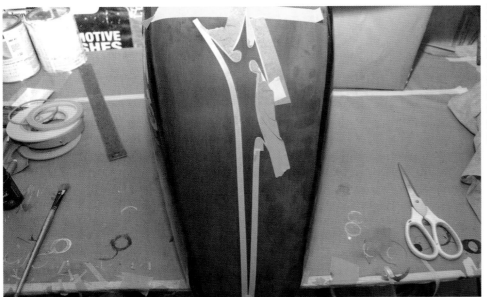

Next, the design is taped off. I use 1/16-inch where the lines have a sharp curve. The fine line is bordered with 3/4-inch masking tape. Next, cut the metal leaf into pieces that will fit onto the design. The leaf tears very easily. Sandwich a sheet of leaf in between two pieces of tracing paper and cut it into strips that will fit the space where it will be put.

APPLYING THE LEAF (continued)

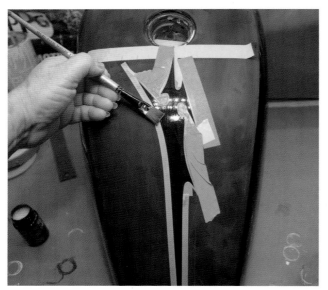

Read the instructions for whatever brand of adhesive size you're using. I'm using Speedball Mona Lisa size. A thin, even layer of size is brushed on. Don't let the size puddle. When finished, wash the brush immediately in soapy water. As the adhesive dries, it will change from a milky white to clear. When it is completely clear, it's ready for leaf application. The Mona Lisa size takes about a half hour.

The size has reached the perfect level of tackiness and I have removed the tape. Use precleaner to remove any size that has snuck past the tape.

Now here's the tricky part. Hold up the leaf above where it will be placed, let the bottom sheet of paper drop away, and place the leaf onto the surface. Make sure no fan is on. Any air movement will blow the leaf sheet around.

DUC'S SIZE

One of the most popular sizes painters use is Duc's Quick Dry Gold Size. It's available on Amazon.

GAPS IN THE LEAF

There are usually gaps in the leafed surface. It's easy to remedy that. Just pull off the leaf that didn't stick, and if needed, dot those areas with size, allow to dry, and then carefully add bits of leaf in those areas.

Smooth the leaf on the design surface by softly smoothing the tracing paper on the leaf. Don't press too hard. It tears quite easily. You may want to use a piece of velvet to smooth the surface and burnish the leaf onto the surface. But I always start working on top of the tracing paper.

Wrap a piece of velvet cloth around a fingertip, and gently but firmly smooth down the leaf. Keep smoothing back and forth, removing any loose leaf. Now, there will be places where the leaf will overlap itself. Make sure to remove the extra leaf in those areas by brushing it away. Closely look over the surface and make sure all the loose bits of leaf are wiped away or bubbles will form when it's clearcoated.

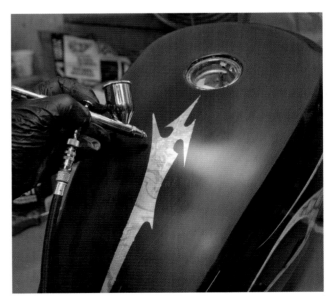

Let the leaf dry for an hour or more. Then apply two light coats of House of Kolor AP-01 [NL1] Adhesion Promoter. Don't skip this step or the paint may not stick to the leaf. Then apply two light coats of basecoat or intercoat clear. It could be freehand pinstriped, but I'm going to airbrush a taped-off stripe, and taping directly on the leaf would ruin it. I'll apply three coats of urethane clearcoat.

APPLYING THE LEAF (continued)

The clearcoat has dried and been sanded. The stripes have been taped off and are ready for airbrushing. Please see chapter 9 for instructions on taping off pinstripes. Using an airbrush, I spray on two to three coats of blue basecoat.

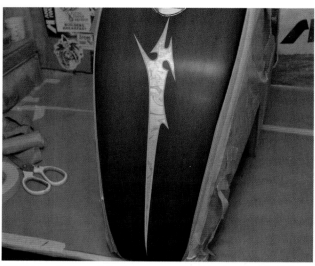

After a few minutes, pull the tape away, pulling it back against itself. Use precleaner and a folded paper towel to remove any adhesive left behind. And here's the completed leaf design, ready for urethane clearcoat.

ENGINE-TURN YOUR GOLD LEAF

To get that classic effect when doing real gold or silver leaf, stick a wad of fabric onto the end of a stick. Then wrap a piece of velvet around the wad, securing it with tape around the handle. Now put the velvet pad against the surface of the leaf and give it a gentle turn. A cotton ball can also be used. Move it over a bit and do it again. Keep repeating along the surface of the leaf, creating soft swirls.

CLEARCOATING METAL LEAF

Painters have different ways to clearcoat over their leaf work. Some painters will brush a clear covering over the leaf itself if they aren't going to spray clearcoat. If you are planning on spraying urethane clear over your leaf work, allow your leaf work to dry for several days. Then spray a few coats of basecoat clear over the leaf and apply the urethane clearcoats. Sometimes if the urethane clear isn't applied just right, the leaf might bubble.

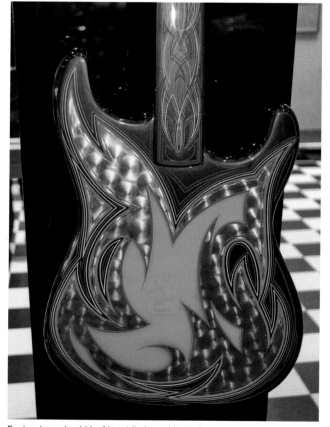

Engine-turned gold leaf in a tribal graphic design on a guitar.

GALLERY OF GOLD AND METAL LEAF PAINT JOBS

The paint job on this Donnie Smith bike features silver leaf stars combined with airbrushed flames that are similar in tone to the silver leaf. When done properly, silver leaf has an almost mirror finish to it.

Gold and variegated leaf can also be used for striping.

Classic engine-turned gold leaf lettering.

The metal effect of this gold leaf lettering adds to the nostalgic theme of this paint job.

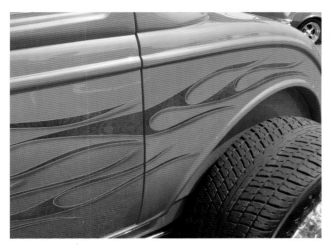

How about variegated metal leaf flames on a hot rod?

This is where variegated metal really comes in handy. Red candy basecoat, red pinstripe, and red metal leaf work together to create a harmonious paint job.

This pearl candy orange paint job needed a graphic that contrasted yet complemented the warm glow of the colors. Variegated red metal leaf with a thin black pinstripe was the perfect solution.

Turned silver leaf adds dimension to this paint job.

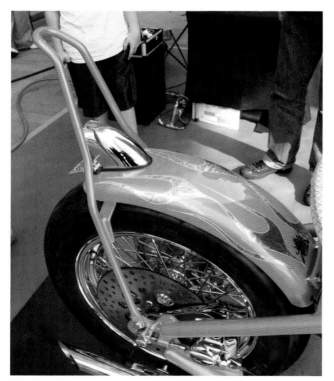

Nothing reflects light like real metal. The lettering on this motorcycle tank is subtle but very eye-catching due to the gold leaf.

Or metal leaf flames on a chopper? Metal and gold leaf are not just for lettering or graphic accents.

Chapter 11
Lettering

You don't need to be an expert at brushing to paint professional-looking lettering. This chapter shows how to use a stencil and an airbrush to create most any kind of lettering. There are two ways to create a stencil for lettering, using a computer and by hand.

USING A COMPUTER TO CREATE A STENCIL

It helps to know a little about using computer programs like CorelDRAW or Adobe Illustrator to create a lettering stencil. There are plenty of online tutorials on using these programs. Chapter 13 shows how to create a vector drawing using CorelDRAW. To begin, open up the program, find a font (lettering style) that works for your project, and type or plot out the lettering you want. If you're not computer savvy, a sign shop can create and cut the stencil for you. See the sidebar on the next page for more on this.

For example, here are the steps if you wanted to letter, "JoAnn's Hot Rod Shop," on the sides of a pickup truck. Pick a font style, type out JoAnn's Hot Rod Shop, and save the file. Then take or email the file to a sign shop. They will use a plotter to cut the stencil in stencil mask material. I recommend using GerberMask Ultra. But some sign shops prefer using an Avery paint mask, which is also a good product. Just make sure to tell the shop you want *stencil mask material*. See chapter 13 for more information on using a computer and a plotter to create stencils.

CREATING A STENCIL BY HAND

You can also create a stencil by hand. Trace lettering onto the stencil material, cut it out, and it's ready to use. More on this later in the chapter.

This 1937 Ford looks like it's straight off a racetrack from the 1950s. The lettering is plain but effective, due to the layout and design.

MATERIALS AND TOOLS

X-Acto #11 Knife
6 and 15-inch steel rulers
3M 1/8-inch 218 Fineline tape
Uncle Bill's Sliver Griper Tweezers
Cutting mat
Plastic spreader
SATAgraph 4 Airbrush
Lightbox
Pencil
Squeegee

PPG DMD6184 Basecoat White
PPG DBC9700 Basecoat Black
PPG DT895 Reducer
Transfer tape
Gerbermask Ultra
FBS ProMask
Masking tape
3M 1/8-inch Fine Line Tape #06300
Masking paper

APPLYING AND PAINTING LETTERING USING A STENCIL

Professional-quality lettering is all about placement. Make sure the stencil is level and straight. The following technique can be used for any style of lettering or with a hand-cut or computer-made stencil. This example demonstrates how I painted metal effect letters with beveled edges on a 2013 Ford Raptor.

The lettering is being re-created on a black panel to demonstrate the process I used on this truck. An Adobe Illustrator vector drawing was fed into a Roland plotter, which cut two stencils with the lettering. It's hard to see

Here's the lettering design and the truck being lettered, a 2013 Ford Raptor. The lettering will be on the back doors as other artwork has been planned for the front doors. Print out paper copies and tape them to the surface of the project. Try out different sizes of lettering and stand back to see which one will fit best the space. I didn't have advance access to the Raptor, so different sizes were tried out using Photoshop.

Position the stencil on the surface. The lettering can be hard to see on the white stencil. Use a pencil to draw around each letter. I also draw lines around the perimeter of the letters and then draw another line about a quarter inch from that border, as seen on this photo. Fine line tape is run around the stencil and a few lines are drawn from the stencil to the surrounding tape. This makes it easier to line up later.

The stencil is removed from the surface. Next, transfer tape is placed on top the stencil. This helps keeps everything in place after the adhesive backing is peeled off the stencil. A plastic spreader is run across the surface, forcing out any trapped air bubbles. Don't worry if it's not too neat. It's just temporary. Flip the stencil over and trim away any excess transfer tape material with a #11 X-Acto Knife.

HAVE A SIGN SHOP MAKE YOUR LETTERING STENCILS

If you have a sign shop cut your stencils, be sure to tell them, *not* to weed the stencils! "Weeding the stencil" is a technical term for removing the cutout pieces from the stencil. Make sure they leave everything in place. Depending on what airbrush technique is used, these pieces might be needed during the artwork process. So don't lose them or throw them away.

LETTERING

the cutlines on the white surface of the stencil material. So, once you have the stencil made, the first step is to use a ruler to draw lines around the lettering. This makes it easier to see the letters, level, and line up the stencil. The lettering will have a border around the letters. This border will be the bevel for the metal effect.

LETTERING STENCIL DON'TS!

Tell the sign shop not to cover the stencils with transfer tape. Order your own transfer tape and do it yourself. You're going to need to see where the stencil cuts are in order to position the stencil. Once the transfer tape is on there, it's impossible to see the cut lines unless they are traced in pencil. Only put transfer tape over the stencil *after* the stencil has been aligned and is ready for placement.

Next, very carefully peel away the adhesive backing. Sometimes it's easier to peel away half of it, cut that part off, and then peel away the remainder. Refer to chapter 13 for more information on handling stencils and an easy technique for applying them. The stencil with the transfer paper is now lined up and put into place. Start at the top, holding the stencil up and away from the surface. I lined up the top edge so that the lines I drew matched up. Then press down the top of the stencil. Working with a squeegee from the middle top, carefully smooth it down to the surface, moving from the point of contact outward to avoid trapping air.

LETTERING

Next, the rest of the surface around the stencil is masked off. The *middle* of the letters is removed using tweezers. Each letter is carefully pulled up. Keep a small ruler or other flat-edged tool handy to hold down areas of the stencil that might want to pull up with the lettering. If you have a cut border around your letters like this one, make sure to leave it in place. Save the removed pieces/letters by placing them on the pieces of backing that were removed from the back of the stencil. The upper left corner of this photo shows what I mean.

Metal effect lettering has reflections, but the reflections are most effective when they are soft and even. Notice the diagonal lines drawn on the stencil? This makes it easy for all the reflection lines to have the same angle across the lettering. White basecoat is reduced down about 1 to 1½ with reducer and loaded into a SATAgraph4 airbrush. Light strokes are airbrushed across the letters and concentrated on the left side and lower edges of the letters.

APPLYING AND PAINTING LETTERING USING A STENCIL (continued)

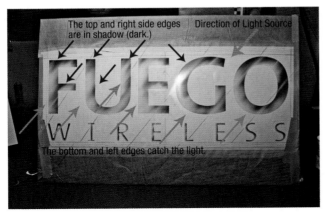

This photo explains how the white or "reflection" areas are airbrushed. It's pretty simple. White on the bottom and left side edges and dark shadowed on the top and right edges. The top letters are done and then the bottom letters are airbrushed in the same way.

This photo shows me airbrushing the lettering on the actual Fuego Raptor. Note how I first airbrush the reflection lines in white. Then I sprayed white on the edges of the letters. One trick is to have a reference photo to work from, which I've taped to the cab window above the stencil. Keep it nearby the work area to look at while you're airbrushing.

Now that the white/reflections are done, the dark/shadows were airbrushed. Black basecoat was mixed 1:1½ with reducer. If the black sprays grainy or rough, mix a little more reducer into it. The right and top edges are airbrushed with black. And some black is airbrushed along with the white diagonal streaks. The bottom letters are very thin, so the airbrush is held close to the surface and a fine line of shadow is sprayed on the top and right edges.

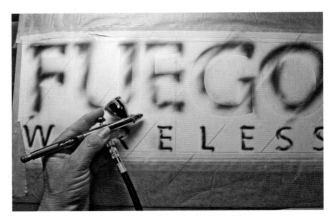

The white edges are very lightly airbrushed with white once more. Don't overdo this step. Next, lightly go over the black edges again. Then pull off the border of the simplest letter and check your work. If need be, remask the border and do any rework on the letters.

SAVE ALL THE PIECES!

Save the backing that is peeled off the stencil. Don't throw it away. Once the stencil is in place and you're peeling away the letters, place those cut-out letters on the shiny side of the backing. You might need them later. I always save as much of my stencil pieces as possible in case I have to go back and do any rework.

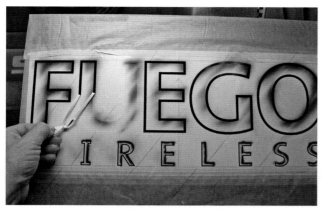

Peel off the border from around the letters.

For plotter-cut stencils, here is why you had the sign shop cut two stencils. The inside pieces of the letters are placed over what has been airbrushed so far. If you are using a hand-cut stencil, this is why you saved those pieces from the last step. Place the pieces over the letters covering what was airbrushed.

THE HINGE METHOD FOR STENCILS

It can be difficult to apply long stencils on surfaces, but here's a trick to use with any long or large stencil. Flip the stencil over, peel up, and cut away half of the backing. Then put it back into place on the stencil. Tape the stencil to the surface using the tape outlines to line it up. Place pieces of masking tape at the halfway point to keep the stencil in place, leaving one side loose to act as a hinge. See first photo.

The next part might require a helper, depending on the size of the stencil. Lift up one end of the stencil and remove the backing. See second photo. Now have your helper hold up the peeled part of the stencil, keeping it off the surface. Using a squeegee, start at the hinge point (at the midway line) and carefully start to work the stencil down onto the surface. Always start at the middle and work to the top and bottom. It's easier with a helper as they can keep the stencil aligned.

Now repeat the process on the other side. Hold the stencil up, remove the backing, and keep the stencil from touching the surface. See third photo. Use the squeegee to work the stencil down while maintaining the alignment of the stencil.

This photo shows the result of the step I'm about to do next. The uncovered area around the letters will become the beveled edge. The letters on the right have had the bevels airbrushed. The next photos show how to airbrush that edge. Airbrushing the bevel follows the same principle as airbrushing the middle of the letters. Dark shadows and light reflections. This same process will be repeated for the bevel, only in reverse.

Using a business card or card with a straight edge, hold the card across the bevel line at a corner of one of the letters and airbrush white on the top side of the corner (left image). Repeat this with each top corner of the letters. Then airbrush white along the inner edges of the border where the light would hit it. Here (right image), I'm spraying along the inner edge of the border on the top part of the U. Give the border of each letter a light dusting of white.

Next, repeat the process with black, only spray the areas that were not sprayed with white, like the downside of the corners.

After the top and bottom letters are done with the black shadow, softly go over the white reflections again. Very lightly. There will be a little overspray from the black on these areas. This last step covers that black.

Here's the finished result before the stencil is removed. Do any rework or touchups before you remove the stencil.

And the result once the stencil has been removed. Now it's ready for clearcoat.

And here is what the finished Raptor looks like. Now you can see why the lettering was done on the rear doors.

SIMPLE LETTERING WITH A BORDER

The previous stencil and masking technique can be used to create nearly any style of lettering, not just metal effect.

Here's a quick and easy way, using those techniques, to create simple one- or two-color lettering. The variations with airbrushed stenciled lettering are endless.

<div style="writing-mode: vertical">LETTERING</div>

The Nu-Relics stencil has been laid out and set up on the doors of a '40s Ford truck and masked off. The inner pieces of the letters are removed as well as the cut borders. The inner pieces of the lettering are saved and put aside. The border pieces are thrown away. The lettering is sprayed with black basecoat.

Next, the inner pieces that were removed from the stencil are put back into place inside the letters. Center each piece so that the space around the letter is the same all the way around the letter. These pieces will cover the center of each letter. White or a contrasting color is airbrushed around the lettering.

Here is the finished lettering, which is part of the logo for Nu-Relics Power Windows.

CREATING HAND-CUT STENCILS

Lettering stencils are easy to make without a computer. Trace lettering onto the stencil material, cut it out, and it's ready to use.

Here I try three different sizes of lettering for this license plate design. I print out three different sizes and find the one that best fits the space.

Place a piece of stencil material over the design you want and place it on a lightbox. If you don't have a lightbox, tape the pieces to a window. I'm using a window in this photo. Trace around the letters with a pencil. Use a ruler to help get clean lines on the straight edges.

Now place the stencil on a cutting board or a piece of cardboard and use a #11 X-Acto Knife to cut out the letters. Now you have a stencil ready to go!

Was this patina lettering done by hand or was it done using a stencil? Most likely it was done by hand.

But you can create patina lettering using a stencil. In 2018, I got to paint the logo for my favorite car magazine, *Car Craft*, while doing an article on creating patina. It's easy and fun to do. Place a plotter or hand-cut stencil on the surface being painted. Then brush on the color for the lettering and use a cloth to wipe some of the paint. You can check out how the plate was created on Carcraft.com.

The stencil for this lettering was done using a plotter, but it's simple enough to be cut by hand. Just cut out two stencils. One for the inner area of the letters—in this example, those would be the pink area. Then cut another stencil with bigger-sized letters, as tall and as wide as the black border. Then place the stencil with the larger letters down first and paint the color you want for the inner part of the letters. Then cover the inner part of the letters using the cutouts from the smaller stencil and spray the color wanted for the border. The Nu-Relics example uses this same process.

Here's the kind of lettering that would be hard to do without a plotter-cut stencil. Plotter-cut stencils are not out of reach for the DIY painters or painters with limited computer skills. Most sign shops are happy to work with you to create stencils for your project. Know the size of the area being lettered and the height of the individual letters. The sign shop can show you some font choices, create a proof that shows how the stencil will look, and then cut out your stencils.

You don't have to get fancy to have nice lettering. This chopper tank has simple white lettering and looks great! This kind of stencil is simple enough it could have been done by hand or with a plotter.

Back your lettering with some graphic effects like this real fire. Mike Lavallee painted the top example. He created a metal effect to the letters using beveled reflective edges and purple tones. In the bottom example, I placed cutout letters over the black basecoat and then painted real fire coming off the letters. Once the letters were removed, this was the result. The black basecoat acts as the color for the letters.

Here's another example of using a basecoat color as the lettering color. This Challenger was first painted white. The black graphic was taped and masked off. Then cutout letters were placed on it. Then the black was sprayed. Then the letters were removed allowing the white to show through.

For this lettering, only the black border was painted on. The blue real fire base paint shows through the inner parts of the letters. To duplicate this effect, cut only the border section of the letters.

Chapter 12
Patina Paint

The interest in patina effects has had a longer lifespan that anyone could have anticipated. The patina trend picked up steam in the early 2000s and has been rolling along ever since. Most patina enthusiasts are familiar with the standard method of creating a weathered surface. It usually involves layering various colors, then sanding and scratching through them in strategic places to create the effect of a weathered surface.

Painting a faux patina surface is one of the most enjoyable painting processes because the artform encourages experimentation. It's a chance to break free from the rigid rules of automotive paint. You can scratch, dig, spatter—it doesn't matter if the paint surface bubbles or has defects. The defects can add to the weathered appearance.

MATERIALS AND TOOLS

PPG Deltron basecoat colors: DBC73753 red, DBC61456 orange, DMD1684 white, DBC9700 black, DBC83033 yellow, DBC17697 turquoise

Modern Masters Metal Effects Oxidizing Iron Paint ME208, Rust Activator PA904

Rock salt

Plastic zip bag

Cotton cloth

Mirka Mirlon red scuff pads SP18-118-447

600 sandpaper

SATAjet 20B Artbrush

Iwata HP-CS Eclipse Airbrush

SATAgraph 4 Airbrush

Spray bottle

Hammer

Mesh bag or netting

Squeegee

Soft sanding pad

This bike is an example of created patina. The blue midcoat works effectively against the black topcoat and white undercoat. The tank was painted with a flat-finish clear.

REAL PATINA VS. PAINTED

Many of the patina vehicles you see are a mix of real and painted-on patina. Sometimes the painted patina is so well-done, it's hard to tell. People experiment with paint techniques along with various chemicals to re-create the rusty metal and aged-paint effect. Here's an example of real versus a mixture of real and painted patina.

This chapter will explain several different patina paint methods. First up is the rock salt method. There will also be a demo for making paint look worn and rusty using the sand and scratch method and by applying a chemical process that simulates vintage rust. I'll also demonstrate a method for patina lettering. Painting patina lettering is similar to painting patina. Wipe, scratch, and sand, to make the lettering appear worn out.

This '32 Ford has real patina straight from the desert.

The Hulk Camino was built by ITW Rods and features a combination of real and painted patina.

A closeup of the Hulk Camino's surface. You can see where the paint was sanded and scratched, revealing the layers underneath.

THE ROCK SALT METHOD

If you look closely at old rusted painted surfaces, rust forms under the paint and pushes up against it. The surface of the rust is rough and the high spots break through the paint, forming a random pattern of various-sized pits in the paint, from large bubbles to tiny pinpricks.

This technique uses rock salt as a masking agent. The different sizes of the salt particles mimic the different sizes of pits. The surface is first painted to look like rust and wetted with a spray bottle. Salt is then scattered on the surface. When the water dries up, the top layer (basecoat color) of paint is sprayed. Once the paint is dry, the salt is brushed away, revealing the tones of the bottom "rusted" layer.

The result has that look of old, blistered, weathered paint. The trick to painting faux patina is to experiment and practice. Play around on old parts and panels. That's the fun of painting patina; there are no rules. In fact, some of the tools and materials you'll use for patina you probably have around the house. Start practicing on a sign for your shop or as a gift for a friend. You might come up with something so cool, you'll have to duplicate it on your car project!

Mix a dark brown and a yellow brown for the rust effect. Then spray the surface with black and randomly spray dark brown across it, leaving areas of black showing through.

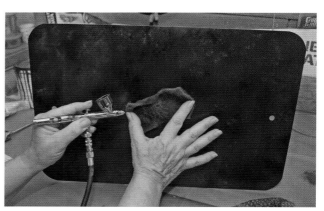

To create muted tones, use a screen, netting, or mesh bag stretched across the surface. Spray the light and medium browns through that. I stretch out a scuff pad and spray through that. Move the material around and spray again. Dab the surface with the still-wet material. Repeat until you get a rust effect you're happy with.

Plan out the size, shapes, and areas of rust you want to show through the "topcoat" color. Rock salt will cover these areas. Pour the salt into a plastic bag and hit it with a hammer until there are all different sizes of crystals. Spray a light coat of water over the "rust" areas, then place the salt on the areas. In areas that will have no topcoat color, I made sure to pile enough salt to cover any gaps.

HINT FOR VERTICAL SURFACES

If you want to use this technique on a vertical surface, you may need to use a medium lighter than rock salt, perhaps confetti or sawdust. Use a rinseable, water-soluble glue, like egg white. Paint and dab it on the side of the vehicle where you want the rust effect to show. Then apply the salt. The glue helps the salt to stick to the surface. Once the paint is sprayed, just wash it all off.

PATINA TOPCOAT COLOR

Faded colors work best for patina, as it's easier to make the surface appear faded by the sun. Red colors are faded to various tones of pink. Dark blue becomes light blue, blacks fade to gray tones. I had some turquoise left over from a trailer project, so I lightened it with white and used that for the examples in this chapter.

Allow the water to dry. A blow dryer can be used to speed up the process. After the water is dry, mix your basecoat and gently spray a light coat over the area. Use low air pressure to make sure not to blow the salt off. Four light coats of turquoise basecoat are applied.

Let the paint dry until it is no longer tacky. Brush and wipe away the salt. Use a gentle pre-cleaner like PPG's SX320 or House of Kolor's KC20 to clean away any remaining salt or water. The edges of the topcoat turquoise are raised and blistered just like natural weathered paint! At this stage you can leave it unclearcoated and raw, allowing the rough edges to be exposed to the elements and enhance the patina effect naturally.

Here's a closeup of the different tones and effect in the exposed painted rust patina. You can have a lot of fun with this technique and create some great effects. As I'm doing white lettering over it, I don't want the white to mix with the topcoat color, so the panel is urethane cleared and sanded the following day.

PATINA LETTERING

Creating time-worn lettering or striping is easy and fun. Spray or brush on the lettering or striping, then wipe, sand, or scratch off the paint. Like with the topcoat color, use faded colors for this. For painting white, use an off-white. For black, use a gray tone.

PATINA PAINT

The stencil for the lettering is placed on the panel and the inside pieces of the letters are removed. See chapter 11 for information about creating and using stencils for lettering. If hand-painting the letters with no stencil, draw out the lettering so you have lines to follow with the brush. Brush white basecoat paint onto the letters. Try to brush the paint strokes to match the shape of the letters. In some places, the paint was thicker, giving it a balance between thick and thin.

I cut a white cotton T-shirt into small pieces. This will be used to wipe away some of the white. Fold the fabric, creating a "point." Apply reducer to the point and wipe away areas of the lettering. If you make a mistake, it's easy to go back and brush on more white. You can also wrap the cloth around a sharp edge like this squeegee.

Here's a closeup of the detail of the wiped areas. In a few places, the paint is completely wiped away. But most of the wiping leaves a thin wash of white over the surface.

Once the paint is dry, remove the stencil. For wiped areas near the edge of the letters, I wiped inward to leave a thin line near the edge of the stencil. I also sanded and scratched across the lettering in some areas, thinning it down even more. And here is the finished result!

CREATING A PATINA FINISH BY LAYERING PAINT

For this example, I'm going to use a classic GME ribbed tank from the 1970s. Three color layers will be applied: a bottom coat, a midcoat, and a topcoat. I'll be using basecoat applied with a spray gun, but this could also be done with spray can paint. Black and red oxide primer could be used instead of the basecoat we're using here. Remember, you don't have to get fancy with this style of patina paint.

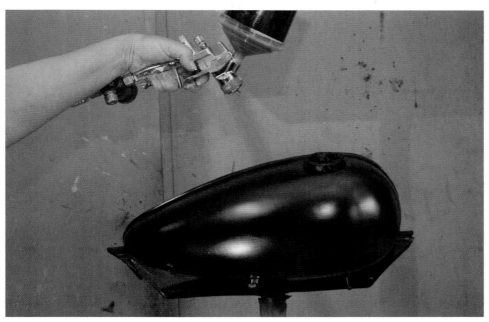

The tank has been sanded and I spray on two coats of basecoat black. Apply enough black so that it won't sand through in a couple of passes. You'll be sanding through the topcoat, the midcoat, and into the black. Try not to sand through the black.

I mix up some red oxide basecoat using equal parts orange and red basecoat and adjusting it using black basecoat. Apply two coats of this mix. If you're doing a car or truck, think about the places that degrade and get the most sun, such as the top surfaces and body or trim lines, and apply it there. I apply the red oxide on the round top sides of the tank and along the seam.

A light turquoise basecoat is applied next. For the top surface areas where you want the sunburned paint effect, apply a thin, semi-transparent coat. Make it easy to sand through. For the other areas, put on two coats to look like a solid coat of paint.

CREATING A PATINA FINISH BY LAYERING PAINT (continued)

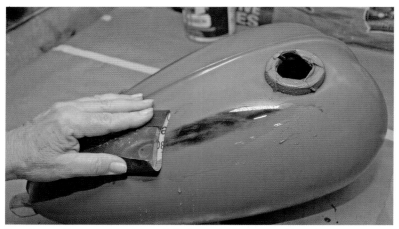

Once the paint is dry, wet-sand through the top and midcoats with 600-grit paper. Use a soft sanding pad to apply even pressure when sanding. Stop and check every few strokes to see what's exposed. It's easy to sand too much and ruin the effect. You can always sand more.

Think about what surfaces wear on the panels being sanded. On vehicles, it's the top surfaces, trim lines, and door handle areas. Look at cars with original patina to see what surfaces wear down. Here, I'm sanding along the raised seam on the top.

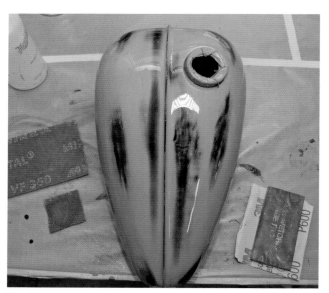

The right side was sanded with 600-grit paper and the left with a red Mirka Mirlon 360 scuff pad. Scuff pads remove less material and give a more subtle effect.

Here is the result of sanding through the layers.

USING A CHEMICAL PROCESS TO CREATE PATINA

Modern Masters Metal Effects is a two-part chemical product that duplicates a natural rust effect on just about any surface. The first part is an oxidizing iron paint. The other part is a rust activator. The activator comes in three colors: orange rust and blue and green patinas. I'll be using the orange rust activator. First, I'll test this metal rust paint on a nonrusting surface to demonstrate its effectiveness.

MORE METAL EFFECT PAINT INFO

Make sure to check out the Modern Masters' website for the complete data sheet for these products. Read through them completely before you use the products.

This is a plastic bicycle helmet. It doesn't rust. Two thick coats of the Metal Effects oxidizing paint are brushed on. It can also be sprayed or rolled. Be sure to sand the area before applying. Allow the paint to dry completely before applying the activator. Depending on conditions, the oxidizing paint can dry in thirty to sixty minutes. I let it sit overnight.

This paint will rust naturally due to moisture in the air. But using the activator speeds up the process. Spray on the first coat of activator. The activator is a mild acid, so be sure to wear gloves and safety glasses. The label recommends applying a second coat of activator five minutes after the first.

Yes, you can make a plastic surface rust! After an hour, the oxidizing paint appears very rusty. The unevenness of the brush strokes makes the rust look even more real. If you're looking for an even application of rust, for example on a large area like a hood or the top of a fender, spray on an even layer of the oxidizing paint.

Now to try the oxidizing paint on the tank project. Create a couple of scratches and gouges and apply the oxidizing paint to those areas.

175

Use a small paintbrush to apply the oxidizing paint to the center of the sanded areas. Once the oxidizing paint has dried, brush on the activator and soak them down. When using the oxidizing paint in small areas, it's more effective to brush on the activator than to spray it.

An hour later, the rust effect is starting to show up. Over time, rusty streaks on paint are created as water rinses over the rusty surfaces across the painted surface. To re-create this effect, mix some rust-toned paint and thin it down. Using a light touch, airbrush from the rust area downward onto the paint.

Here's a closeup of the airbrushed effect with the rust paint.

Here is the finished product: rusty timeworn paint on a classic bike tank. I could apply a few coats of flat clear, but I'm going to leave this surface unprotected to become even more aged.

Definitely real rust showing on this Chevy truck. But the lettering? That could be re-created patina.

This '58 Chevy truck was painted by Bill Steele to look old.

This Harley knucklehead was painted to look old. The paint layers were sanded through, and the lettering was worn down. The result is paint that looks as old as the bike.

Another great motorcycle patina paint job. Note the "rusty" scratches. Play around with patina techniques and create your own.

The pinstriping was aged and more rust created on the top of the tank. Bike by Stinger Custom Cycles.

Real patina or new "patina" on this 1928 Ford ragtop?

Believe or not, this is all created patina. The owner told me a secret chemical process was used to build up the rusty effect.

Chapter 13
Creating and Using Plotter Stencils

Custom paint shops paint a lot of lettering and logos these days. Plotters make it easy for painters to do sharp, clean artwork and much more. A plotter is a machine with a blade that cuts vinyl material. Plotters were once used mainly in sign shops, but over the past fifteen years, they have found their way into custom paint shops too, as more affordable models have hit the market. Small hobby plotters, like a Roland Stika, are available for about $500 for an 8-inch version up to $1,000 for a fifteen-inch model.

PLOTTER EQUIPMENT

Go to an online sign supply website and look through the many choices available. There is a plotter for every budget and need. I use a Roland Camm 1 GX-24, one of the most popular plotters for custom painters. It's a 24-inch desktop plotter, but I also bought the stand for it. The plotter was $1,800 with the stand. One of the

This is a Roland Camm 1 GX-24 plotter on a stand. Note how the stencil material hangs down in the back. The roll of stencil film sits on two rollers at the back of the plotter and the material hanging loose in the back needs to be as long the stencil being cut. The machine pulls the material back and forth, cutting the stencil.

Most of the graphics on this guitar body were done using plotter-cut stencils—the stars, knobs, lettering, and all those little dots. Check out the tiny stars and hearts on the neck. Imagine trying to cut those by hand.

Here is a vector drawing for a Celtic cross. It was made by tracing a drawing using CorelDRAW.

Here's the finished artwork. To start, a simple stencil for the cross was applied, the black sections were airbrushed, and the stencil was removed. Next the stencil for the granite sections was applied and the granite was airbrushed.

reasons for the stand is that the plotter needs the freedom to move the vinyl back and forth as it cuts. The plotter will push a length of material out, then pull it back, and then start cutting, moving it back and forth as it cuts. My shop is small and my overheads need to be low. My purchase of the plotter, the stand, and graphic program was one of the biggest one-time equipment purchases I have ever made. It's also one of the best decisions I've ever made for my shop, as it improved the quality of my work and reduced my labor hours.

PLOTTER AND VECTOR DRAWING SOFTWARE

To create a vector drawing, you'll need a graphics program like CorelDRAW or Adobe Illustrator. CorelDRAW is amazingly easy for beginners and it's what I use. Corel has released a new program, CorelDRAW Graphics Suite 2021. It retails for $249 per year, about $21 per month, or $500 for a one-time purchase.

Your plotter will need cutting software. There are several, but Roland CutStudio is simple to use. For some lettering projects, you can design the lettering directly on CutStudio. It's as easy as typing out the

lettering, then picking a font. This chapter will show how it's done. CutStudio enlarges, reduces, positions, rotates, and mirrors images. And it works with CorelDRAW and Adobe Illustrator.

STENCIL MATERIAL

Stencil film is a vinyl film with a low-tack adhesive on the back. It's especially important to use *only* a vinyl film that is designed for use as a stencil. Regular vinyl material has very sticky adhesive and is made to stick in place permanently. GerberMask Ultra and FBS Blue Mask plotter film are two great stencil products that cut cleanly and are easy to work with.

A VECTOR DRAWING

So, what is a vector drawing? Very simply, a vector drawing is an image made up of groups of lines that a plotter can read. A plotter cannot read a regular image. It needs to see the lines it has to cut. For example, see the next step by step project.

CORELDRAW TOOLS

Listed below are the tools that will be used in the tutorial. These tools are from CorelDRAW, but similar tools exist in other vector graphic programs. A full explanation for all tools in the program can be found in the Help section of the application.

Some tools are grouped together in a Fly Out bar that is noted by the arrow at the bottom right of the button. Hover over the button and click to display the Fly Out bar. Click on the desired tool and the bar will close. All the tools listed can be found in the CorelDRAW toolbox. When a tool is selected, the Property bar along the top of the screen will display the available properties for the selected tool.

	Pick tool: Select Objects to move or resize. *Tip:* Press Shift to select multiple objects. You can also click and drag a marquee box around the objects to be selected. The Pick tool can be quickly selected by pressing the spacebar.
	Shape tool: Edit nodes and paths to change the shape of objects.
	Knife tool: Break an object into more than one object. Allows the objects to be reshaped or deleted.
	Zoom tool: Allows magnification of objects. *Tip:* Left click to zoom in and right click to zoom out. You can also click and drag a marquee box around the objects to zoom only that area.
	Bezier tool: Draw curves by placing nodes and editing the line segments between the nodes.
	Outline tool: Change the color, size, and shape of outlines.

CREATING A VECTOR DRAWING

For this tutorial, we'll use CorelDRAW, but many of the programs out there, like Adobe Illustrator, use similar tools. This basic overview should give you enough knowledge to get started on the vector drawing process. Whatever program you choose will also have tutorial guides. Remember that the learning process here and with all aspects of custom painting will continue for as long as you practice the craft. Experiment around, clicking on tools to see what happens. Many online videos explore the process.

CREATE A VECTOR DRAWING WITH CORELDRAW

A plotter can help you produce a straight line just like using a ruler, only you're drawing the lines with a computer mouse or trackball. This tutorial will give you

WHAT IS AN ANCHOR POINT?

An anchor point or node appears as a square dot on a line. You build off these dots to manipulate a vector drawing. The point remains stationary when you stretch, scale, mirror, or skew an object. Anchor points correspond to the eight handles that display when an object is selected, as well as the center of a selection box marked by an X. These points can be divided and split.

a basic understanding of using CorelDRAW to create a vector drawing for a plotter. First, we'll draw out a spade shape. Later in the chapter, I'll show how to create a logo and lettering and how to paint them.

Create the vector drawing on CorelDRAW by selecting File – New in the upper left corner of the screen. Then select File – Import. Import the image you want. Here we selected a spade.

Next, we select the Bezier tool (#1) from the toolbar. Then click on the top of the spade (#2). This will create an anchor point. Then click on the lower right side of the spade (#3). There's a black line that connects these two anchor points, but it's very hard to see. So, we'll change the line color and width next.

To change the outline color, select the Outline tool from the toolbar (#1). From the dropdown menu, select the second from the top (#2). This will bring up the Outline Color box (#3). We selected red. Next, go back to the Outline dropdown menu and select the width of the outline (#4).

Now we have a bright red line that's easy to see.

Select the Bezier tool and continue to create anchor points around the spade. To put in an anchor point, simply left click on the image wherever you want to put a point. Put an anchor point in areas that require a change of direction, such as a corner or where a curve starts or stops. To complete the last segment, click on the first anchor point created or press the escape key to end the segment. In the image, you can see the anchor points and connecting line segments are ready to be edited.

LEARNING THE TOOLBAR

Hover your mouse pointer over the buttons and the tool name will be displayed. If the tool has a small arrow on the bottom right, click the arrow to display the flyout/dropdown menu and the tools that are grouped together on that tab.

CREATE A VECTOR DRAWING WITH CORELDRAW (continued)

To curve and shape these lines, select the Shape tool (#1). Then right click on whatever line you want to edit (#2). A dropdown menu will pop up; select To Curve (#3) and then select Cusp (#4).

Left click on the anchor point at either end of the segment you want to edit, and the control handles will be visible. The handles appear as little squares along the line. Move them around by left clicking on them and get used to how they work. Now you can also move or adjust the line by putting the Shape tool cursor over the line and holding down the left mouse button. Between moving the line this way and adjusting the line with the handles, you'll see just how easy it is to get the line to fit whatever shape you want.

Move the handles to adjust the line. Here the top handle is moved inward to curve the line in. The bottom handle is moved outward to curve the line out. Press and hold the left mouse button on the control point, then move the mouse or trackball to drag the handle to adjust the shape of the line segment to match your reference image. Click on the next anchor point to access the handles for that segment. If you do something and the handles disappear, simply left click on the anchor point and they'll come back up.

Continue to adjust all the line segments until the outline matches the reference. Fine tune any segments that need adjusting.

The vector drawing is complete. Save your file. Now if you have sign software that's compatible with your drawing program, a plugin button was installed on your drawing software when you installed the sign software. CorelDRAW works with Roland CutStudio, so there is a plugin button on the Corel toolbar on the upper left. Clicking that button will open the drawing in CutStudio.

The drawing is now open on the CutStudio plotter software and is ready to be cut on the plotter. If I want to change the size, I can select the drawing, right click, and then click on Properties on the dropdown menu that will appear. A popup box has settings for size and directional changes.

CREATE A VECTOR DRAWING WITH CORELDRAW (continued)

To save the vector drawing in CorelDRAW, use the Pick tool to select the outline. Then left click on it and move it away from the solid image.

Now use the Pick tool to select the solid image. And then go to Edit and Delete the image. Now the vector drawing file can be saved.

How about creating a vector drawing for a whole playing card? It can be done the same way. Using the same tools and techniques, the card image has been completed by zooming in and working one area at a time. This drawing took about three hours to do. As the bottom is the same as the top, only the top half of the card was drawn. Then it was flipped over and reversed for the bottom half.

188

HOW TO CUT AND DELETE A LINE SEGMENT

When designing for the plotter, it is important to remember that most plotters will cut all the outlines even if they pass under another object. The knife tool is used to remove portions of the line segments that should not be cut with the plotter.

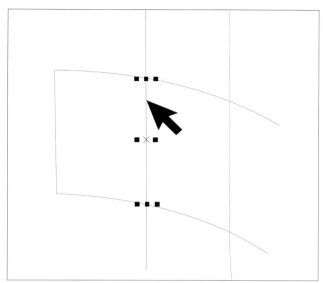

Select the Knife tool from the Shape Edit flyout on the toolbar. On the Property bar, locate the Leave As One Object and the Auto Close On Cut buttons and turn both buttons to the Off position. Left click on the spot to be cut with the Knife tool to create the cut point or points.

Press Esc (Escape) on the keyboard to deselect the line segment. Select the Pick tool from the toolbar and select the area to be deleted by left clicking the line segment.

Press the Delete key on the keyboard to delete the unwanted line segment.

BEFORE AFTER

Continue cutting segments until all unwanted areas are removed.

CREATING AND USING PLOTTER STENCILS

SETTING UP A PLOTTER

Carefully pick a good location for the plotter. Don't put it where it will be in direct sunlight or exposed to paint overspray. I have all my computer equipment in a separate room from where I airbrush. Make sure the rear of the unit is not obstructed. Your plotter will come with a detailed instruction booklet for setting it up.

Most plotters also come with a cutting program software. Roland plotters come with CutStudio, which has a plug-in for Corel. The CutStudio software installs a button on CorelDRAW. That means I can create a vector drawing in Corel, then click on the CutStudio button. CutStudio will open, and the drawing will be on it, ready for cutting.

There's about 10 inches between plotter rollers and the wall. Plenty of room for the plotter material to move freely.

CREATING A LETTERING STENCIL WITH SIGN SOFTWARE

Sign or cutting software like CutStudio and graphics programs like CorelDRAW can both be used to create a lettering stencil. Let's try using CutStudio first. Open up CutStudio and type the desired lettering. Here I'm making a shop sign for a motorcycle tank.

Next, select the Pick tool (#1) at the top of the toolbar on the left and select the lettering by left clicking on it. Whatever items are selected will turn blue. Then right click on the selected lettering and a dropdown menu will pop up. Select Properties (#2).

This is the Properties box. Select the Format tab (#1). There are options for changing aspects of the lettering in this tab of the Properties box. You can select whatever font style you want (#2). Look closely at the options. You can change the text height, line, and character spacing; the sentence alignment; and adjust the boldness of the lettering. I picked Retrotype as the font style for my sign. Retrotype has a built-in border. Not many fonts have that.

Once I click "OK," the box disappears, and the font style has been changed. Now I need to adjust the size to fit the side of the tank. The lettering is selected, and I right click on it. The Properties box comes up again, and this time the Size and Shape tab (#1) is selected. The size selection boxes are at the top of the box (#2). Fill in whatever size you want. There is also a selection box to keep the current aspect of the design (#3). Make sure that's checked if you want the proportions to stay the same when the size is changed. Click OK when done.

CREATING A CURVED LETTERING STENCIL USING CUTSTUDIO

To create a curved lettering stencil, type in the lettering and configure the font as in the previous steps. Here only the top line will be curved, so only the first line is typed. Select the lettering and right click on it to bring up the Properties box. Now check the Align with Curve box (#1). Under that box is a dropdown menu to place the curve on the Top or Bottom of the lettering. I picked Bottom (#2). Click OK when done.

Now the lettering is curved. To adjust the curve, select the Outline Tool (#1). A blue line will appear under the letters. You can left click on the little black square on the blue line (#2) to move the line up or down. For the second row of letters, type the letters, then bring up the Properties box to change the font.

And here is the plotter-ready stencil drawing ready to cut! You might have a newer version of CutStudio, but the basic tools and process are the same. Please watch the tutorials that come with whatever sign software you have.

USING CORELDRAW TO CREATE LETTERING WITH A BORDER

It's easy to create borders around any kind of vector lettering or image using CorelDRAW. Corel has an interactive contour tool that can create a border around the outside or inside of an image. Use it to create a perfectly spaced border around your lettering or image.

Go to File – New. Then select the Text tool (#1) and select the size (#2) and font style (#3). Type out the lettering. The letters will appear to be a solid black. Switching to a Wireframe view will show the outline of the letters. Go to View (#4), then select Wireframe (#5) from the dropdown menu.

Next, use the Pick tool and select the lettering. On the toolbar, click on the Interactive Blend tool (#1). In the flyout menu, select the second from the top. It looks like squares inside squares (#2). That's the Interactive Contour tool and it gets a lot of use creating borders.

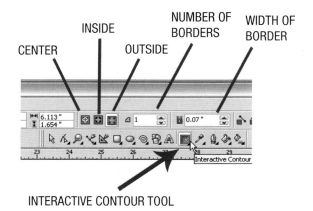

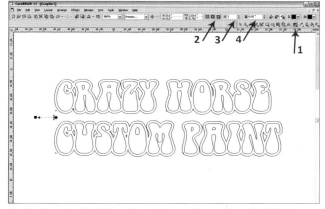

On the right side of the Property bar, you'll see buttons that control the various aspects of the Interactive Contour tool. This is a closeup of that area. On the left there are three options to place the border in the center, to the inside, or to the outside of the image or lettering. Outside is used the most. Next, pick how many steps for the border. And finally, choose the width of the border.

For the shop sign, the Interactive Contour tool was selected (#1). I choose a border around the outside of the letters (#2), one step/border (#3), and a width of 0.02 (#4).

USING CORELDRAW TO CURVE LETTERING

CorelDRAW also can be used to curve a line of lettering. Start with a new file and use the Ellipse tool (#1) to create an ellipse with the same curve wanted for the lettering.

Go to Edit – Copy – Paste to create a second ellipse directly on the first one. Then use the Pick tool to select one of the circles. The nine squares around the circle shows it's been selected. Then hold down the Ctrl key on the keyboard and place the cursor over the upper right square and drag the square inward. The second circle will reduce in size but will be perfectly aligned with the first circle, as seen here.

Select the Font tool (#1) and hover the cursor over the black line of the second circle until you see an A with a curved line under it (#2). Now type the desired lettering. If the lettering isn't centered on the top, use the space bar on the keyboard to type spaces at the end of the lettering. This will push the lettering over onto the top.

The lettering is centered on the top. Now we'll get rid of the circles and leave the lettering.

Select each circle. Go to Edit – Delete. Now you can type in another line of lettering under the curved letters.

Here's the completed lettering with the second line of text and borders added. It's ready for the cutting software, where the size and other aspects can be changed if needed.

USING A PLOTTER STENCIL TO PAINT LETTERING

CorelDRAW was used to create this retro groovy lettering with three borders around it. Next, the file was opened with CutStudio. It will be painted on a motorcycle tank. The tank side is measured, and I use the Properties box to resize the lettering. To resize, use the Pick tool (#1) to select the lettering; right click on it to bring up the Properties box. Then change the size (#2). Click OK.

Four stencils of the lettering are needed. One for the inside of the lettering and three for the borders. Once you're ready to cut the stencil, make sure to watch a video that explains how to use your brand and model of plotter. Make sure the plotter is turned on and the stencil film is loaded and aligned. Then in CutStudio click File – Cutting. The plotter will start to cut.

TRYING OUT SIZES

Your sign software has a Print Option. Use it to print out different sizes of your design on paper before cutting the stencil and try them on your project. Make sure the design or lettering is the size that will best fit the space.

Within image 1: PLACE THIS STENCIL FIRST, EXTRA STENCIL #3, EXTRA STENCIL #1, EXTRA STENCIL #2

CREATING AND USING PLOTTER STENCILS

APPLYING AND PAINTING A PLOTTER-CUT STENCIL

It's simple to plan out and apply the various colors and layers when working with stencils. Common sense is your best tool when working with plotter-cut stencils. For most stencils, the main vector drawing with all the details will be the first stencil placed on the surface. Then remove the stencil pieces for the first color to be painted and paint that color. Next, remove the pieces for the second color to be painted. Cover up the first color sections with the extra stencil pieces that were cut, and spray the second color. Repeat this process over and over until all the colors have been painted. The next demo will show this process.

WEEDING

After a stencil is cut, at what point is the area to be painted removed from the stencil? Remove that material *after* the stencil is in place on the surface, *not before*. Having that material in place will help keep the other parts of the stencil in place, even after the transfer tape is on it.

First, the stencil is lined up on the tank. Tape is placed around the edges of the stencil, and lines are drawn from the tape to the stencil to indicate the positioning. Next, the stencil is removed, and transfer tape is applied to the top surface of the stencil and pressed down with a squeegee. Then, the stencil is applied to the tank and smoothed down with the squeegee. Refer to chapter 11 for more on applying transfer tape and stencils.

The insides of the first set of inner letters are removed using tweezers, and purple basecoat is airbrushed.

APPLYING AND PAINTING A PLOTTER-CUT STENCIL (continued)

The stencil material covering the border around the purple letters is removed. Here's where the extra stencils will be used. The purple letters are covered up with the letters from the extra stencil, stencil cutout #1.

Yellow basecoat is airbrushed. This will be the border around the purple letters.

The stencil material around the yellow border is removed and the yellow and purple letters are covered up with stencil cutout #2. Then orange basecoat is airbrushed.

The process is repeated one more time using stencil cutout #3. A red border is painted around the orange. And here is the finished shop sign on the side of the tank.

ARTWORK DONE WITH PLOTTER-CUT STENCILS

This POW logo was done with two stencils. One for black, one for white.

The stencil on the left is placed down first and sprayed with black. The stencil on the right is for the white parts of the logo. It was the same size as the first, so it could be placed directly on top of the black and everything would line up.

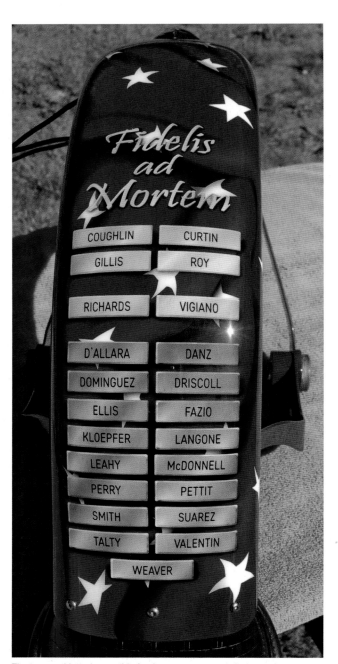

The tags and lettering on this fender were easy to do but complex to place. The stencil for each row of tags was placed separately on the fender. It can be challenging fitting a flat stencil on a curved surface. Take your time and figure out the best way to keep the stencil flat. Sometimes that means cutting the stencil into pieces.

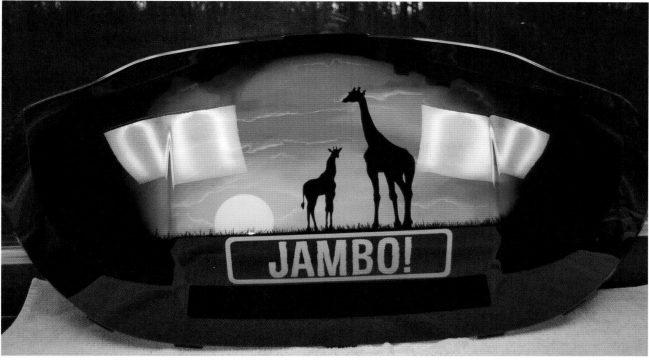

This was a simple but effective lettering project using CorelDRAW. After finding the desired font style, the letters were typed out, and a rectangular box was drawn around them. The stencil was applied to this golf cart hood, masked off, unneeded material was removed, and the letters were sprayed.

The complex logo on the side of this tank was created using a series of stencils, one for each color. The graphics around it were done after the logo was painted.

This Marine Corps emblem was challenging as it was large and detailed. It required multiple stencils and careful planning for the process.

ARTWORK DONE WITH PLOTTER-CUT STENCILS (continued)

The logo and lettering for Nu-Relics Power Windows has four colors and multiple layers. See the next photo for how it was planned and painted. The process was similar to the shop sign demo.

The top half shows the overall vector drawing for the stencil. This is cut and placed on the surface. But eight other stencils are also cut. These are seen on the bottom half. First, the parts that are black are removed from the surface and black is sprayed. Then using the extra pieces that were cut, the black areas are covered. Next, the red is sprayed and then covered. This process is repeated until all the colors are sprayed.

Chapter 14
Clearcoating

BEFORE YOU CLEAR OVER YOUR ARTWORK

Carefully examine the painted surface around your completed artwork. Are there any marks or impressions in the surface from the taping materials? Marks can sometimes be removed by precleaner, but actual impressions in the surface might need to be lightly sanded depending on how deep they are. Check the surface for any leftover adhesive from the masking materials. Spray or apply precleaner to a wipe cloth and clean the surface around the artwork. It's OK to preclean over your artwork, but do it carefully. Don't wipe too hard, especially if thin coats of paint were used for the artwork. Also, don't soak down your artwork.

Look for any paint that has snuck past the edges of your tape or stencils. Look for overspray, leftover pencil or powder lines, and anything that has affected the areas *around the artwork*. Because the surface is dull, it might be hard to see imperfections. Wipe some precleaner on it and look at it the sun or in the best light you have available. A powerful LED flashlight will work.

In some cases, I'll use 800-grit paper to lightly damp sand the areas that *did not receive any artwork*, carefully sanding around the artwork. This will remove things like overspray or drips that have found their way onto the surface. Never touch the parts with your hands. Wear nitrile gloves when handling, cleaning, or sanding the surface. After sanding, wipe the part or area down with a wet wipe cloth, followed by a dry one, and remove any water. Never let water dry on the surfaces.

The main reason for removing this water is so that minerals in the water won't remain on the parts after the

Show-quality clearcoat needs to be perfectly flat, without any orange peel or imperfections. The entire surface should look like it was dipped in liquid glass. The process is not complicated, but it requires a great deal of time and patience.

water has dried up. This can be a real problem if your shop is in an area with hard water or if you use well water. You can use compressed air to blow off the water immediately after wet sanding, but make sure your air source is clean and well filtered. Avoid blowing dirty, oily air onto a fresh, clean surface. Then recheck the surface with the precleaner and a flashlight. Chances are good that you missed something the first time. This step will also remove any leftover contamination.

TO SAND OR NOT BEFORE ARTWORK

One big thing to remember is what is under your artwork. Did you apply the artwork over basecoat color, basecoat clear, or urethane clear? What, if anything, was applied over the color coats? If the answer is basecoat color, do not sand it! If you sand or dig into that basecoat color, a light or uneven spot might be created. You'll be sanding into those color coats. That's why it's always a good idea to apply clearcoats of some kind over the color coats. If it's basecoat clear and there are flaws that need removed, carefully sand the flaw. Do not sand through the basecoat clear into the color coats. If urethane clear is under the artwork, sand away, but try not to sand through the clearcoat.

BASECOAT CLEAR	URETHANE CLEAR
USES	**USES**
• Can be used as a lockdown clear • Can speed up the artwork process • Dries quicker, doesn't pull or sag artwork • Great for use with dry pearl powders and metalflake • No pot life. Extra mixed product can be used later	• Once dry, it's an impenetrable barrier over artwork • Can be used as a lockdown clear • Better, more stable surface to work over • Recommended for leveling thick paint edges • Recommended for application of candy products • Candy colors will not bleed through dry UC
WATCH FOR	**WATCH FOR**
• Some candy colors can bleed through BC clear • Thinner product than UC, doesn't build up like UC • Not recommended for heavy, leveling coats • Not recommended as a build up clear • Heavy coats can take a long time to dry • Heavy coats can result in problems like wrinkling • Less stable surface for rework	• More costly • Requires hardener and has a pot life • Runs can drag down artwork on vertical surfaces • Runs easily if painted in heavy coats • Longer dry time than basecoat clear • Strictly follow the instructions in the P sheet

Basecoat and urethane clears each have their uses in custom painting. This graphic shows the uses and what to watch out for when using both basecoat and urethane clears.

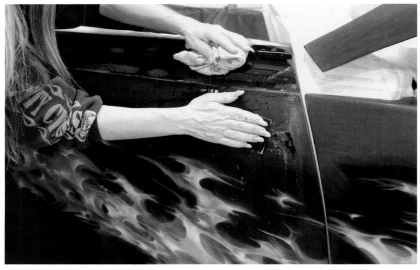

When possible, sand the surfaces around your artwork to remove any flaws or overspray. Look closely at the sanding debris in this photo. It has an orange tint to it. The overspray from the real fire flames traveled far past the flame area to the surfaces that needed to remain black. I was able to sand it off and then blend some black to soften the transition. Use common sense when sanding around your artwork.

DON'T OVERSAND!

Use care when sanding any clearcoat. It's very easy to sand through the clear, especially in areas like body lines and on edges. Sometimes it's better to wet sand up to the edges and bodylines, then switch over to a scuff pad for those areas.

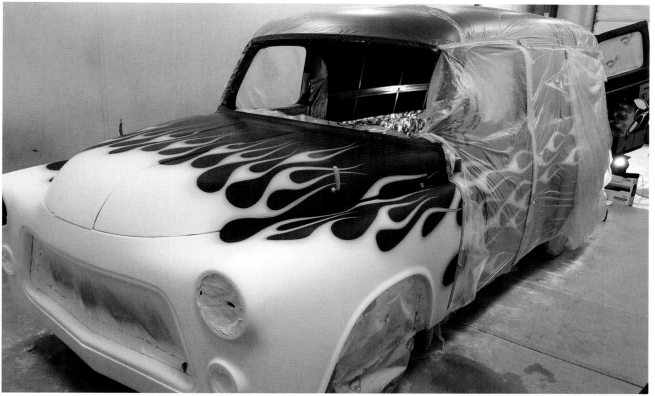

Here's the Dodge panel truck project. The clearcoat over the flames has been sanded and it's ready for rework and pinstriping over the flames. The back end and roof of the truck are masked off with plastic to keep off any overspray caused by the rework on the front end.

BASECOAT AND URETHANE CLEARS

Experienced custom painters use these products to protect artwork and level paint edges. There are various uses for both kinds of clear. Learn the benefits of both basecoat and urethane clearcoats. Urethane clearcoat is a thick solid material that works great for leveling out thick paint edges and provides a solid, secure surface over your artwork, which makes it easier to do rework. For example, if the airbrush spits out a blob of paint, the solvents in the blob might penetrate into the basecoat clear and into the paint beneath that. Solvents do not penetrate as deeply into urethane clear. Paint drips and flaws can be easily sanded off the thicker, more solid urethane clear without affecting the paint under the urethane. Urethane clear also locks down artwork and can keep candy colors from bleeding up into the topcoats. Use a urethane clear that is easy to paint.

Basecoat clears are thinner and have more solvents in them. Some painters use them as lockdown clears over artwork. They are sometimes used in between layers of artwork so that the tape and masking materials don't disturb artwork under them. If you need to touch up some candy paint, add candy concentrate to basecoat clear and use that. It's quicker and easier than mixing up urethane for a small touchup. Basecoat clears are good for locking down artwork and for mixing with dry pearl powders and metalflakes. But they are not recommended for leveling out paint edges. Do not apply more than four coats of basecoat clear.

As always, if you are trying something for the first time, create a test panel with artwork on it. Try both kinds of clear and experience the advantages of each kind. If you have test panels from creating your artwork, then use those to test and see how each clear reacts over your artwork.

CLEARCOATING WITH BASECOAT CLEAR

Clearcoating over artwork with basecoat clear is fairly simple. Apply it like you would any basecoat. Follow the directions on the product's P sheet. Apply up to four coats of clear. The first coat should always be a light coat, followed by light to medium coats. No heavy coats! The

product's P sheet will also tell you how long the basecoat should dry before sanding or recoat. One advantage to using basecoat clear is that you don't always *have* to sand it before more basecoat is applied over it. House of Kolor's SG100 and PPG's DBC500 Color Blender are two good examples of basecoat clear.

CLEARCOATING WITH URETHANE CLEAR

Urethane clear is designed to flow out after it's sprayed and dries much slower than basecoat clear. That means if a run or sag is created over uncleared artwork on a vertical surface, the clearcoat can "grab" the artwork and the artwork might flow with the run or sag. So, it's very important to use the hardener and reducer best suited for the temperature in the paint area. For leveling out over artwork, you want a hardener and reducer on the fast side. But not too fast or the top surface will skin over before the solvents in the bottom coats have a chance to evaporate out. This can cause solvent pop. Use the products best suited for the temps in your shop and test with painted panels before trying it out on the actual artwork.

Start by applying a light to medium coat of mixed urethane clear. This allows the urethane to cover the artwork and create a barrier over it, locking down the artwork. Now heavier coats can be applied without affecting the artwork. Follow the instructions on the P sheet for times in between coats. The second coat can be more of a medium coat. The third coat is usually a medium to heavy coat followed by a heavy coat—heavy enough to flood clear over the paint edges, but not heavy enough to run or sag the paint.

On the last coat, a painter may try to "flood" the edges with a little extra clear. But this can lead to more problems. Clear applied too heavily can result in solvent popping and other issues depending on the brand or kind of clear being used. To avoid such problems, it's good to know your products and get some experience

CHECK YOUR HARDENER/CATALYST

When using urethane clear, make sure the catalyst is fresh. If the catalyst looks syrupy, yellow, or has solid or seedy bits in it, don't use it. Always check the appearance of any product you're looking to apply. If it doesn't look right, don't use it.

with them before you push the limits. If you're unfamiliar with using urethane clear over artwork, do a few tests. Make learning mistakes on test panels, not on your project.

REWORKING YOUR ARTWORK: BASECOAT CLEAR

If you used basecoat clear as a lockdown over your artwork, and you'll be applying urethane clear after any rework is done, the basecoat clear will need to be lightly sanded or scuffed. Refer to the product's P sheet for recoat or sanding requirements. Many paint brands require the surface to be sanded or scuffed if it has dried for twelve hours. For wet sanding basecoat clear, using 800-grit sandpaper is usually a good choice. When and how to do any rework or edits to your artwork depends on the kind of clearcoat used and the kind of rework needed.

If basecoat clear was used and minor touchups are needed (no taping), then the rework can be done shortly after the basecoat clear has flashed (dried dull). If you need to tape off and then apply the touchups, then you need to make sure the basecoat clear has dried enough so that the tape doesn't leave impressions in the surface. Apply some tape to a test area and pull it off. If the tape doesn't affect the surface, then do any touchups. But don't leave the tape on overnight. Just have it on long enough to do the rework. Once the rework is completed, examine the surface for flaws and you're ready for finish clear.

REWORK OVER URETHANE OR LEVELING CLEARCOAT

One big fact to remember when sanding (leveling) urethane clearcoat over artwork is that each situation will be different. It's not a one size or one technique fits all. This is where common sense is one of your best tools. For thick paint edges like those on traditional flames or complex graphics, don't try to sand the artwork edge until it's flat. Often, if you sand a thick paint edge completely flat, you'll not only sand through the clear, but you might also sand into the artwork.

Sand the surface, but don't sand through the clear. Once the surface is taken down as much as it can be without going through, then stop. How can you tell? When you sand clearcoat, the residue from the clear is white. Once you start to sand through, you'll see some color in that residue. Don't sand any more in that area. Look carefully as you sand, and hopefully if you do sand through, it's not too deep and not in a critical area.

Once the urethane clear is sanded, chances are there will be some places where the layer of urethane clear has been sanded down and now that layer is very thin. If you're applying basecoat over urethane clear, take care not to apply it too heavily. If basecoat is heavily painted over a thin spot in the urethane clear, the solvents in the basecoat can wrinkle or lift that thin layer of urethane clear. For example, if you've sanded away part of your basecoat color while sanding the leveling clear, use care when touching it up. Apply light coats and, if possible, mix your basecoat color with less reducer in it.

For very thick edges, once you've sanded as much as you can, you'll see a shiny area along the edges of the artwork. Those shiny areas need to be scuffed. Using a scuff pad like Mirka's Mirlon 800 #18-118 scuff pad, sand along the shiny areas until they are dull. Super thick paint edges might need a second round of sanding and clearing.

Now do any rework and recheck the areas around the artwork. Once you're satisfied with everything, it's time for finish clearcoat.

PREPPING FOR THE FINISH CLEARCOAT

If you're ready for finish clearcoat, then all the old masking materials, like around trim or glass, must be removed from the vehicle. That means everything, all the tape, everything! Some painters will simply tape over the old materials with fresh ones, *but* that approach wastes an opportunity. No one is perfect. There's a chance some mistake was made when taping the car the first time. This is the time to find that mistake and fix it.

Then, if possible, move the vehicle to a different place and clean the paint area. If you're working in your garage or using a professional booth, this is the time to clean your area. Once everything is clean, place the vehicle or parts in the paint area and blow out every crack and crevice of the vehicle. If using a paint booth, have the fans running. Give the area time to clear. Then wipe the vehicle or parts down with a post-painting solvent precleaner, like PPG's SX320. Look for sanding residue in any recessed areas and wipe it away. Make sure to wipe away any precleaner.

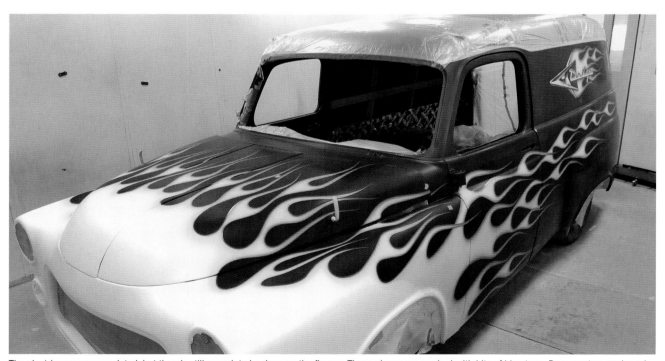

The pinstripes were completed, but there's still rework to be done on the flames. Those places are marked with bits of blue tape. Document or mark each flaw that needs to be addressed.

CLEARCOATING

Next, it's time to remask the vehicle. Proper masking for finish clear can make a big difference in how much debris lands in the clearcoat. Take time with masking your project for finish clear.

Now blow off the vehicle or parts again while the fans are running. Next, wipe the surface with a Gerson Blend Prep tack cloth to remove any dust or debris that remained on the surface.

Sometimes there's not much room in the paint area, so in this home shop, some of the parts are hung up for finish clearcoating. When hanging up flat parts like hoods and trunk lids, take care not to run the clearcoat. Spray the first coat of finish clear and see how much it flows after fifteen minutes. Then adjust your timing to achieve a smooth finish with no sags or runs.

There's plenty of space in this paint booth to lay out the parts and have room to move around while finish clearcoating. The undersides of the hood and fenders have finish clear on them already, so those undersides are masked off.

Please note that the next three photos were taken after the clear was done. The trunk lid, hood, fenders, fender extensions, and lower front valance were painted off the car. The rear window and trunk openings are masked off. To mask off the trunk, I ran American Tape's 2-inch Aqua Mask around the bottom edge of the drip channel. Then I cut out a piece of USC #38018 masking paper in the shape of the opening and laid it on top of the tape that stuck out past the drip channel. For the rear window opening, I simply taped along the edge. And then cut a piece of masking paper to fit.

It's better to clearcoat doors off the car, but it's not always possible. On this Firebird, the doors were clearcoated while on the car. Masking is all about common sense. You need to know what will show and what will be covered by chrome and trim. Hopefully, reference pictures of the vehicle were taken before the car was disassembled. If not, then go online and find pictures of your vehicle and see exactly what shows. You want the clearcoat to flow under the edges of any trim pieces.

There was a special coating under the car and in the wheel wells. To keep overspray off these areas, masking paper was taped around the bottom of the car and allowed to hang down. It was then taped to the floor. This completely masked off the underside of the car. This also is very helpful if you're painting a vehicle with the suspension installed.

MIXING AND APPLYING THE FINISH CLEARCOAT

Mixing finish clear is not a step to be rushed through, as you need to consider multiple variables. Because each brand and kind of clearcoat is different, consult the P or product sheet for your clear, and mix the product accordingly for your shop conditions. For example, our shop was on the cold side with temps around 65–70 degrees Fahrenheit. I used a medium reducer with my clear. The DCU 2021 urethane clear was mixed four parts DCU 2021 to one part DCX61 hardener, and one part DT885 reducer was added.

To spray the best possible finish clearcoat, start by spraying a medium to heavy coat. Watch as the paint hits the surface and adjust your gun speed to get a smooth, flat coat. But remember, slower clears will flow for a while after you're finished spraying. A finish with a slight orange peel at the time of spraying might flow out to a smooth, glassy finish after ten or fifteen minutes. If you're using a clearcoat product for the first time, test your product on a spare car part. Spray it just like you would on the vehicle. Does it flow out? Or run? Or stay bumpy? Find out which temp reducer works best and fine tune your painting technique until you get the desired finish on the test panel. Then repeat on your project vehicle.

Clearcoat likes to build up on edges and in recesses on the parts and tends to run or sag. Use care not to apply the clear overly heavy in these areas. A spray technique that works great for large flat horizontal panels like hoods might not work so well for recessed trim areas on the side of the car or truck. Adjust your gun speed as you paint.

HOW PAINT WORKS

While temperature is important when painting, it is absolutely critical when it comes to spraying clearcoat. A poor decision here can add untold hours to the job after the clear is sprayed. You want the paint to flow smooth, and slower reducers do that. But remember, the colder the shop is, the more the paint will flow. In fact, it can flow right off a panel or part, creating runs and sags. Be sure to use the proper temperature of reducer in your clear. The colder the temps, the faster the reducer needs to be. The hotter the temps, the slower the reducer needs to be.

Clearcoat will take longer to flow and dry when it's cold. That means it's more prone to run and sag. If you have a booth with heat, then you can fine tune the temp while painting. If not, then you need to pay attention to make sure you are mixing and applying the clearcoat to best suit the temperature in the paint area or booth. Spray the first coat medium and see how much it flows during the recoat window. Then adjust your spray technique accordingly. Heavy coats take longer to dry and will flow more than thinner coats.

MIXING AND APPLYING THE FINISH CLEARCOAT (continued)

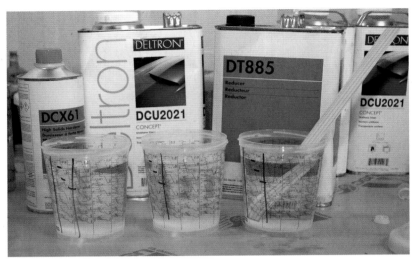

Mix up enough clearcoat to apply one coat of urethane clear on the vehicle. I've mixed up three 18-ounce cups (54 oz.) of PPG DCU2021 Deltron clearcoat. The DCU2021 is mixed 4:1:1 with DCX61 and DT885. When painting finish clearcoat, slower reducer slows down the paint and allows the clear to flow out better. Use the reducer best suited for your painting conditions. After the first coat, you'll have a better idea of how much clear to mix up for the second and third coats. The marks on each cup document the exact mixture in the cups. If there's a problem later, I'll know the paint mixture is not to blame.

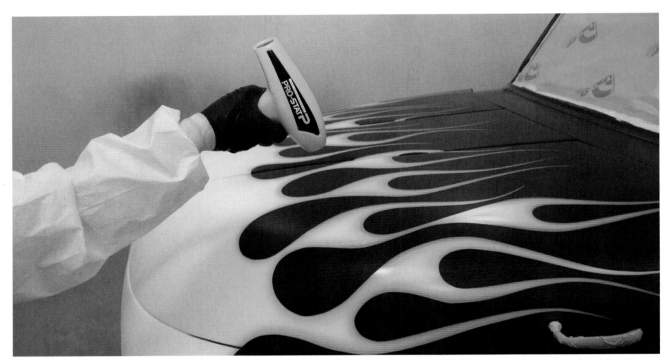

One trick to help get a dust-free finish is to use an antistatic gun like this ProStat. Painters have several tricks to remove static from surfaces. They'll attach a ground cable from the car to a steel rod attached to the concrete floor. Another trick is wiping the car with an antistatic precleaner, like House of Kolor KC-20. Always do this after the surface has been tack ragged. Wiping creates static.

LESS CAN BE MORE

One of the biggest things to remember when spraying clearcoat is that it's easier to remove orange peel than sand out runs. Runs are tricky to remove for many reasons. But sanding and buffing clearcoat is much easier. Many show car painters sand and buff the entire surface of their projects. They'd rather do that than try to remove runs. Remember this as you're spraying the clearcoat. Orange peel and dry spray are much better than runs.

WHY ARE CLEARCOAT RUNS SO BAD?

Runs are difficult to remove completely. The worse or bigger the run is, the harder it is to remove. One reason is that the paint on the run is thicker than the paint surrounding it. This means it's drying slower than the surrounding paint. Paint shrinks down as it's curing. If the run is sanded off before the paint is completely cured, the paint around the run will cure (shrink down) faster than the paint of the run. The run will actually "ghost" through the surface and be visible again. Solvent pop also can happen in very bad runs, especially on paint that builds up on edges. It's also easy to sand through the clearcoat surrounding the run when trying to sand the area level. Once that happens, you'll have to sand and reclear that panel.

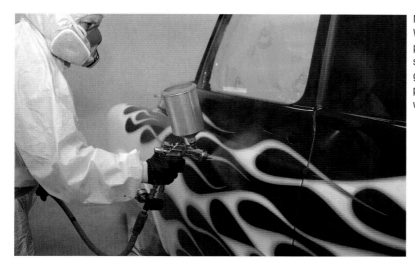

Now it's time to spray the clear. I'm using an Anest Iwata WS400 with a 1.3 nozzle applying the clear with a 75 percent overlap and moving the gun at a medium-fast speed. I like to spray very close to the surface. Here the gun is 7 to 8 inches away. This is where spraying on a test panel comes in handy—to help develop the technique that will work best for you.

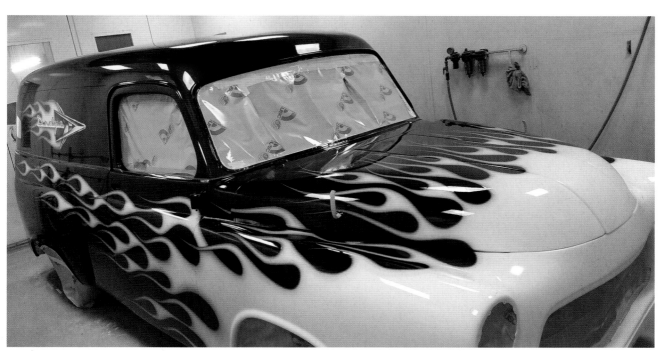

The clearcoat is done on the Dodge panel truck. It was challenging, as the hood panels and doors were in place on the truck. I had to take my time. It's very easy to rush through this last step in the paint application process. Don't paint finish clear when you're tired or at the end of the day. Give this step plenty of time to get the job done properly.

Chapter 15
Troubleshooting and Problem-solving

Problems are going to happen when you do artwork. There's no escaping it. Weird, irrational errors will crop up, and most of the time, there's no obvious reason. This can stress out the calmest person. The main thing to do when troubles pop up is to remain calm. Keep hold of your common sense. Investigate the problem, research it, think it through, and fix it. The following are common difficulties that arise when painters do custom artwork along with solutions to the problems.

PAINTED SURFACE PROBLEMS

Dripped or spilled paint on a freshly airbrushed surface. Let it dry. Or if it's a heavy drip, using a soft, lint-free wipe, gently blot the *very top* of the bubble of paint. *Don't* push down on it and smear it onto the surface. Just blot away most of it. After it dries, gently sand away as much of the drip as possible without getting into the color beneath it. Then retouch the surface with your airbrush. Don't worry if an outline of the drip can still be seen. After you clearcoat, just retouch that area again with the airbrush and it should disappear.

But what if the drip or spatter lands where there's no artwork being done? This is a reason I only airbrush artwork over urethane clear. It's easy to sand off flaws. If the drip or spill is on urethane clear, just let it dry and wet sand it off. If paint is dripped on basecoat color or clear, the solvents in the drip might penetrate into the basecoat layers. Try to damp sand off as much of the drip as possible without removing any basecoat color. Then try to touch it up. Solid colors are much easier to touch up than candy, metallic, or pearl colors. You might have to respray the entire area, depending on how obvious it looks.

Pulling up tape and paint comes with it. Hope that it's happening in just one spot. Look at the edges of the spot. Use a stencil knife to poke the broken edge and see if the whole layer is lifting. Did you thoroughly sand all the previous coats that needed to be sanded and used

Don't let airbrush problems get you down. Thinking through the problem and factoring out causes helps resolve most issues. Worst-case scenario, you may have to start over completely, but that is very rare.

This is what happens when the cap is not tightened down securely on a gravity-feed airbrush. And the reason why a painter should always thoroughly mask off around the artwork area. While this spill would be relatively easy to damp sand away if spilled on a urethane base, if it was spilled on basecoat, it may have been a disaster.

the proper grit paper? If so, then this may just be an isolated incident. After removing the lifted paint, feather edge sand the area. Make sure to remove all lifted or loose paint. If it's real deep, fill the pit with polyester filler, tape off, spot prime, spot paint, rework the artwork. If shortcuts were taken or you're not 100 percent sure of the adhesion of the paint layers or if

someone else did the basecoats, this could be a serious problem. Stick 2-inch tape onto the part, let it sit a while, then rip off the tape. Did the paint come up? In short, test the area to see if it keeps happening. If it does, remove all the paint.

Tape marks in paint. This tends to happen when the paint being taped is not dry enough. Thin applications of solid colors will dry fast and can usually be taped over immediately after airbrushing without issues. But thicker applications of paint like candy and pearl colors will need some time before being taped over. As for how much time, that depends on the thickness, the paint, and the painting conditions. Get to know the products you're using. Some dry faster than others. When taping over candy or pearl graphic layers, I might wait six to twelve hours just to be sure.

Paint sneaking under tape. This happens because the tape wasn't pressed down firmly enough. Always double and triple check your tape, especially where the surface is not flat. Any time tape goes around a curved inset, the tape wants to pull away from the surface. Any place the tape goes over other tape or masking, it will tend to pull up at that point. This is a big problem when doing rally stripes because the tape lines will cross each other in many places.

Some tapes are more forgiving than others. Test your tape and know what to expect and which areas you will need to double check once the taping and masking is done and you're ready to spray the paint. If painting rally stripes, check each tape intersection right before painting. Use a fingernail or the sharp edge of a tool or squeegee to secure the tape edges against each other. If paint does sneak under your tape, try to sand away that paint. Or rework the area. Then respray the hard line.

Ragged or rough paint lines. This tends to happen when masking tape is used to create a hard line in rally stripes, flames, and graphics. Use fine line tape instead. Fine line tape has a much cleaner and sharper edge than masking tape. You can practice with both materials on a test piece to see the differences prior to doing the job.

Sanding through candy and pearl color layers. If you sand through your candy or pearl layer, creating a light spot, it's a hard problem to fix. Depending on the color, you might be able to carefully spot it in without creating a dark spot or uneven area. If it's a layer in a graphic, it

This is an extreme example of what happens when paint layers don't bond securely to the paint underneath. I had sanded and then stuck tape to the trunk of this Miata. The paint came up with the tape. I used an air hose and sheets of paint came off the car. Most of the white paint had to be removed from the car and the white was resprayed before I could do any artwork.

Here's what happens when tape is applied on paint layers that aren't dry enough. The tape dug into the soft black paint of the graphic and left impressions. I had to sand down the impressions and respray the black.

might be easier and quicker to let the area dry and respray the graphic.

Contamination and fingerprints. Always make sure your surface is clean. Keep precleaner close by and use it as needed. I also keep a spray bottle of House of Kolor KC-20 handy. KC-20 is a water-based cleaner that is great at removing organic contamination, like fingerprints. But then I always follow up with a solvent-based cleaner, like PPG's SX330. As a rule, unless you have prior experience with the products you're using,

use a solvent-based cleaner after cleaning with a water-based cleaner.

Fingerprints under clearcoat don't show up right away. It can take a few months and then these ghostly fingerprint images will start appearing. Sure, your hands seemed clean while painting, but something was deep down in the ridges of your fingerprints, and over time, what was left behind on the surface has reacted with the paint. Now you have ghost fingerprints under the clearcoat.

It's hard to avoid getting fingerprints on your work surface. We're constantly touching it. Even though we're using gloves for most of the job, it's hard to tape off graphics wearing gloves. The way to deal with fingerprints on paint surfaces is to remove them completely before spraying any paint or especially clearcoat. Take the time to thoroughly clean that surface! If you get ghost fingerprints under your clearcoat, there's no easy solution. Sand the part and rework the area with the fingerprints. Treat it like you would any editing of artwork post clearcoat.

Uneven fades. Getting a consistent and even candy fade on flames and graphics is a challenge for beginners. The airbrush or mini spray gun must be moved at an even speed and the movement itself must smoothly follow the line of graphic. Keeping one finger touching the surface as you move the airbrush will help steady the motion. Jerky or irregular movement will make the fade

uneven. If you produce an uneven candy fade, there are two ways to fix it.

1) You can try to softly retouch the center of the fade before touching up the fade itself. For example, to fix yellow hot rod flames with an orange fade along the edge, take an airbrush and softly spray some yellow along the center of the flame. Then redo the orange fade.

2) For candy fades where the center cannot be touched up, like with a metallic or pearl base, try using the candy to extend the fade close to the center of the flame or graphic. Hopefully, this will even up the fade.

What to Never Do. Never, never, never bake paint in the sun. I tried it once. Extremely bad idea. The heat of the sun dries the top layers of the paint too fast, trapping solvents in the lower layers. The trapped solvents push up against the top paint layers, forming bubbles. Ever since, I dry my paint in my shop. As a rule, I tend not to bake paint that has artwork on it. Some painters do; most don't. If you are a newcomer to custom painting, it might be a good idea to let custom-painted parts or vehicles air dry.

Shortcuts = Problems. Many paint-related problems are due to rushing through the artwork process. Take the time to do the job correctly. Clean the surface between each application or layer of graphics. Look over your work surface for problems. Double check all the tape immediately before spraying paint. A few moments of precaution can save hours of rework.

The Reality of Rework. Like it or not, most automotive or motorcycle artwork will need some rework. Paint sneaks past tape lines, metallics will look uneven, or the airbrush will spit out a blob of paint. The best thing to do is to realize and know it, and plan on spending a day or more doing rework after the first round of filler/leveling clearcoat has been completed. This happens on most paint jobs and to most custom painters. And the more artwork you paint, the more rework you will need.

Don't get frustrated when you see small flaws appear. They're part of the process. Print out photos of the artwork and mark on the photos the areas that need to be reworked. This way you don't miss any. It's an awful feeling when you think that you're completely finished with a paint job and you see a small flaw that would have taken five minutes to fix had you seen it before spraying the finish clear.

This is a flaw in the artwork on a Trans Am hood. See the little black marks in the darkest gold? There was a little bit of adhesive left from the previous layer on the surface. It was not cleaned enough before spraying the color. I had to mask off this small section and respray the dark gold. This is why you always carefully check and clean the surface before applying paint. It's also a good idea to mix plenty of paint for artwork. Chances are it will be needed for touchups like this.

AIRBRUSH PROBLEMS

The specific remedy for an airbrush problem depends on the airbrush being used. Visit the website of the airbrush you're using and find a parts breakdown. This way you know the location and name of each part of your airbrush. Keeping the airbrush clean is the best way to keep it working fine. At the start of each airbrush session, I remove the needle and give it a quick wipe with thinner. In addition, always protect the business end of the airbrush. Keep protective caps in place when airbrushes are not being used. Here are common airbrush problems and their causes and remedies.

Grainy Airbrush Spray or Gritty, Rough Paint Surface. Instead of a smooth, soft distribution of color, the paint hits the surface and appears grainy or spotty. In some cases, the paint actually spits out of the airbrush. There could be several reasons why this is happening.

Cause: The most common cause is that the paint is either too thick or the air pressure is too low. Look at your paint. Is it already very thin? Then turn up the air pressure a few pounds. Also check to make sure the spots or "spit" are coming from the tip of the airbrush. Sometimes paint can build up on the crown cap or spray regulator. This will also cause spitting.

Remedy: Unscrew the crown cap/regulator and clean it with a cotton swab dipped in thinner. And while you have the spray regulator off, carefully clean the area around the tip.

Cause: Paint buildup in or on the tip or the spray regulator can restrict the flow of paint and cause the airbrush to produce a grainy spray.

Remedy: Remove the tip and spray regulator and carefully clean them. Using a reducer that is too fast causes the paint to start to dry before it hits the surface. Use a slow reducer for the best results.

TINY PIECES

Some tips are held in place by threads and the little wrench that comes with the airbrush must be used to unscrew the tip. Other tips are simply pushed in place and held there by friction. Take care with those, as they can fall out very easily when working on the airbrush. Work over a towel. That way the tip won't roll away and be lost forever.

Paint comes out of the airbrush even when the trigger is not pulled back.

Cause: Something, maybe dried paint, a hair, or a fiber, is caught in the tip causing the needle not to close into the tip properly.

Remedy: Remove the tip and clean it. Very carefully, use an old airbrush needle or airbrush reamer to poke into the tip and see if there's anything caught in the passage. Flush with thinner or cleaner.

Cause: Wear and tear on the needle and/or on tip is causing paint to escape through those gaps.

Remedy: Replace the needle and/or tip. Replace the needle first. If the problem is still present, replace the tip.

Cause: This issue can also be caused by paint leaking into the air passages past the needle bearing/seal.

Remedy: Refer to second problem on page 216.

No paint comes out of the airbrush or the trigger must be pulled back farther than normal to get paint flow.

Cause: This problem is caused by something caught in the paint passages.

Remedy: Remove the needle and tip. Thoroughly clean them and the paint passages in the airbrush body.

Air flow is inconsistent.

Cause: The spray regulator or airbrush head is not sealing properly, causing outside air to affect the airflow. This part could be loose, or with some airbrushes, the head washer could be worn.

Remedy: Remove the spray regulator or head. Look to see if sealing surfaces are clean and free of debris. Properly tighten regulator. Replace head washer if applicable.

No airflow.

Cause: Refer to previous problem.

Remedy: If that doesn't fix it, the most likely reason is that the seal in the air valve has swelled up and needs to be replaced.

Cause: The air valve is on the bottom of the airbrush where the air hose attaches to the airbrush. Inside the air valve is a thin piston. When you push on the trigger of the airbrush, it presses down on this piston. The seal wraps around the piston. Sometimes paint can get down into the air valve chamber and the seal swells up and will block the airflow.

Remedy: Replace the seal.

No paint comes out when using a siphon-feed airbrush.

Cause: Either the tube or siphon cap is clogged or the air hole in the top of the cap is clogged.

Remedy: Check and clean the paint passage up from bottle and clear out the air hole.

Needle does not move smoothly when pulled back.

Cause: Paint may have leaked back past the needle bearing/seal and is sticking in "machinery" that pulls the needle back. Very reduced paint will leak out faster than thick paint. Paint leaking into the airbrush body can also leak into the air passages of the air valve.

Remedy 1: Remove needle and clean. Replace needle in the airbrush and test. If not fixed, try Remedy 2.

Remedy 2: Remove the needle and needle guide spring/chuck assembly. Remove trigger. Take apart the needle spring/chuck assembly and thoroughly clean. Clean out the airbrush body inside with cotton swabs or brushes. Use a small, round brush to clean out the needle chucking guide and parts. Reassemble. If paint has been leaking into these areas, the seal, bearing, or packing that seals the head from the body is worn. This part has different names depending on the brand of airbrush, but it's the packing that the needle slides through. It's installed in the airbrush body, between the head and the open area where the mechanism is that holds the needle. In some airbrushes, this packing or seal is not too hard to replace. In others, it's a total pain. And in some airbrushes, like Badger and SATAgraph 4 airbrushes, there is an adjustable set screw that tightens up the packing seal. Clean out the body, and if needed, take apart the air valve and clean that also. Remove the head assembly, reinstall the trigger, and blow air through the brush until it comes out clean. Basically, clean out every bit of paint from the airbrush, then reassemble.

Paint piling up on the tip of the airbrush. Water-based paint users get used to "picking" the paint off the tip of the airbrush. This problem arises more often with water-based products, as they dry so quickly.

Cause: A few things contribute to this issue. Fine work requires lower air pressures, but the lower the pressure is, the slower the paint flows through the airbrush. Because of the low velocity, bits of paint stick to the end of the needle and it builds around the tip.

Remedy: Always pay attention to the airbrush. When using auto paints, I've gotten into the habit of "clearing out" an airbrush that's been sitting for a while with paint in it. For example, I'm spraying yellow for a woman's hair. Then I need to add white highlights. After I'm done with the yellow, I pick up the airbrush with the white, which hasn't been used in the past few minutes. I point this airbrush towards my ventilation outlet and away from the painting surface. I pull back all the way on the trigger and give a good blast of paint out of the airbrush. This does two things. It takes away most of the paint that is built up on the tip and it also clears away any wet paint that may have settled on the inside surface of the spray regulator or crown cap.

Note: This only works with solvent-based paints, as the solvent in the paint is so strong, it can soften the paint on the tip so that it blows away. This trick *does not work with water-based paint*, which does not resoften. Once waterborne paint is dry, it must be picked off the tip. If using water-based paint, get in the habit of picking the paint off the tip each time you pick up the airbrush and every few minutes while airbrushing. It seems frustrating at first, but after a while, it will become something you automatically do, without even thinking about it.

CARE OF YOUR AIRBRUSH

Many airbrush problems arise from poor airbrush maintenance. Airbrush days are long, and the last thing any artist wants to do at the end of a brutal frustrating day of attempting perfection is to thoroughly clean the airbrushes. It's easier to fool yourself into thinking, "I'll just take a little break and come back later to clean the brushes." And then you wake up the next morning and sit down to airbrushes still full of paint. It happens to everyone once in a while. So, take the extra five to ten minutes and clean them. Each brand of airbrush is different and will be slightly different in the way the inner workings are designed. Don't lose or discard the little pamphlet that came with your airbrush. It will have a diagram that shows how the pieces inside your airbrush fit together. Even though the airbrush appears to be clean, it's amazing the amount of stuff that gets left behind.

HOW TO CLEAN YOUR AIRBRUSH

Cleaning a Gravity-feed Airbrush

Once you're done painting, pour the paint out of the airbrush. Then add a little thinner to the color cup and swirl it around with a small paintbrush, pushing down into the recesses of the cup. Pour out the thinner and refill the cup with thinner. Now pull back the trigger and blow the thinner through the airbrush. Using a cleaning brush or cotton swab, wipe the color cup. If you see any color residue, repeat the cleaning process. Remove the needle, clean it, and reinstall it. *If using water-based paint, only use the recommended cleaning products.* Do not use auto paint thinner to clean up water-based products.

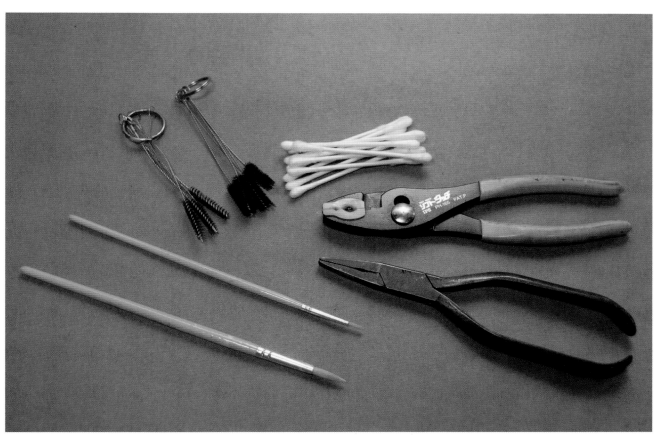

Here are the tools I use to keep my airbrushes happy and healthy: cotton swabs, narrow paintbrushes, small diameter soft round brushes, soft jawed airbrush pliers, and a set of pliers with flat, yet toothed jaws.

COMMON PROBLEM FOR DUAL-ACTION AIRBRUSHES

Many times, the airbrush just seems to be working incorrectly. Maybe paint comes out when it shouldn't. Or the trigger feels funny. If you find yourself dealing with a problem that is hard to pin down while using a dual-action airbrush, try this. Remove the airbrush handle. Grab onto the needle-chucking assembly. Is it loose? If so, simply tighten it up. This assembly has a habit of coming loose occasionally. I have no idea why, but it happens.

CLEANING A SIPHON-FEED AIRBRUSH

Keep a bottle filled with thinner. After you're done airbrushing, place that bottle on the airbrush and run the thinner through the airbrush. Then place a soft rag at the end of the airbrush and pull back the trigger. This will clear out any materials in the paint passages of the airbrush and push them into the thinner bottle. Look to see if clean material is blowing back into the bottle. If it's not clean, then repeat the cleaning process. Then remove the needle and clean it. Swab out the bottle connection with a cotton swab or brush.

Many times, even with proper cleaning, you'll go to the airbrush and the trigger won't move, or it doesn't move smoothly. No problem, it happens all the time. Just pull out the needle and clean it. Much of the time, stuff forms on the inner diameters that surround the needle and after a night of sitting, that material gets on the needle, causing it to stick. This happens very frequently when using automotive paints. In fact, I clean my airbrushes each morning before I start working and then clean them at the end of the day.

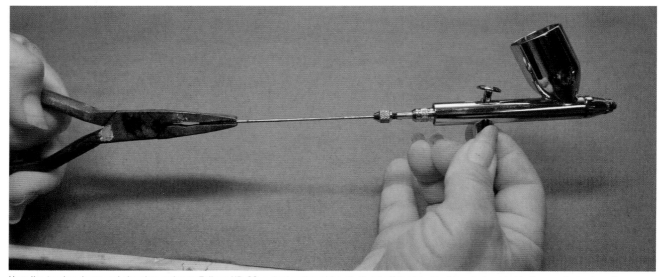

Here I'm tearing down and cleaning an Iwata Eclipse HP-CS, a dual-action airbrush. Twist off the handle. A knurled nut holds the needle in place. Loosen that and slide out the needle. If the needle does easily pull out, firmly grasp it with the pliers and pull it *straight* back. Make sure to pull it straight back because if you pull it at any kind of angle, it will bend the needle. Take care or else you will be replacing the needle.

Wow, look at all the paint residue on the needle! I'll wipe it with thinner and clean it until it's all smooth, using a cotton swab to wipe down the needle.

Inserting the needle back into the airbrush is the tricky part. It takes a little experience to know when the needle is seated properly in the tip. Push the needle in too far and it will damage the tip. But if the needle is not inserted far enough, there will be space between the needle and the tip and paint will go through that opening, even if the trigger is not pulled back. So gently slide the needle and feel it settling up into the tip. It will stop when it is properly in place, so don't force it. Next, tighten the nut. Pull back on the trigger and make sure it has nice smooth travel. If not, then repeat the needle-cleaning procedure.

AIRBRUSH AND CUSTOM PAINTING RESOURCES

The following places may come in handy for finding products, answering questions, airbrush classes and so on:

www.coastairbrush.com

Coast Airbrush is a great resource for most kinds of painting tools, equipment, paint, templates, and any kind of material for airbrush artists. The website also video tutorials and news about events and classes. Follow their social media to find out the latest new products and advice. Coast is a great resource to help with problems. And a great way to find out what's going on in the airbrush world.

https://airbrushthemagazine.com/

This magazine and its website is all about helping airbrush artists. They have many great tutorials and feature all kinds of airbrush artists. See the new upcoming artists and find the best advice and how-to articles from many legendary artists.

www.crazyhorsepainting.com

This is my website. From this site you can check out my social media pages. Post questions and check out the latest work. There is also a link to my YouTube channel, which has a good deal of how-to videos posted on everything from metal fabrication to custom painting to airbrushing. There are several stores where you can buy merchandise, such as airbrushes, equipment, and cool shirts. There's also a link to all the tools I use.

Resources

For more information on the products used in this book, please check out these websites.

SATA Spray Equipment (sata.com)
Spray guns, airbrushes, air systems, breathing protection, air filtration, and more. They also have a YouTube channel with excellent how-to videos.

Anest Iwata (anestiwata.com)
They have professional spray guns, spray equipment, compressors, and many things for the paint shop that I use.

Badger Airbrushes USA Airbrush Supply (usaairbrushsupply.com)
A one-stop shop for airbrushes, paints, and other artistic products.

PPG Refinish (us.ppgrefinish.com)
High-quality paint and painting products. The website features the latest news and products concerning automotive paint and refinishing.

FBS Distributors (fbs-online.com)
Tapes, sprayers, masking systems. I use a lot of their products.

Rupes (rupes.com)
This company makes the best equipment for buffing and finishing paint. Their Bigfoot sander gets used all the time in my shop.

JoAnn Bortles' Amazon List (https://www.amazon.com/shop/crazyhorsecustompaint)
Many of the tools and materials seen in this book can be bought on Amazon. All of the items in this store are products I use. Many unique tools that make my work life easier.

Artool Templates (www.iwata-airbrush.com)
Artool templates are the handiest tool for anyone doing custom paint and airbrush work.

House of Kolor (houseofkolor.com)
Many great products, paints, pre-cleaners, pearl powders, and flakes for the custom painter.

Gerson (gersonco.com)
Tack clothes, respirators, strainer systems, and more.

Acknowledgments

The author would like to thank the following people for their help and support. Tom Prewitt, Ron Peyton, Vinny Liotta, and Mike Lavallee for their advice and words of wisdom in tense painting situations. To Johnny Hunkins of *Car Craft* magazine for his editorial honesty. Thanks to Zac Faukenberry, Ryan Young, Andy Anderson, Paul Stoll, Frank Ruiz, Sean Sweeney, and Ron Gibbs for their help and for sharing their knowledge and photos with me. Much appreciation to Walt Clark and Mike Charles for the 55 Dodge Project. Thanks to Karen Salvaggio and the Valkyrie Project and to Dave Smith and Factory Five Racing for the Factory Five Flamed Hot Rod Project. Thanks to Capt Larry and Steve Sharkey for the Fire Merc project. Many thanks and appreciation to Cristina Fronzaglia for all her support over the years. Her support for my shop and books have made all the difference. Thanks to Jim Bortles for building incredible motorcycles for me to paint! Much gratitude to Jon Kosmoski of House of Kolor for inspiring me and being my friend. And complete gratitude to David Malkin, my partner in work and life.

About the Author

JoAnn Bortles started working on cars and motorcycles in 1976 and is the owner of Crazy Horse Custom Paint. She is an awarding-winning custom painter, airbrush artist, automotive restoration expert, tech writer, and photojournalist with over 40 years of experience in the motorcycle and automotive industry.

She is the best-selling author of eight books on automotive and motorcycle painting and has written for many motorcycle and automotive magazines including *Easyriders, Car Craft, Hot Rod, American Iron, Ironworks,* and *Chevy Hardcore.*

JoAnn is the first woman to own her own custom paint shop and has been breaking barriers ever since. In September 2004, JoAnn made history when her bike was featured on the cover of *Easyriders* magazine, making her the first woman to have her own personal bike featured on the cover.

Her paint work has won some of the top awards in U.S., including *Easyriders* Best Paint of the Year and PPG's Top 5 Most Outstanding Paint. Her work has been featured in numerous automotive and motorcycle publications including *Easyriders, Car Craft,* and *Hot Rod* magazines. She has appeared on *NBC News, The Today Show, Musclecar TV,* and *Motor City Masters*. When she's not working or carving up the mountain roads on her Sportster, she's kayaking or spending time with her grandsons.

Index

A

adhesive, 150
Adobe Illustrator, 157, 184
airbrushes
 airsystems, 29
 care of, 216
 cleaning gravity-feed, 217
 cleaning siphon-feed, 218–219
 dual-action, 217
 resources, 219
 spare parts and, 215
 troubleshooting and, 212,
 215–216
antistatic guns, 210

B

brushes
 freehand striping and, 128
 palleting, 130–131
 preparation for pinstriping, 129
brush oil, 129

C

centerlines, finding, 50
cleaners, 28
clearcoating
 applying, 209–211
 artwork rework and, 206–207
 with basecoat clear, 205–206
 basecoat clear vs. urethane clear,
 204–205
 mixing, 209–210
 preparation for, 203–204
 prepping for finish clearcoating,
 207–208
 runs and, 210–211
 sanding before artwork and, 203
 temperature and, 209
 with urethane clear, 206
color, choosing, 15, 19
computers, 17
CorelDRAW
 creating a lettering stencil, 157,
 190–196
 curved lettering and, 192–195
 deleting line segments, 189
 font styles and, 191
 tools for creating a vector
 drawing and, 184–189
 tools/toolbar, 183, 185, 189
CutStudio software, 182, 190
cutting mats, 33

D

design
 blanks, 17–18
 body shape and, 10–14
 effectiveness and, 10
 examples, 18–19
 graphics layers, 18
 lowrider graphic style and,
 103–104
 software and, 20
 some reasons for, 8
 testing look of, 17
 transferring, 105

F

Faulkenberry Designs, 128
Faulkenberry, Zac, 128–133, 137
fingerprints, 213–214
flake paint
 clean up and, 95
 lowrider graphic style and, 102
 mixing, 96
 retro styles and, 94–95
 spray guns for, 97
flames
 design and, 62–63
 examples, 69
 ghost flames, 70
 paint application, 67–68
 pinstriping of, 144–145
 taping, 63–66
 tracing paper pattern technique
 and, 63–64
 See also realistic flames

G

ghost flames, 70
gold leaf, 149. *See also* metal leaf
graphic designs
 checkered flag graphics, 85–86
 examples, 92–93
 layout methods, 80
 materials for, 80
 multiple layer in basecoat,
 88–91
 multiple layer over basecoat,
 81–84
 patters and, 81
 taping and, 83, 88–91
 transferring/reversing, 87

H

hand brushes, 33

I

Indocil Designs, 128

L

lettering
 beveled edges and, 161
 borders around, 164
 creating stencil with
 CorelDRAW, 190–196
 examples, 166–167
 graphic design software and, 157
 hand stencils and, 157, 165
 hinge method for stencils and,
 161
 metal effect, 159–160
 patina effects and, 172, 177
 stencil mask materials, 157
 using stencils and, 158–163
 working with sign shops and,
 158–159, 193
lighting, 35
lowrider graphic style
 candy wipe sections, 115
 design and, 103–104
 design layout, 105–108
 elements of, 102

examples, 121–125
fade sections, 116
lace sections, 112–114
materials for, 103, 105
metal leaf and, 103
snakeskin effect and, 118
spraying metallics and, 104
sunburst sections, 108–111
taping, 108, 110, 112, 115–118
transferring designs, 105
waterdrop effect, 119–120

M

machinist scales, 33
Mack Sword brushes, 128
magnets, 34
markers, 33
masking tape, 35
metal leaf
 adhesive and, 150
 applying, 150–152
 clearcoating, 152
 engine-turning, 152
 examples, 153–156
 supplies for use with, 148
 taping, 149
 types of, 148–149
Modern Masters Metal Effects, 175

O

overspray, 204

P

paint
 air systems for, 29
 choosing temperature solvent
 and, 25
 cleaners and, 28–29
 cleaning from skin, 25
 dripped or spilled, 212
 mechanism of, 21
 thinning and, 73
 time between coats, 25
painter's easels, 33
painting process, testing and, 16
paint types
 basecoat/1K, 22
 clearcoats (1K and 2K), 23
 lacquer, 23–24

single-stage urethane 2K, 23
 thick vs. thin, 23
patina effects
 chemical processes and,
 175–176
 examples, 177–180
 layered-paint effects and,
 173–174
 lettering and, 172, 177
 materials for, 168
 real patina vs., 169
 rock salt method, 170–171
 topcoat colors and, 171
pearl powder, 27, 40, 213
Photoshop, 20
pinstriping
 brush palleting, 130–131
 brush preparation, 129
 examples, 127, 145–147
 finishing, 146
 of flames, 144–145
 freehand process detailed,
 134–138
 freehand supplies for, 128
 methods of, 126
 over graphics, 139–140
 position and, 134, 140
 practicing of strokes, 132–133
 tape and, 141, 143
 taped off, 126, 141–145
 uses for, 126
plotter stencils
 about plotters, 181–182
 about vector drawings, 182–184
 applying, 197
 cutting software, 182
 examples of art made with,
 200–202
 locating, 190
 painting with, 197–199
 software and, 182–183
 stencil material, 183
 weeding, 197
 working with sign shops and,
 193
pot life, 22
P sheets, 22, 24

R

rally stripes
 examples, 58–61
 matching stripe curves, 54
 materials for, 49
 paint prep, 57
 stripe kits, 48–50
 tape removal, 57–58
 taping, 49–56
realistic flames
 basic principles, 71–72
 colors for, 72
 embers and, 77
 examples, 78–79
 materials for, 72
 overspray and, 75
 paint thinning and, 73
 static electricity and, 72
 technique for, 73–77
 templates for, 72, 75–76
reflections, 159–160
retro designs
 examples, 99–101
 fish scale scallops, 96
 flake paint and, 94–97
 lace, 96–99
 layered line technique, 97–99
 materials for, 94
 sunburst design, 97–99
Ruiz, Frank, 88–91

S

safety
 cleaning paint from skin and, 25
 respirators, 35
sanding, paint adherence and, 21
shape, paint design and altering,
 10–14, 19
software
 creating lettering with
 CorelDRAW, 190–196
 creating with CorelDRAW,
 184–189
 cutting software for plotters,
 182, 190
 design and, 20
 lettering and, 157
 for plotter stencils and, 182–183

specialty paints
 candy, 26, 213
 flake, 28, 94–96
 metallics, 103
 non-flake, 96
 pearl, 27, 40, 213
 See also metal leaf
spray guns, 30–31
spray-out cards, 35
stencils
 checkered flag graphics and, 85–86
 hand cut, 165
 hinge method and, 161
 for lettering, 158–163
 materials for plotter, 183
 removing stubborn, 86
 saving, 162
 See also plotter stencils
stencil stripe tape, 143
Stoll, Paul, 88–91
supplies
 flames and, 62
 for freehand pinstriping, 128
 graphic designs and, 80
 lettering and, 157
 lowrider graphic style and, 103
 masking tape, 35
 metal leaf and, 148–149
 for patina effects, 168
 retro styles and, 94
 spray-out cards, 35
 stencil materials, 35, 157
 for taped off pinstriping, 141–143

T
tape measures, 33
taping
 for finish clearcoat, 207–209
 flames, 63–66
 graphic designs and, 83, 88–91
 line straightening, 51
 matching stripe curves, 54
 metal leaf and, 149
 pinstriping and, 126, 141–144
 rally stripes, 49–56

trouble-shooting issues with, 212–213
two-tone paint jobs, 37–39, 41
terms
 pot life, 22
 P sheets, 22, 24
testing, 16
tips
 for beginners, 9–10
 candy colors and, 26
 outside input and, 9–10
 pinstriping and, 137
 recommended hardeners and, 24
toners, candy, 26
tools
 airbrushes, 32
 air compressors, 34
 air systems, 29
 for cleaning airbrushes, 217
 cleaning supplies, 34
 flames and, 62
 graphic designs and, 80
 hand tools, 33
 lighting and, 35
 lowrider graphic style and, 103
 magnets, 34
 metal leaf and, 148
 for patina effects, 168
 plotters, 181–182
 retro styles and, 94
 rolling carts, 34
 spray guns, 30–31
 templates, 34
 Trulers, 105
 X-Acto stencil knives, 33, 85
training, as ongoing, 9
troubleshooting
 airbrush issues and, 215–216
 dripped paint, 212
 fingerprints and, 213–214
 paint removed with tape and, 212–213
 paint under tape, 213
 rough paint lines, 213
 sanding through candy/pearl layers, 213
 sun dried paint, 214
 uneven fades, 214

tweezers, 33
two-tone paint jobs examples, 43
 on motorcycle, 44–47
 paint order and, 36
 parallel tape method, 37
 second color application and, 42
 spraying of pearl coat and, 36, 40–41
 taping, 37–39, 41

V
vector drawings
 about, 183–184
 anchor points and, 184
 creating with CorelDRAW, 184–189

X
X-Acto stencil knives, 33, 85

Y
Young, Ryan, 128, 131, 139–140